Vincent van Gogh
Genius and Disaster

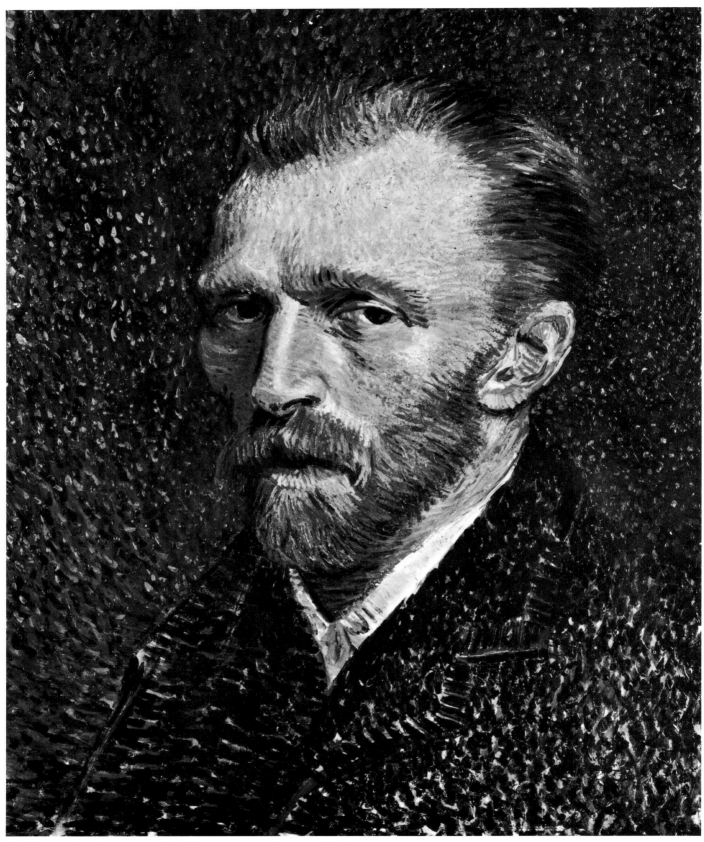

Self-Portrait. Paris, c. 1887. The Art Institute of Chicago

Vincent van Gogh

Genius and Disaster

A. M. Hammacher

Abradale Press/Harry N. Abrams, Inc.
New York

Library of Congress Cataloging in Publication Data
Hammacher, Abraham Marie, 1897–
Vincent van Gogh : genius and disaster.
Previously published as: Genius and disaster. 1968.
1. Gogh, Vincent van, 1853–1890. I. Title.
ND653.G7H24 1985 759.9492 84-21752
ISBN 0-8109-8067-3

Designed by Melissa Feldman
This 1985 edition is published by Harry N. Abrams, Incorporated, New York.
Previously published as
Genius and Disaster: The Ten Creative Years of Vincent van Gogh.

Printed and bound in Japan

Contents

The Awakening
9
The Fulfillment
41
Chronological Summary
190
Author's Note
192
List of Illustrations
193

The Awakening

T HE first important essay devoted to Vincent van Gogh appeared in the *Mercure de France* of January, 1890. It was written by Albert Aurier, a young poet, who in the overwrought Symbolist style of his day ranked Van Gogh among the group of Les Isolés. Vincent was both pleased and disturbed by the article, and commented tellingly that Aurier "propounds a collective me, as unreal to others as it is to myself." Though isolated, Van Gogh did not escape his time; and indeed, his apartness can be properly understood only in relation to contemporary society. He perceived a great deal, but the antennae of other sensitive thinkers of the time perceived as much—the poets and painters who appreciated what Vincent accomplished. Aurier, also doomed to die young, used words to penetrate Van Gogh's terrible isolation in an unresponsive society and thereby released a stream of words that has yet to be exhausted. Theo van Gogh applauded this when he wrote to Aurier after Vincent's death: "You were the first to appreciate him, not only for his greater or lesser abilities at making paintings; you have read into his work and have seen *the man* very clearly."

In a generation and an age dominated by the Impressionists, Aurier's was an important word. He had seen the painter in a larger, more symbolic context. But, for Van Gogh, the response was too late: he could no longer cope with either the words or the images the public attached to him. Perhaps conscious of the few months left to him, and undermined by the ever-increasing tempo of his creative life,

he wished to silence publicity such as Aurier's with which his work was objectified and handed over to the world. It was not that he disdained acclaim; but, accustomed to little response or else resistance, he was overwhelmed.

More than anyone else in the second half of the nineteenth century, Vincent attempted in his paintings a totality of human experience. This was *the man* whom Aurier discovered with his symbolic divining rod and whom Theo knew firsthand. And they, together, provide the source for the publications about Van Gogh. Theo requested Aurier, before he himself collapsed, to study and publish not only the work but part of the correspondence. This task Theo's wife later fulfilled almost completely (1914), and her son thoroughly accomplished (1952)—so that now anyone who reads about Van Gogh can view him in his entirety: not only his thorough commitment to painting from 1880 onward, but his difficult youth and the shocking days among the miners of the Borinage, where he experienced society's contradictory reaction to the Christian message.

Vincent's formative, unfolding stage was more than simply a preamble to painting in which gradual development attained completion. As soon as he abandoned all attempts to be anything but a painter, he appeared to achieve a kind of maturity. His message was prepared. He then had to battle with time and with technique to create as directly as possible the powerful images that would allow him to convey what neither word nor action could ever show.

In him the image always coexisted with the word, but as yet it had neither its place nor its power. His drawings from childhood on, both the separate sheets and those in the letters, are in this respect more important than was earlier realized. The relationship of image and word had to be struggled with. It is impossible to separate the letters from the drawings and, later, the paintings. That he came to find the drawn or painted image superior to the written word is shown by his advice to his sister Willemien: to be able to write, he told her, she would do better to make her life more intense and to aim higher rather than to study more, for she would then sooner be able to give her feelings expression in brush and pencil.

Among artists, only Delacroix led a similar double life with written word and rendered image. Van Gogh kept no diary as such, but his letters to Theo fulfilled this function. He always repeated his life in words, not as a report but as a re-experiencing of events, which sometimes deviated from what had actually happened. What is most important about this is Van Gogh's revealing of experiences that could not be conveyed in words but which could be expressed in line and color. The adventures of his youth and shortly afterward had a lasting effect upon him. His country childhood and the Dutch landscape formed a reservoir of rich images which, though repressed at first, later, with his growing thoughts of death, had an increasing power over him. The beginning was finally understood in the end.

His sternly pious parents in their little Brabant village trained him in virtue and civic duty based on theology. However, as soon as he had to live in The Hague, London, and Paris in order to learn the art dealer's trade, he participated in a more cosmopolitan culture by reading and by visiting museums and exhibitions. The influences on his character—ethical, social, pictorial, and literary—became broader in range.

Vincent had little interest in the past, either then or later. He did not see large cities in an artistic or historical light. The Roman monuments next to the monastery at Saint-Rémy simply escaped his notice. The famous Romanesque church and monastery at Arles did not really appeal to him, and in museums he paid attention not to periods or styles, but to painters who impressed him through their human compassion and pictorial greatness. The nineteenth century interested him the most. In general he found that it was fatal to look back to the old world to which his parents still belonged.

It was the novelists with an ethical, social, or historical turn who contributed most of all to the broadening and deepening of his way of thinking, which was originally based on his knowledge of the Bible. He was influenced by Dickens, Balzac, Zola, and especially Jules Michelet, the French historian. He even used Michelet, whose work he had read in London as early as 1874, to determine his behavior toward women. He was acquainted with the work of Renan and Taine. Like many artists in France he realized the significance of the 1848 revolution and saw therein a spirit different from that animating

the *bourgeoisie* of the French Empire, who had their origins in the industrial development following the revolution and believed in progress and the machine.

In his painting he drew from very rich but also very limited sources. Frans Hals excited him, but it was Rembrandt who moved him most profoundly. The painter Mauve awoke respect in him for the achievement of Meissonnier, but Millet and Jozef Israels were closer to him, their religious and ethical attitudes more like his own. He was to take over Delacroix's vision in line and color, even before he had actually seen that painter's work, but he was no less engrossed with the Japanese woodcut artists, not only for their technique, but also for their human and emotional qualities.

Through the work of an artist he came to perceive the man, and as soon as he thought he could recognize himself in another, admiration turned into identification, as in the case of Monticelli. He never ceased to search for his own likeness in Monticelli's fate and conduct. His feeling that he was merely to continue the work of others came continually to the fore, so that his self-consciousness was balanced by his feeling for the great river of living tradition.

By the time he went to the Borinage to realize his message pictorially, the young man of twenty-seven had assimilated a mixture of literature, philosophy, Biblical knowledge, and seventeenth- and nineteenth-century art. He had gained wisdom and insight. Several deeply disappointing experiences with women made him realize, through erotic awareness followed by catharsis, the futility of his pas-

Continued on page 16

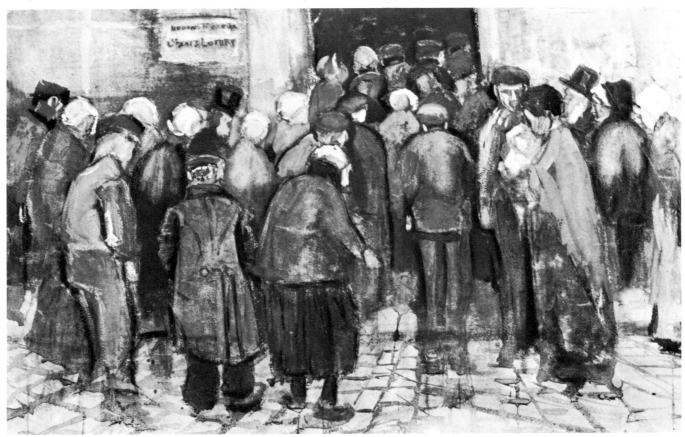

The State Lottery. The Hague, 1882. Rijksmuseum Vincent van Gogh, Amsterdam

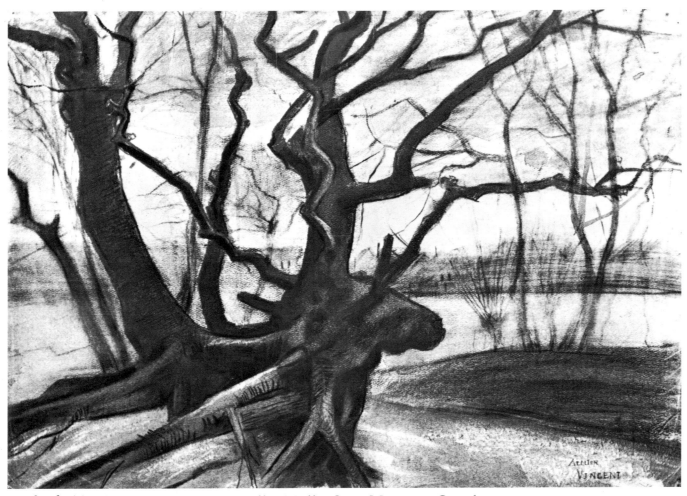

Study of a Tree. The Hague, 1882. Kröller-Müller State Museum, Otterlo

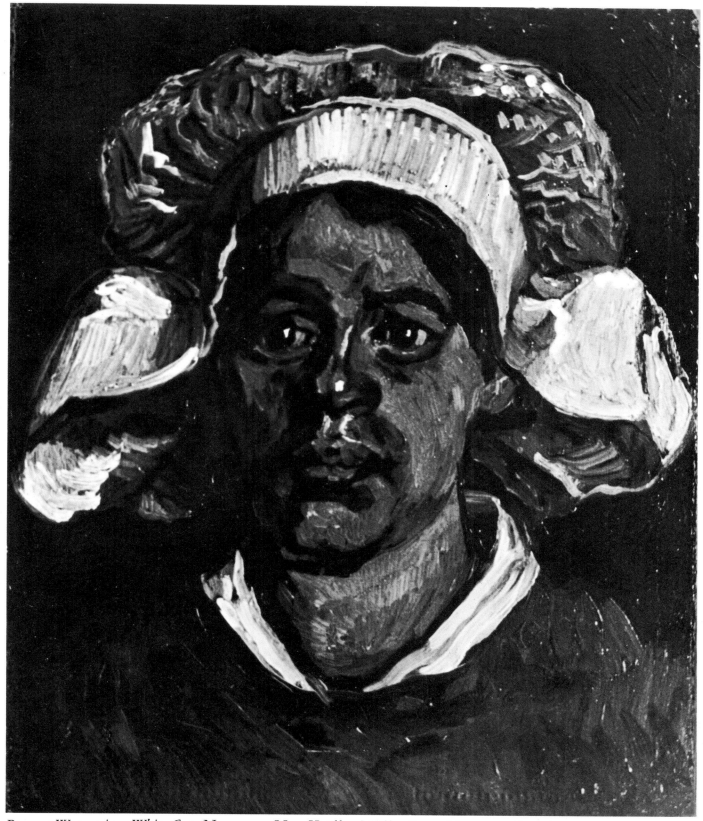

Peasant Woman in a White Cap. Nuenen, 1885. Kröller-Müller State Museum, Otterlo

sionate and ecstatic inspiration through love. His deep longing for shelter in the family was not destined to be satisfied. Women nevertheless remained for him the dominating symbol of order and regularity. In the painting *The Potato Eaters*, the women in the composition form a triangle, the youngest placed at the bottom and almost in the middle. He was fond of the old order around the hearth. For these reasons, too, he liked the work of Chardin, the eighteenth-century French painter of interiors and still lifes. Women predominate among the figures in many of his drawings.

Although his personal impulses seemed anarchic within the context of nineteenth-century society, he called artists "the great lovers of order and symmetry." He knew that the age and his own temperament prevented his own fulfillment of these ideals. He was a vagabond not from desire, but from necessity. His whole being was imbued with a sense of matriarchy which, despite his familiarity with large cities, still bore traces of his rural upbringing. His limited interest in architectonics and his liking for the humble cottage are also typically rural.

By his thirtieth year he was conscious of what was in store for him. With second sight he explained to Theo in a letter from The Hague how his life would turn out. He realized that he had begun late, and that his health would probably give out after six to ten years. "My plan is not to spare myself, not to avoid difficulties; it is relatively indifferent to me whether I live longer or shorter." He explained, as briefly as possible, with complete calm and serenity, just what it was that he wanted to do

Continued on page 36

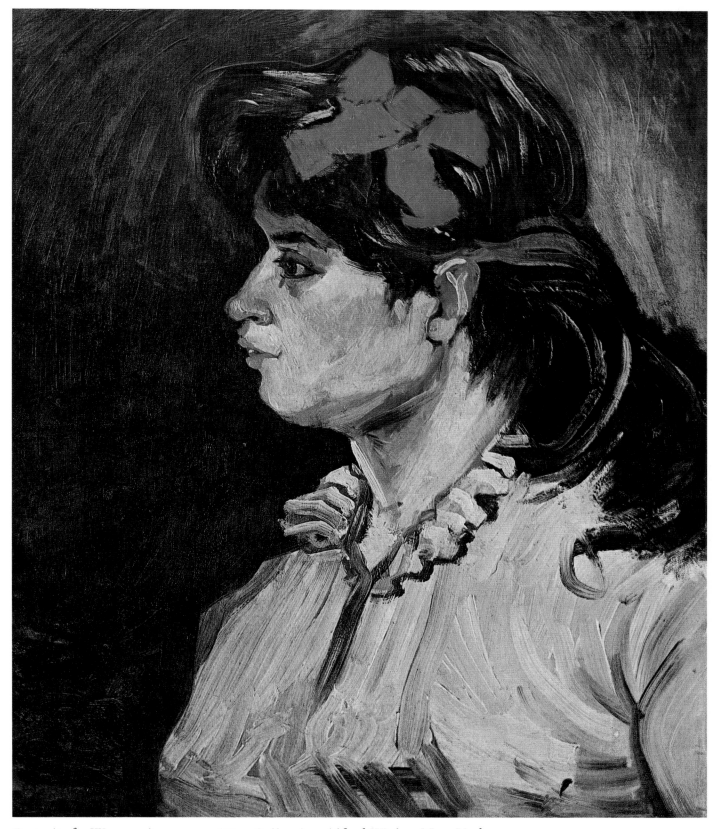

Portrait of a Woman. Antwerp, 1885. Collection Alfred Wyler, New York

Vincent's main purpose during his stay in Brabant was to become "the painter of the peasants," but in Antwerp he not only discovered Rubens, but came in contact with people from the docks, middle-class café patrons, and the handsome girls who served them. From letter 442 (December 28, 1885) we learn that the model for this profile was a girl from a *café-chantant* through whom Vincent ". . . tried to express something voluptuous and at the same time cruelly tormented." His color scheme is different from that of the darker Brabant period. The flesh color, the scarlet notes, the whites, are partly due to his new artistic discoveries, partly to the character of the model herself.

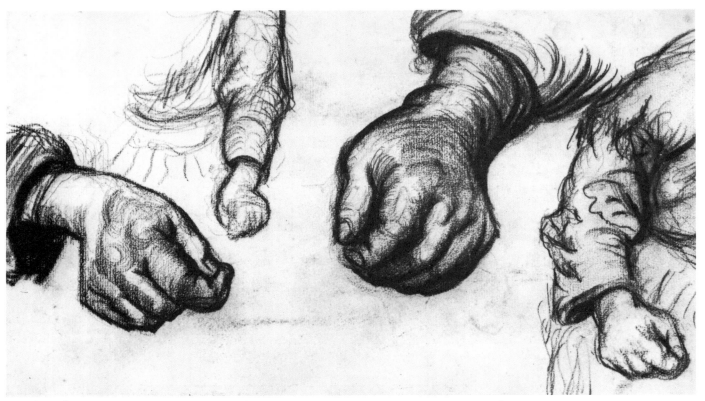

Studies of Hands. Nuenen, 1885. Rijksmuseum Vincent van Gogh, Amsterdam

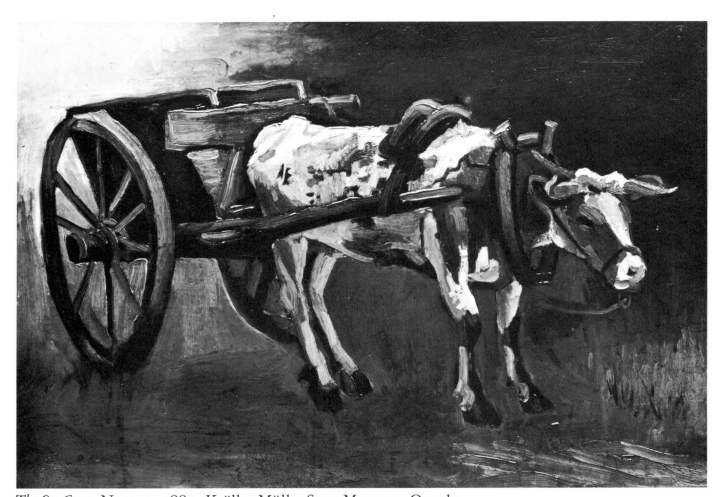

The Ox Cart. Nuenen, 1884. Kröller-Müller State Museum, Otterlo

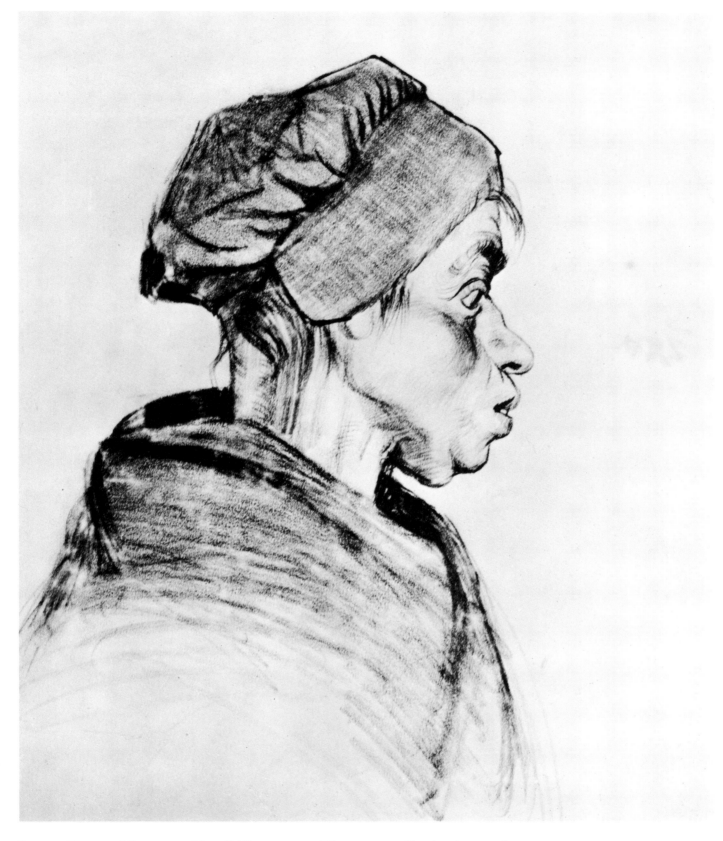

Peasant Woman. Nuenen, 1885. Rijksmuseum Vincent van Gogh, Amsterdam

Since his early work in the Borinage, Van Gogh had developed his drawings as the basis of his whole *oeuvre*. After leaving The Hague his emotional feeling for color had taken hold of his drawing. Moreover, in Brabant he discovered Delacroix's concept attacking the academic law which made drawing dependent upon outline. In Brabant the drawings became freer, and his ability to express observed movement developed.

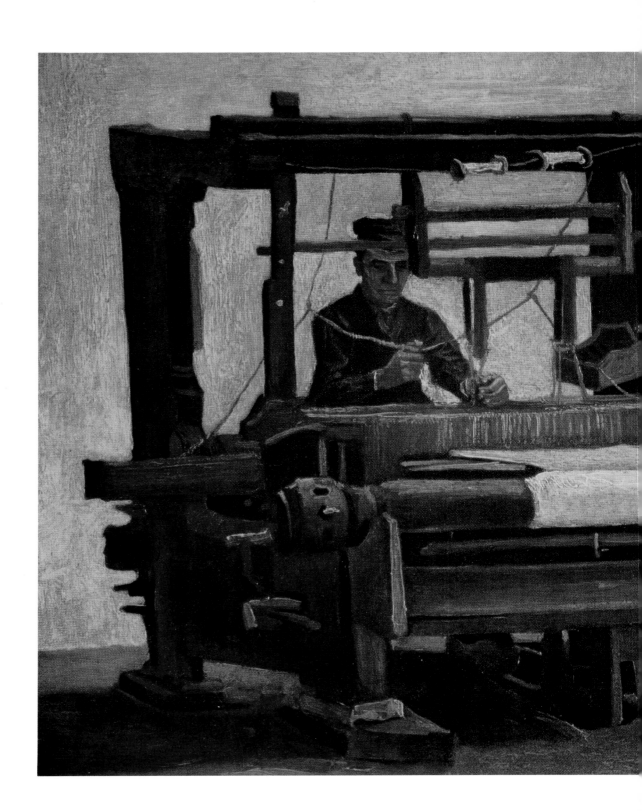

The Loom. Nuenen, 1884. Kröller-Müller State Museum, Otterlo

Van Gogh had come to know the weavers during his foot journey to the painter Jules Breton in the winter of 1879–80. Seeing them again two years later, he found an impressive dignity in their poverty. They seemed a separate, doomed race of somber dreamers. In 1884 in Brabant, he wanted to render more than a visual impression of these weavers and their equipment. He wished to give a matter-of-fact report of this old Brabant trade: its human aspects, the light effects, the well-worn wood of the machinery. There is tangible evidence in the painting of the influence of English illustrative art. His structural vision of the scene and the vigor of the forms are remarkable and quite different in kind from Dutch Impressionism.

Peasants Digging. Nuenen, 1885. Kröller-Müller State Museum, Otterlo

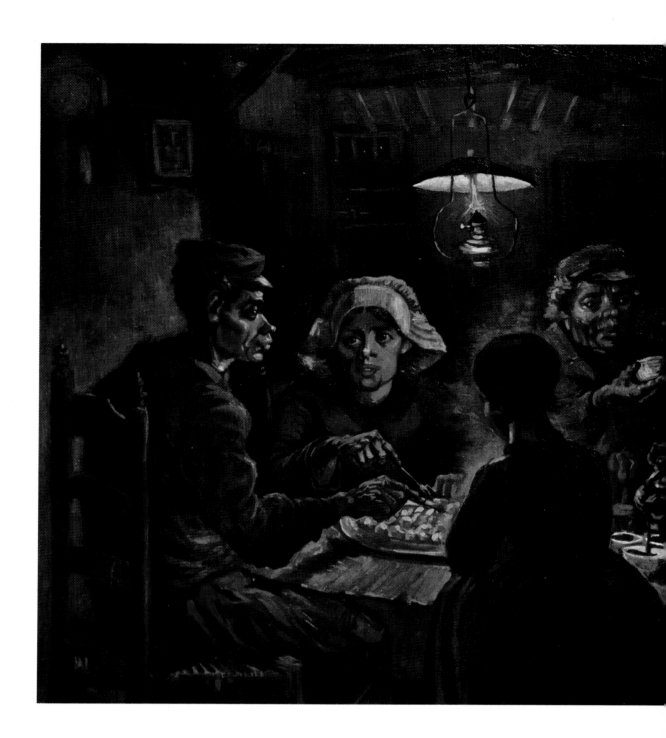

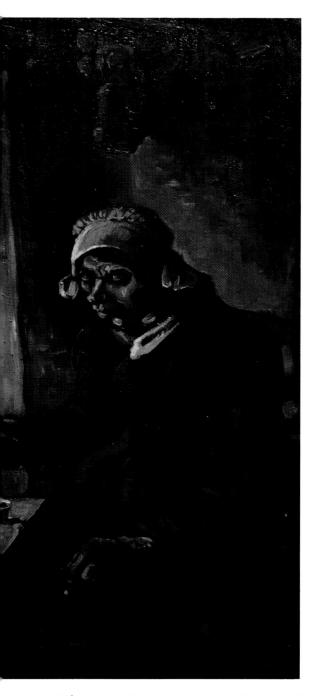

The Potato Eaters. Nuenen, 1885. Rijksmuseum Vincent van Gogh, Amsterdam

The whole struggle of Van Gogh's Dutch period culminated in the two versions of *The Potato Eaters*. His reading of Zola's *Germinal* and especially of Michelet had reinforced his innate feelings for the working man. He still had strong rural affinities and loved the fireside, the family, and the cottage. In this painting he makes a conscious break with the conventions of proportion for the sake of expressing character, thus becoming a forerunner of Expressionism. The potato eaters are emblematic of his aversion to the *bourgeoisie.* They are the personification of his urgent craving for vitality, his love for the earth, and for the men who toil and bear the marks of their arduous work. His ambition to become the painter of the peasants was not contemplative but dynamic. Later he wrote to his sister from France: "What I think of my own work is that the painting of the potato eaters that I made in Nuenen is after all the best I have done." In a letter to Theo (No. 533) he ranked his painting of the night café at Arles, which he regarded as one of his ugliest canvases, along with *The Potato Eaters*.

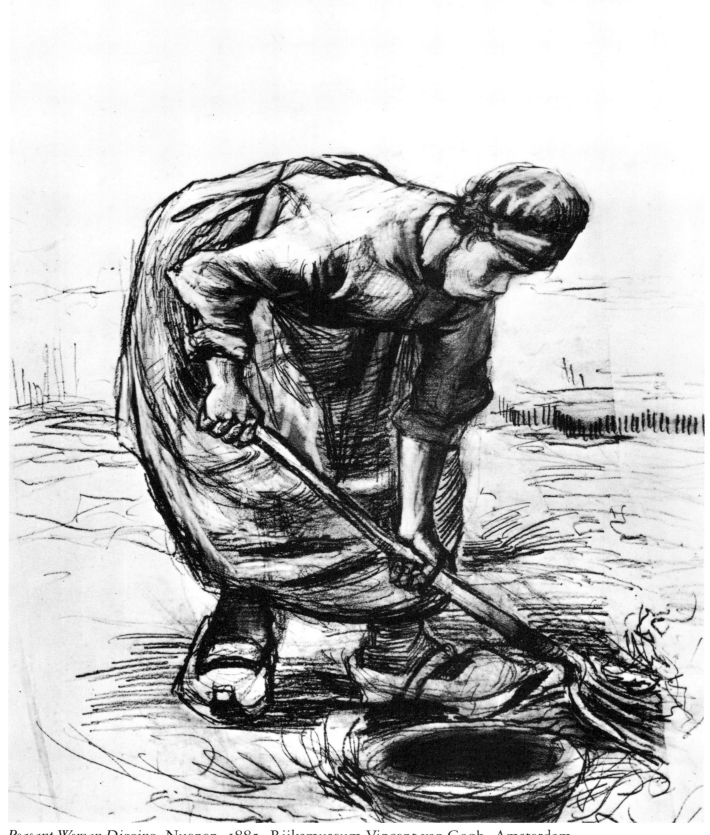

Peasant Woman Digging. Nuenen, 1885. Rijksmuseum Vincent van Gogh, Amsterdam

Study of an Auction near Nuenen. Nuenen, 1885. Kröller-Müller
State Museum, Otterlo

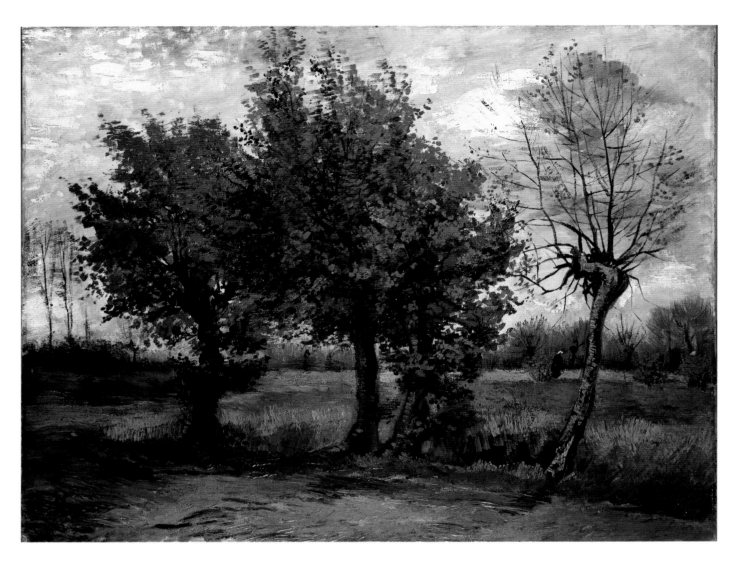

Autumn Landscape with Four Trees. Nuenen, 1885. Kröller-Müller State Museum, Otterlo

This picture is among the last landscapes Vincent painted in Dutch Brabant (November, 1885) before leaving for Antwerp. In his letters (No. 421) he mentions only three trees, concentrating as he was on the foliage. But there is also a fourth tree, poor and more or less isolated. In his book, *The Symbolic Language of Van Gogh,* H. R. Graetz says (p. 33) that it is this tree which makes the painting a "Van Gogh." Unconsciously he may have identified himself with this tree, feeling himself an outsider, a big rough dog in the family home. In any case, this picture, with its fine silver-gray and other delicate pale tonal values, contradicts the general legend that Vincent's Dutch period was a dark one.

Montmartre. Paris, 1886. The Art Institute of Chicago

Van Gogh's dark Dutch palette gradually became lighter, especially in Paris, where Impressionism began to affect him. His way of painting became lighter and more sketchy, his drawing swifter and more colorful. In Antwerp the color was fuller and his touch heavier; he admired Rubens. *Le Moulin de la Galette* is another example of his Dutch bronze tones applied with a freer touch. *Montmartre* has lighter and subtler grays, and a remarkable accent on the vertical lines of the lanterns, the fence, and the scaffolding.

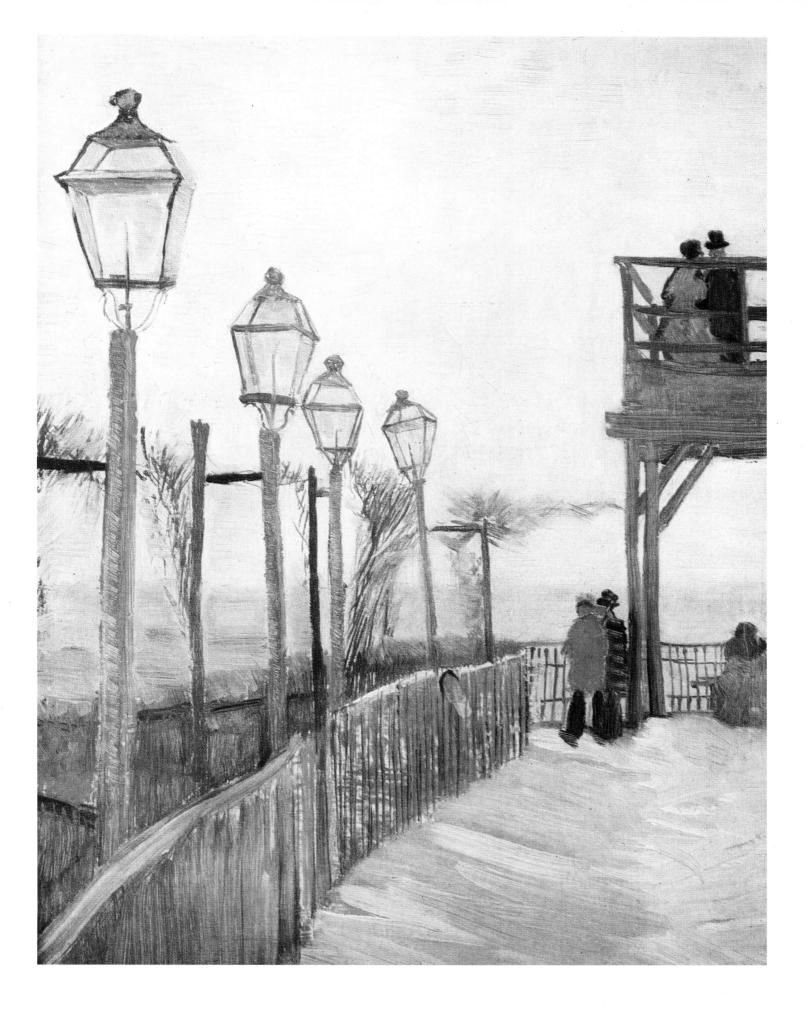

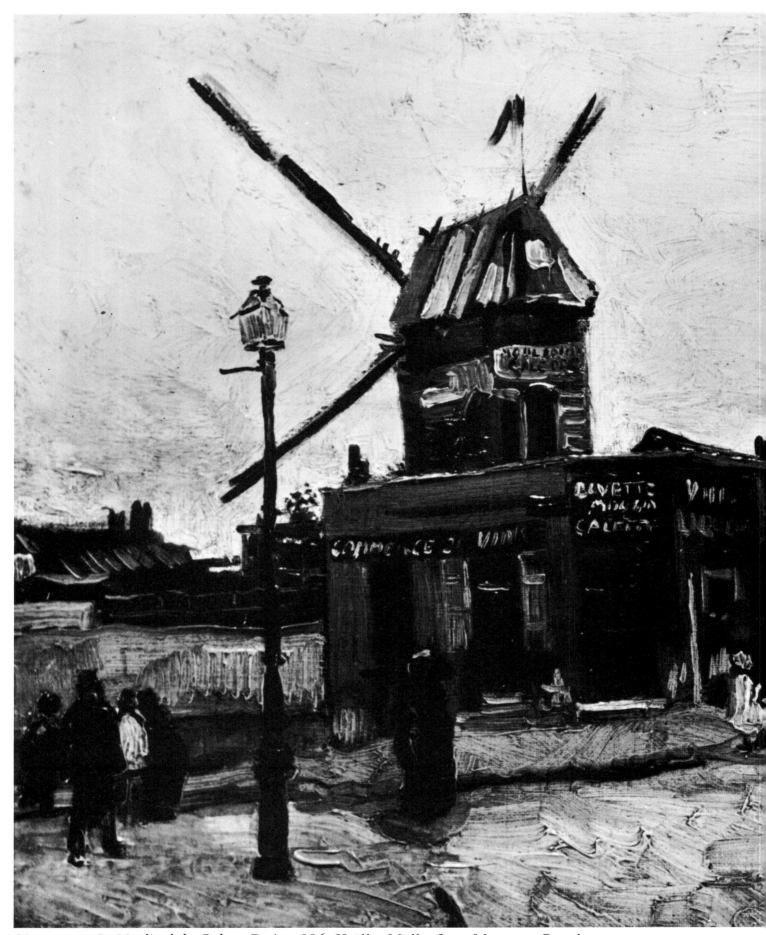

Montmartre, Le Moulin de la Galette. Paris, 1886. Kröller-Müller State Museum, Otterlo

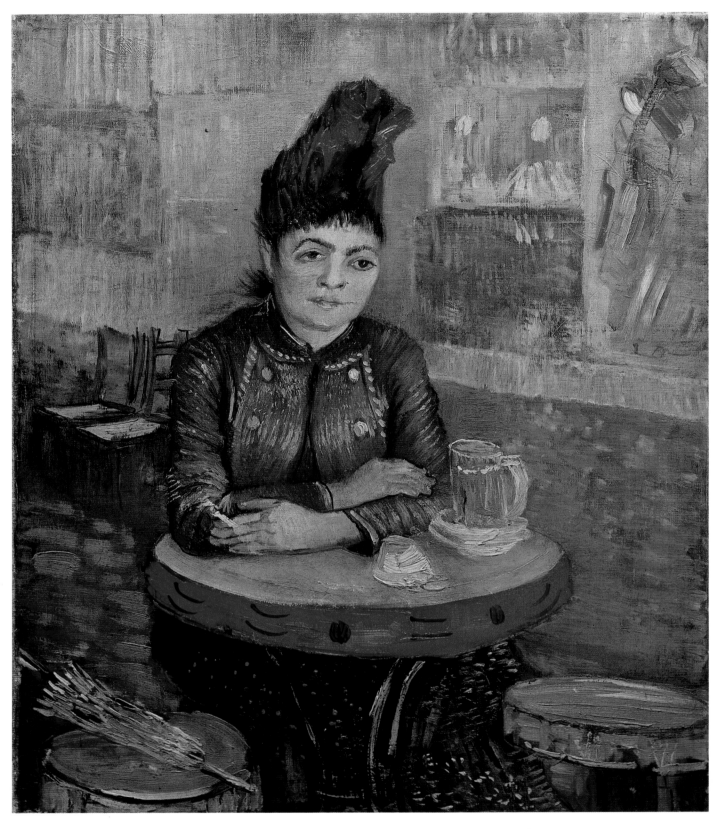

La Segatori in the Café du Tambourin. Paris, 1887. Rijksmuseum Vincent van Gogh, Amsterdam

Van Gogh painted the woman in the Café du Tambourin using a Lautrec-like atmosphere and a Japanese background. He attempted to hold small exhibitions there of his own and other artists' work (Bernard, Lautrec, Anquetin) for the benefit of its clients, but a clash with the proprietress put an end to the scheme. Only in the restaurant interior does he achieve pointillism; he was too bound to objects, and his sensitivity to their structure prevented any formal adaptation of the system of Signac and Seurat. Never again was he to paint so lightly and poetically as in Paris, freed from the peasant epic that he had wanted to create in Holland.

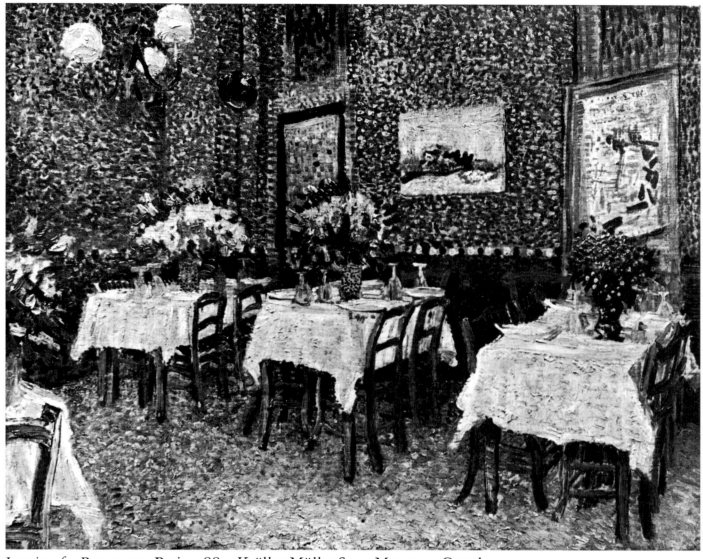

Interior of a Restaurant. Paris, 1887. Kröller-Müller State Museum, Otterlo

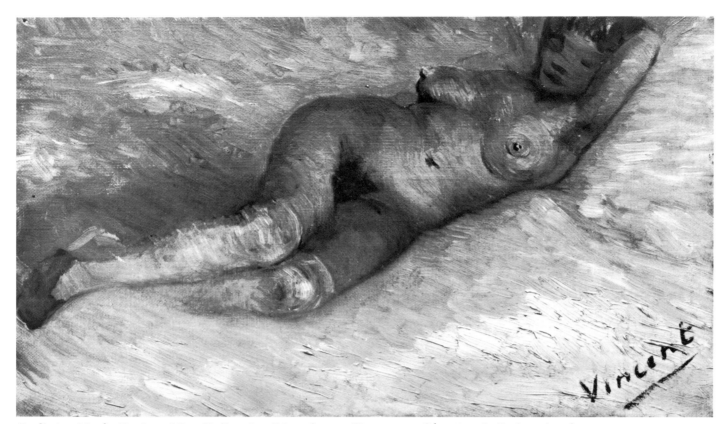

Reclining Nude. Paris, 1887. Collection Mrs. S. van Deventer, Oberägeri, Switzerland

Female Torso. Paris, 1887. Private collection, Tokyo

Unfortunately, written documents and information of Van Gogh's Paris period are rare. However, the letters from the preceding period, in Antwerp, do give a clue to his intentions with a series of studies after plaster casts of female torsos and nudes. At the Academy in Antwerp he learned to draw and paint after plaster casts of ancient sculpture, and was ". . . amazed at the ancients' wonderful knowledge and the correctness of their sentiment" (letter 445). His way of drawing these casts scandalized his professors, though, for, as nearly as he could, he translated them from sculpture into living human models.

This reproduction makes it clear that in Paris Van Gogh was also fascinated by the problem of space, and that some of the Antwerp influences continued to preoccupy him during his first months in France.

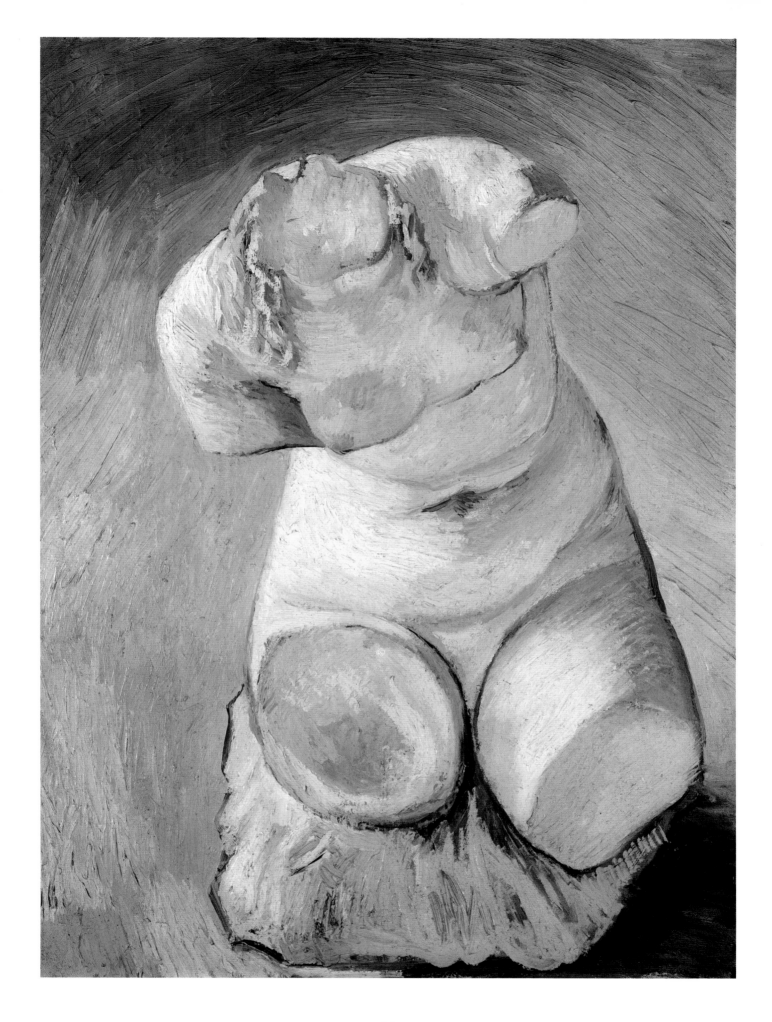

in these few years. He cited the example of someone who had died at the age of thirty-eight. He wanted to be scorched by the consuming flame.

Living with this awareness, which acted like a dam, he understandably looked always for means of expressing himself as directly and quickly as possible. One reason he so admired the Japanese artists was their lightning-swift drawing: he had no time to lose. The thought of speed and of immediate action linked up with the picture of death that was growing in him. For him to die peacefully in old age would be impossible. He wanted to travel more rapidly. He regarded incurable diseases as heavenly means of transportation, comparable to the steamers, buses, or trains that connect places on earth. If we take the train to go to Tarascon or Rouen, why not take death to reach a star?

The eight years in which his work was accomplished became a race against death. Their urgency came from a clear prescience of the time allotted to him on earth. He arranged his life and relentlessly excluded anything that would divert him from his goal. His only concern was to create. Schemes to promote the sale of his work were put aside. The legend that blames public incomprehension for the failure of his work to find buyers is not supported by his actual relationship to society. He shrank from publicity and sales, sometimes even requesting Theo to do nothing in this respect. His refusal to become involved in business was in effect a refusal to hamper the assimilation of his experience and interrupt the flow of his creation.

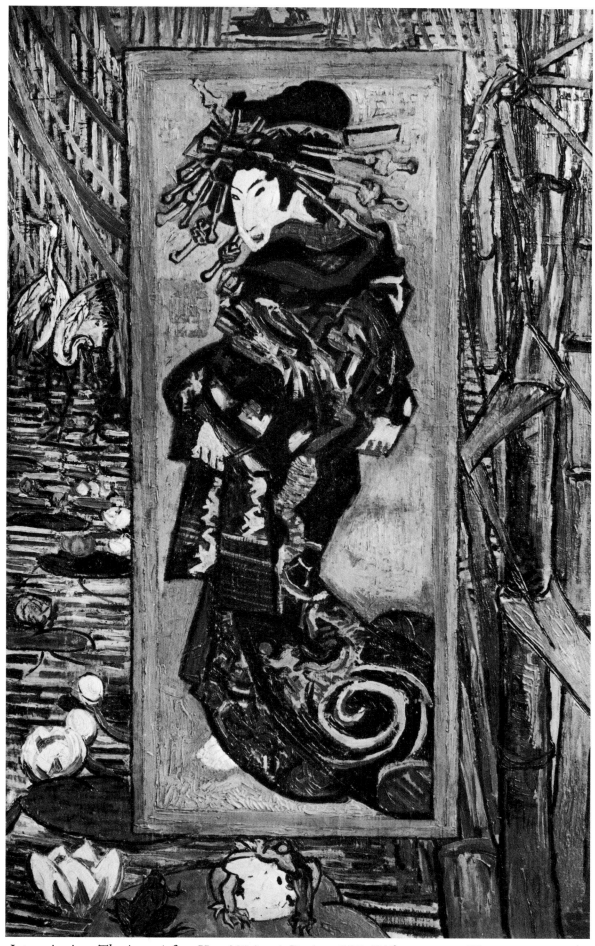

Japonaiserie—The Actor (after Kesai Yeisen). Paris, 1888. Rijksmuseum Vincent van Gogh, Amsterdam

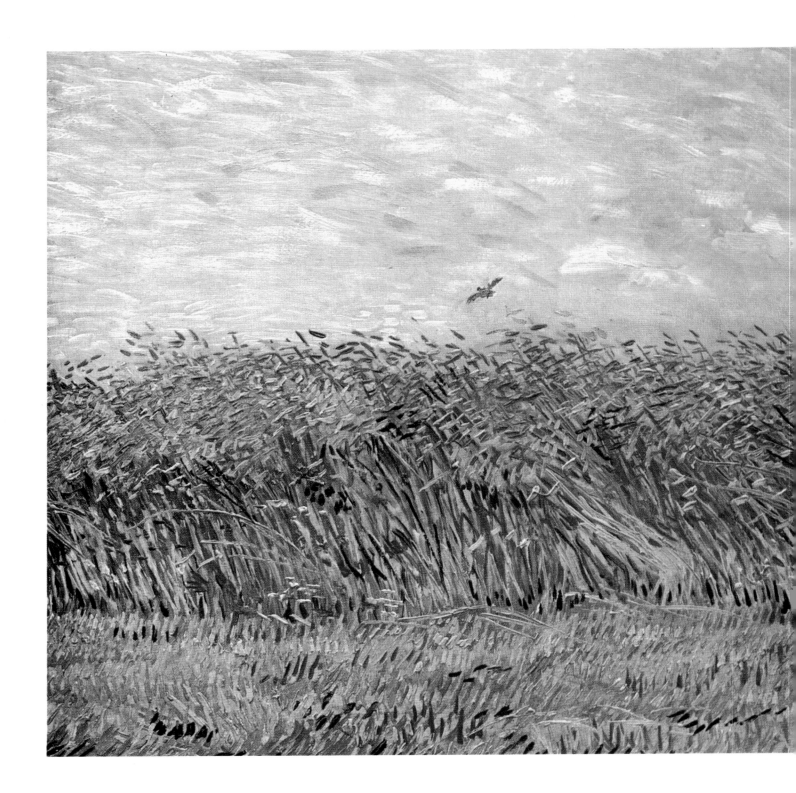

A Wheat Field. Paris, c. 1887. Rijksmuseum Vincent van Gogh, Amsterdam

The short stroke, perfected by the Neo-Impressionists Signac and Seurat, gave Van Gogh the chance to express the vibration which light and wind bring to landscape. This subject in all its difficult simplicity appeared in Daubigny's work. In this canvas and in the related *Pasture Land* from the Kröller-Müller Museum, Van Gogh arrived at an abstract rhythmical effect that resulted in an almost two-dimensional picture.

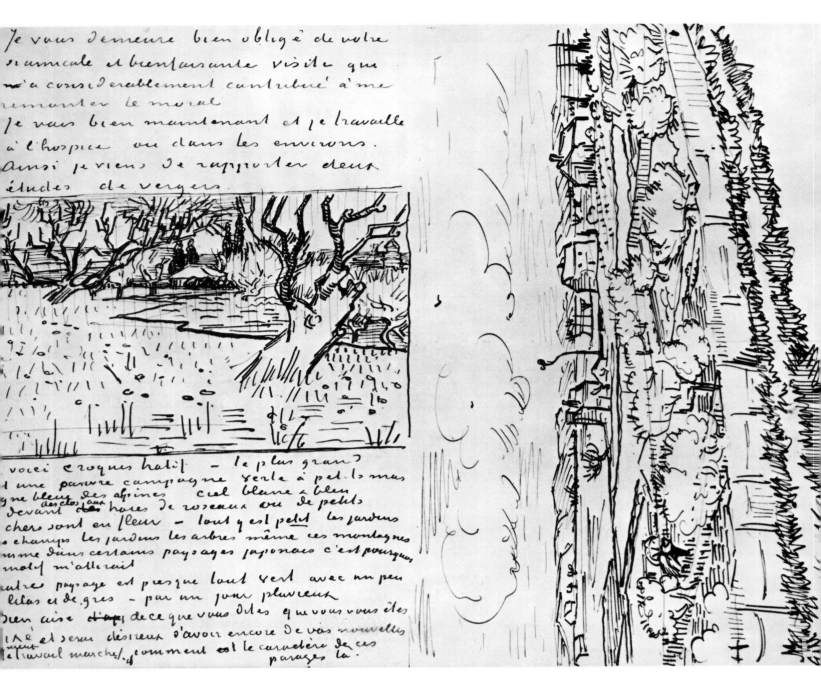

Letter No. 583B, to Signac. Arles, March, 1889

The Fulfillment

THE customary classification of Van Gogh's *oeuvre* according to the places where he lived and worked has the advantage of being simple and arresting. Nuenen, Paris, Arles, Saint-Rémy, and Auvers have become almost symbolic, their names evoking not only landscapes but the style in an aesthetic-geographic succession. However, more important insights to the painter's nature emerge from the chronology of his work and letters, a chronology suggesting that actual events, rather than mere change of surroundings necessitated by psychological tension, caused the alterations in his style.

We can safely make the classification a little freer by concentrating on the rise and continuity of the themes as they attain maturity, and we can follow the so-called Dutch period into Paris, or the Parisian into Arles. The Saint-Rémy period has its beginnings in Arles; and the last phase, that of Auvers, can only be understood as the consequence of factors already evident at Saint-Rémy.

Van Gogh's contact with his motifs was always complex in nature. His point of departure was not solely an aesthetic one; for, alongside his potent and immediate awareness of the forms around him, he possessed an intuitive feeling for humanity. The emotive content of things, the history and drama of the moment, fascinated him. In this respect he was still firmly rooted in the first half of the nineteenth century. The pictures he hung in his boyhood rooms and the reproductions he collected were sentimental, anecdotal, and illustrative. It is not unusual that his years at Brussels and later at The Hague

saw him with a multitude of interests, but it is surprising that at the center of his early artistic conceptions was the work of certain English artists who drew for wood engravers.

This important influence began in London in 1873. He would go each week to examine the latest issues of the *Graphic* and the *London News* in the showcases of their printers. Ten years later, in a letter to his artist friend Anthon van Rappard (R 20), he stated that the drawings were still clear in his mind and his enthusiasm for them even stronger.

Despite the scorn of other painters, he tirelessly insisted on the merits of these graphic artists. Vincent defended illustrative art against the Impressionist vogue of his time. With great difficulty he tried to put into words the emotional and pictorial quality he felt in them. In a lengthy correspondence with Van Rappard, who like Van Gogh was an avid collector of illustrations, he mentioned *Harper's Monthly*, the *Graphic*, the *London News*, *Punch*, *Scribner's Magazine*, and, from Belgium, *Uilenspiegel*, for which De Groux and Félicien Rops drew. Of the Englishmen he cited Herkomer, Fildes, Pinwell, Ridley, Walker, Green, and Holl; of the French black-and-white artists he liked Lançon and F. Régamey, this last artist for the close attention he paid to Japanese painters.

During this Dutch period, the themes Van Gogh stressed can be found among the English artists, whom he considered more inspired than the French. Weavers, mineworkers, orphans, homes for the aged, Dickens' empty chair by Fildes, whose whole story he related—these highly charged and emo-

tional subjects led him to take his own themes from the lives of ordinary people at home and at work.

Sadly he noted in 1883 that the *Graphic's* illustrations had deteriorated for commercial reasons: the magazine had now started showing "Types of Beauty" instead of "Heads of People." He saw moral greatness making way for material considerations, though the impression of life itself was still the first impulse from which the motifs of the pictures were taken. The weavers, for example, he encountered in English drawings between 1881 and 1883; but in the winter of 1879–80, on his journey by foot to Cour-rières, he had seen with sympathy the villages of these isolated, neglected workers, whom he compared with the miners. The weaver, he felt, was pensive, a dreamer, almost a somnambulist. Though obscure and impoverished, the weavers and their looms were to become an important motif for Van Gogh in Brabant. He wished to show the monstrous, clattering, begrimed machine with a ghostly or apelike figure at its center from early morning till late at night.

If, at Brabant, Vincent finally reached the peak of his Dutch period with *The Potato Eaters* and certain landscapes, it is due largely to extensive preparation, emotional as much as technical. His dispute with Van Rappard about the dimensional and graphic accuracy in the lithograph of the potato eaters con-tains the essence of what he had accomplished, and at the same time reveals the nature of the opposition to his art.

Van Gogh understood from the first that he would have to learn to draw—perspective, anatomy,

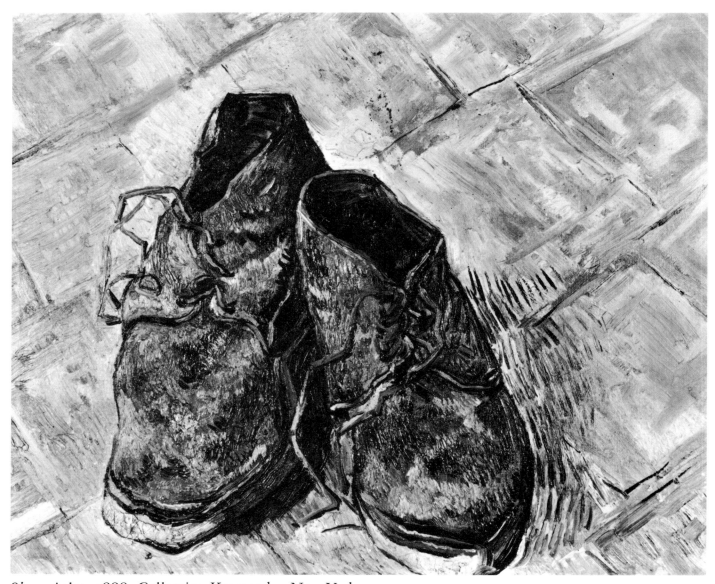

Shoes. Arles, 1888. Collection Kramarsky, New York

proportion. Examples were of great assistance. He used Bargue, John's anatomical diagrams for the use of artists, and Cassagne's essay on watercolors. He took courses at the academies in Brussels and, later in Antwerp, supplemented these lessons by copying Millet from photographs and Holbein out of *Models from the Masters*. When his resources permitted he tried to hire suitable models, and he collected articles of clothing for practice in rendering the clothed figure. His Dutch landscapes nearly always begin with trees, and the surroundings emerge from them. But even here, in the drawing of trees, he was inspired by their figurative, almost human, aspects.

Ostensibly there was enough opportunity here for academic practice, had not Van Gogh been convinced that such drawing lacked life and expression. He did not want to work in the academic manner; he had no fear of structural faults, provided he achieved character, feeling, and the expression of life and movement. He wished for continuous contact with nature and could not work without it—but not for the sake of copying nature "correctly." He was indeed sick of the flabbiness of nineteenth-century civilization, and expressed this forcefully: "It is better, one is almost literally happier, if one can carry this out [to be outdoors]: one feels really alive. And that's something—in the winter it is good to be in the snow, in the autumn good to be in the yellow leaves, in the summer good to be in the ripe grain, in the spring good to be in the grass, it's something to be the whole time with the reapers and the farm girls, in summer with the great sky above, in winter beneath the black chimney. And to feel that that

45

Continued on page 48

Self-Portrait with Easel. Paris, 1888. Rijksmuseum Vincent van Gogh, Amsterdam

Before he left Paris for Arles, Vincent painted himself in a mirror, with a blue smock and red beard, his palette and easel. He described himself in a letter from Arles to his sister as wooden, rather untidy, sad, with a deathlike countenance. He was looking for a likeness more profound than that of the photograph. In Paris he produced a far greater number of small self-portraits than at any other period, as well as some large ones. They are with and without hat, with and without his pipe, never full-length, and with a hand showing in the last Parisian portrait. Among his contemporaries, Cézanne alone had succeeded in a series of important self-portraits. The glance of the eyes and the swiftness with which Van Gogh's portraits followed each other indicated his need for self-analysis. He observed and questioned his various states of worry, inner turmoil, and obsession. The lightly lyrical and Impressionist style of his middle and last Parisian periods is so deceptive that only in the self-portraits does this profound anxiety appear.

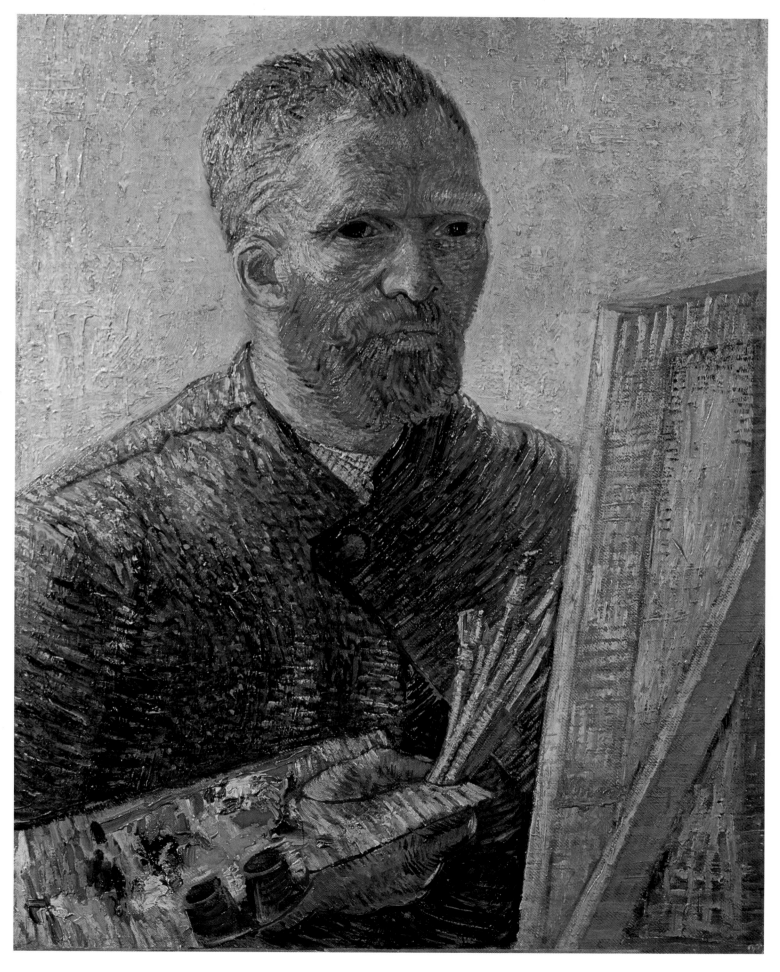

Garden in Provence. Arles, c. 1889. Rijksmuseum Vincent van Gogh, Amsterdam

has always been and will always continue to be." In this statement, which contains a theme running throughout his letters, we can find a determined program, a negative reaction to his time and to what other painters and dealers termed "technique." He felt that to draw a figure correctly or to paint in an even and reasoned way had little to do with "the urgent needs of the present time in the field of painting."

He agreed enthusiastically with Delacroix, Géricault, and the ancients that in drawing, the outline of the subject was not the first thing to be determined. Rather one should model as one draws, directly with the pencil. To draw one starts with oval masses, correctly joined, not with contour. In this he disagreed with David, for example, and the routine academicians. In Antwerp this awareness was heightened by the criticism of his teachers at the academy: Verlat, Sibert, and Van Havermaet.

As far as color was concerned, Van Gogh discovered its symphonic value after his Hague and Brabant periods. Color released in him the autonomous values of paint which in themselves have expression. He said of carmine that it was as red as wine, as warm and gay as wine. Cobalt blue he considered a godly color. With these convictions about drawing and painting, he would be forced to part from the prevailing system like all artistic revolutionaries.

In color he defined his relationship to nature, his indispensable ingredient. It was a self-revelation to see his palette beginning to thaw, as it did in his last months at Nuenen (Brabant) (see letter 429). He

The Road to Tarascon. Arles, 1888. Kunsthaus, Zurich

could now take a single color for his point of departure and have clearly in mind what must follow. It was a startling discovery that he need no longer strive for the actual hues of his subject, but instead begin with the colors on his palette. From then on his creative power was dominant, and it was unimportant whether a romantic or realistic emphasis predominated. The sweeping lyricism of symphonic painting came alive in him; and he summoned up a vision of Veronese creating, from the richness of his palette, his *Marriage at Cana,* a canvas unrestricted by exact imitation, arising instead from a calculation of colors. He rediscovered how others worked—how the old Dutch masters did relatively little drawing, but how, when they did, they drew astonishingly well. They accomplished much with their brushes. "They did not fill out." Vincent now preferred to sketch roughly with a brush rather than use charcoal; his sweeping evocations recall Hals, Vermeer, Van Goyen, Chardin, and Cuyp.

In principle he had found what was essential for his future development in France. The brief interim at Antwerp brought him back to life again, ending the seclusion of the countryside. He delighted in his female models, viewed Rubens with critical admiration, and compared his own work, made from peasant models in Brabant, to the plaster casts of ancient sculpture in the academy. He modified the flesh tints: positively, by seeing the models and by studying Rubens' work; and, negatively, by criticizing his teachers at the academy, Vinck and Verlat, who did not paint true flesh even though they approximated its color. In Antwerp he expressed for the first time his views on Japanese woodcuts,

Continued on page 56

Orchard, Springtime. Arles, 1888. Private collection, New York

The late spring of 1888 found Van Gogh in a lyrical mood, after his flight from Paris. The little town of Arles and its surroundings revived the power he always derived from a rural atmosphere. He transferred everything to an imaginary Japanese landscape and profoundly relived his youthful images of the North. Between these two approaches lay his greatest clarity and firmness of both vision and execution. This masterly control of the world he saw and heard about him lasted but a few months—until Gauguin's arrival. He drew for the first time without his perspective frame. There was no problem of expressive deformation. The hand obeyed the clarity of his vision, at times with a seventeenth-century Dutch balance. Only the penetrating quality of the color and the occasional unusual lucidity of vision betray the man of the late nineteenth century.

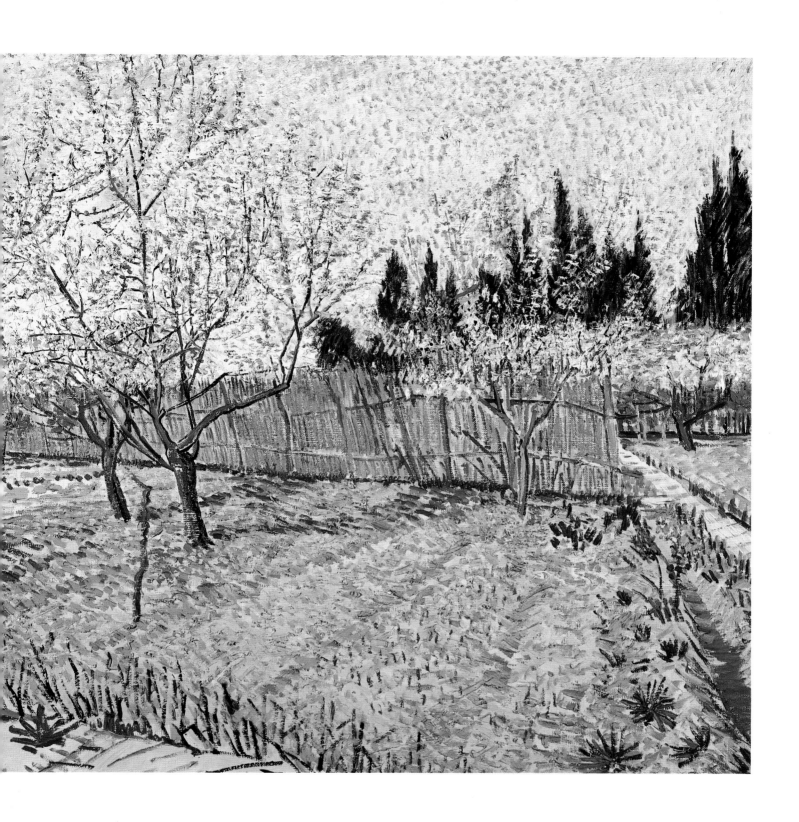

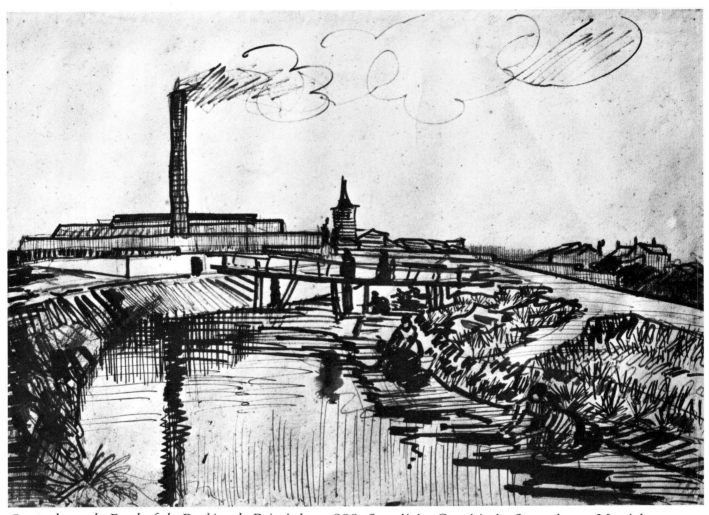

Gasworks on the Bank of the Roubine du Roi. Arles, 1888. Staatliche Graphische Sammlung, Munich

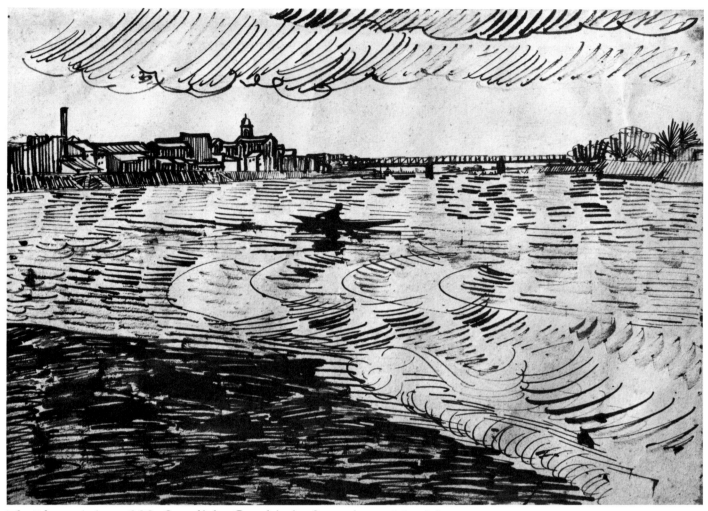

The Rhone. Arles, 1888. Staatliche Graphische Sammlung, Munich

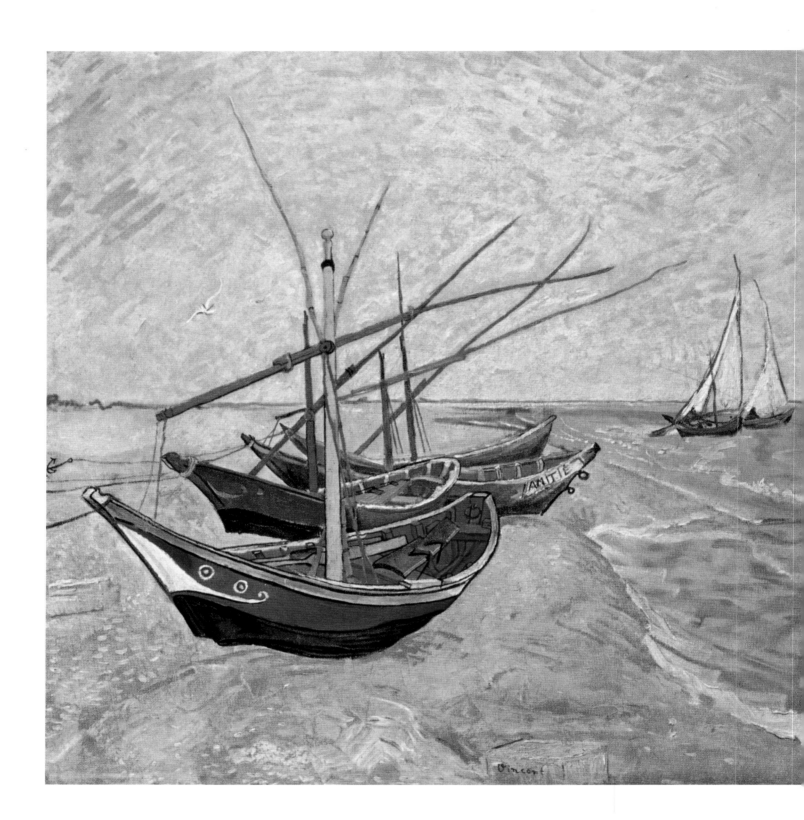

Fishing Boats on the Beach at Saintes-Maries. Saintes-Maries, 1888. Rijksmuseum Vincent van Gogh, Amsterdam

A journey to Saintes-Maries on the Mediterranean coast gave Vincent new impressions of blue. He went for night walks by the sea. "The sky of deep blue was mottled by clouds of a blue deeper than the primary blue of an intense cobalt, and by others of a clearer blue, like the bluey whiteness of the Milky Way..." (letter 499). He had to sketch the boats quickly, very early in the morning; painting was out of the question, for the fishermen departed very early. The colored boats reminded him of flowers. He was happy, for in Paris he had not been able to draw so swiftly, without a perspective frame and without measurements, simply letting the pen have its way. He thought of the lightning-swift sketches of the Japanese. His abilities were undeniably increasing at this time. Intensive observation of the world in which he lived was deepened by a past still under control and a Japan of his dreams.

The Beach at Saintes-Maries. Saintes-Maries, 1888. Rijksmuseum Vincent van Gogh

which had influenced his vision of life among the dockers. In Paris Japanese art incited him to attentive study. His flower pieces betray a Japanese influence in their composition and conception. Nevertheless his palette remained Dutch for a long time; his touch had already become looser and freer in Antwerp, while in Paris it was more nervous and quick, even to the point of wildness (e.g., *A Flower Piece with Roses*).

His two years in Paris (1886–88) had both a negative and a positive effect on his creative power. He did not immediately abandon his old antagonism toward Impressionism and a brighter palette. He confessed to his sister after he arrived in Paris that Impressionist art did not come up to his expectations. He was still too much taken with Mauve and Israels, who worked in grays. But he could scarcely hold out against the attacks of the avant-garde circles in which he found himself, thanks to living with Theo and to his four months' work at the Cormon Studio. After half a year he decided to replace his gray harmonies with stronger, more intense colors. He admitted that he had met the Impressionists only recently, and that he did not wish to identify himself with them. The first painter he mentioned was, not surprisingly, Delacroix, whose theories he had already assimilated in Holland. Then he mentioned Monet and Degas. Next he experimented with color in flower pieces and judged drawings from the viewpoint of color. Vincent came gradually under the influence of his new Parisian milieu. For the first time (apart from The Hague, where he had only slight contact with painters), he found himself

Continued on page 64

Fishing Boats at Saintes-Maries. Saintes-Maries, 1888. Musée d'Art Moderne, Musées Royaux des Beaux-Arts de Belgique, Brussels

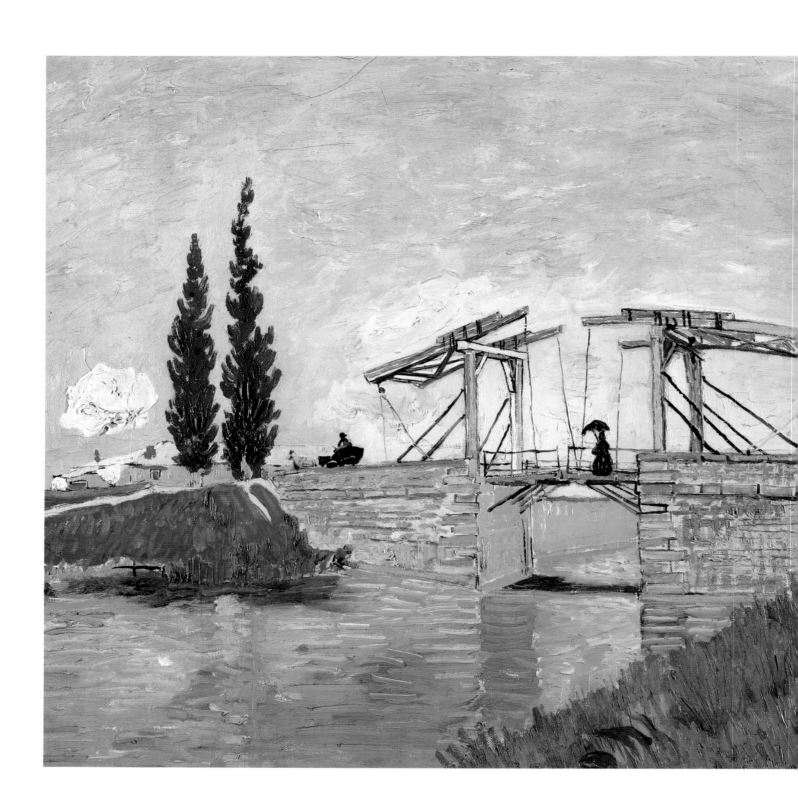

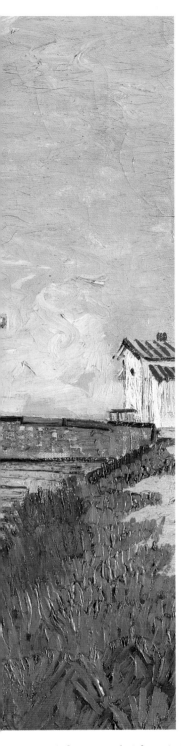

The Drawbridge. Arles, 1888. Wallraf-Richartz Museum, Cologne

Meyer Schapiro sees in the treatment of this motif a suggestion of the art of the Far East. At the same time it betrays the force of Vincent's Dutch memories; several times he chose to paint typically Dutch landscapes in Provence. In this case he was thinking of Brabant, where in his early years he regularly had to pass such a bridge. During this time, blue (which appeared in some of his Parisian self-portraits) attained its greatest intensity.

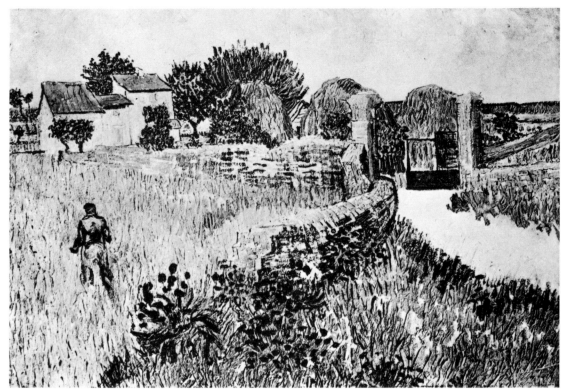

Farmhouse in Provence. Arles, 1888. National Gallery of Art, Washington, D.C.

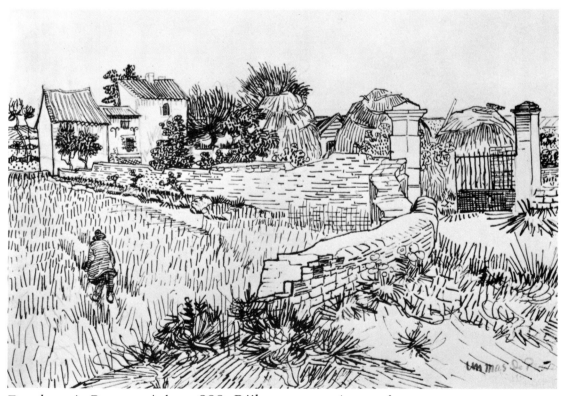

Farmhouse in Provence. Arles, 1888. Rijksmuseum, Amsterdam

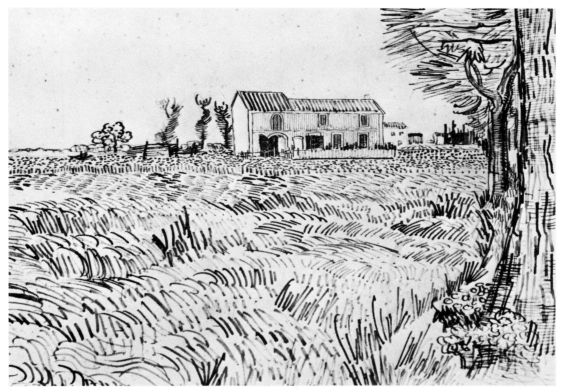

Wheat Field with House. Arles, 1888. Rijksmuseum Vincent van Gogh, Amsterdam

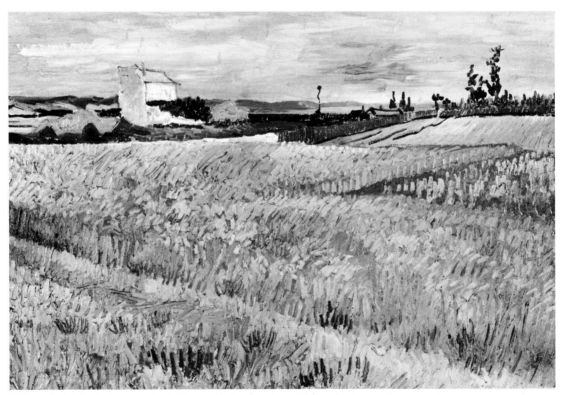

Wheat Field. Arles, 1888. P. and N. de Boer Foundation, Amsterdam

"La Mousmé." Arles, 1888. National Gallery of Art, Washington, D.C.

In Arles Van Gogh attached the greatest importance to his portraits, although he also painted many landscapes. He wrote in emphatic terms to his young friend Émile Bernard about the importance, for the future, of figure drawing and portraiture. To Theo he explained that he was not in the best of health, that he felt older, and that the portrait he painted of a girl between twelve and fourteen years old took him no less than a week. He had read Pierre Loti's *Madame Chrysanthème,* and, entirely taken up by the Japanese dream atmosphere, he called his model a "Mousmé." He did not often paint hands. In this case, however, the long, thin hands loosely hanging down continue the descending movement of the blood-red stripes of the bodice and of the bent, dark lines of the chair, making a magnificent contrast with the orange-yellow dots on the surface of the skirt. The blossoming pink laurel branch in her left hand deflects the downward movement and connects the upper and lower color.

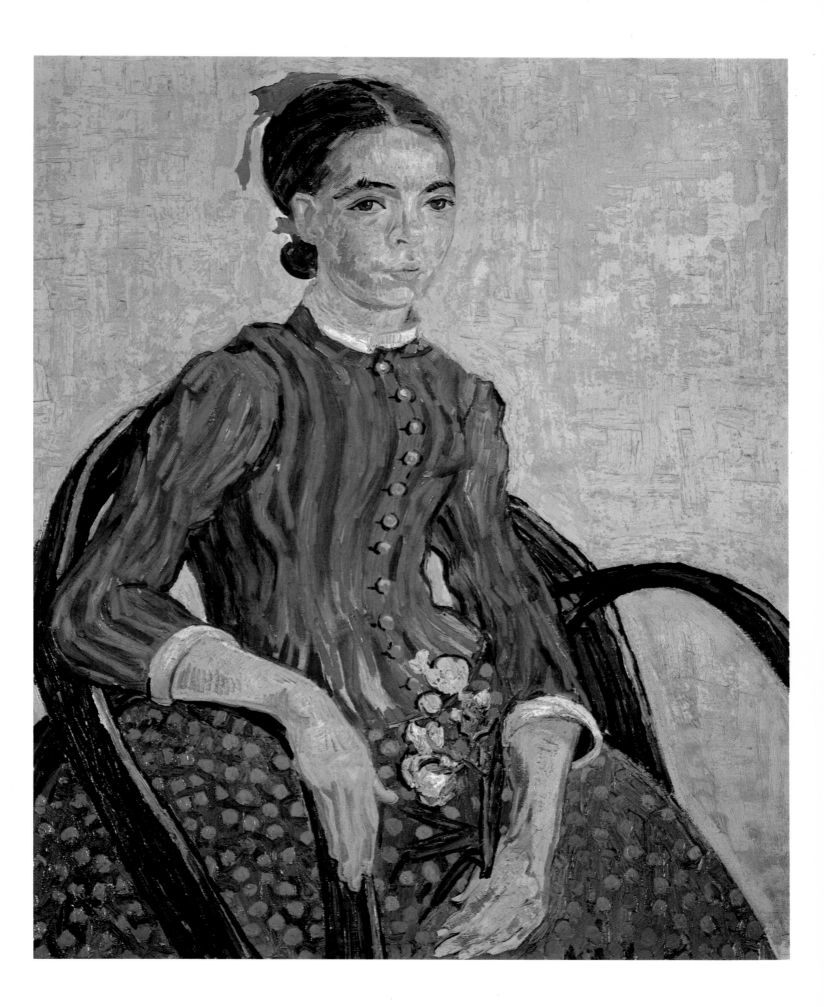

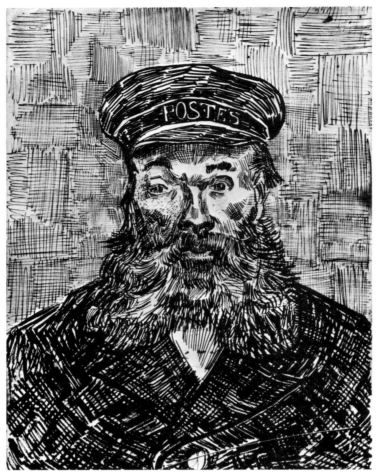

The Postman Roulin. Arles, 1888. Collection Dr. H. R. Hahnloser, Bern, Switzerland

in an international circle of painters with all its frictions and difficulties. He met Lautrec, Gauguin, the Pissarros (the father Camille and the son Lucien), Guillaumin, Laval, Bernard, Angrand, Anquetin, Seurat, Signac, and Schuffenecker.

Theo's amorous troubles also kept him busy. Theo had a relationship with a mentally unbalanced woman, from which Vincent wanted to release him by the hopeless but characteristic solution of marrying her himself—for his brother's sake!

His palette had already changed by mid-1886, especially the yellows, which gradually gained a clear predominance. In 1887 he adopted the shorter stroke under the influence of Seurat; he used it, however, unsystematically and, as far as color is concerned, without any basis in the theoretically stated division of the constituent colors. He worked with Bernard and Signac at Saint-Ouen and Asnières, in the open air by the water, and saw further color possibilities. In Asnières he stayed at the home of Émile Bernard's parents and got to know the Countess de Boissière and her daughter, to whom he presented some of his work. Thus his contacts were varied, and he was not confined exclusively to Theo's circle.

The Impressionist vision of landscape permeated him, but depressing situations often arose. Sometimes he felt old and broken, and he was continually planning to go to the Midi, largely to escape his fellow painters. His relations with Agostine Segatori, a former model of Gérôme's who now kept the restaurant Le Tambourin on the Boulevard de Clichy, were stormy and provided the inevitable com-

Continued on page 69

The Postman Roulin. Arles, 1888. Museum of Fine Arts, Boston

Within the family of the postman Roulin, Vincent rediscovered something of his own parental home. He painted the whole family in quick succession. Roulin was a friend for whom he felt a very close personal attachment. He was republican and cheerful, and Van Gogh called him "Socratic." There are six portraits and drawings of this model. The portraits with the hands and the one from Bern were made before, the others after, Gauguin's arrival. Then he began to stylize, and the spiral began to dominate—even in the beard; in the Boston portrait, not style but observation and the expression of character are uppermost.

Overleaf left

The Zouave. Arles, 1888. Private collection, South America

Van Gogh liked the rough portrait, in contrast to the salon portrait or the chic tone of a Toulouse-Lautrec. In one version of *The Zouave,* he deliberately painted the torso hard, in shrieking colors, and brutal ("...I would like to work always at vulgar portraits..."). The present portrait, with the figure set against a wall, is somewhat less harsh, but the broad yellow strokes on the fierce red reveal an increasing violence. In spatial terms the rising of the almost vertical floor does not entirely agree with the position of the upper part of the body. One's gaze is misdirected, and the perspective unity is weakened. Something similar occurs in a drawing and in a painting by the canal, *Roubine du Roi.*

Overleaf right

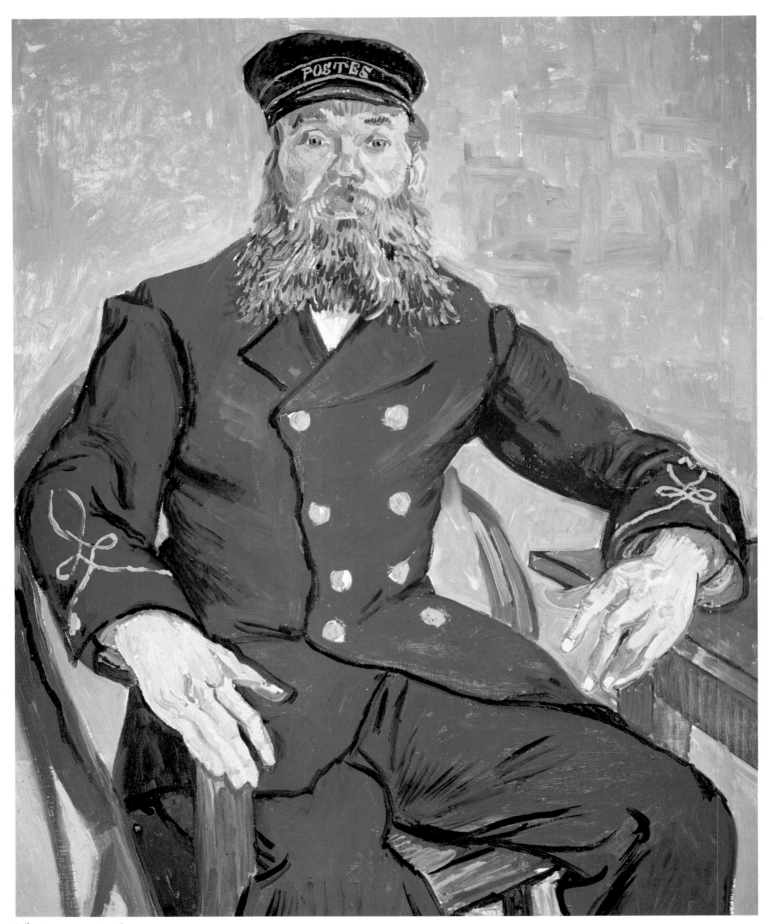

The Postman Roulin

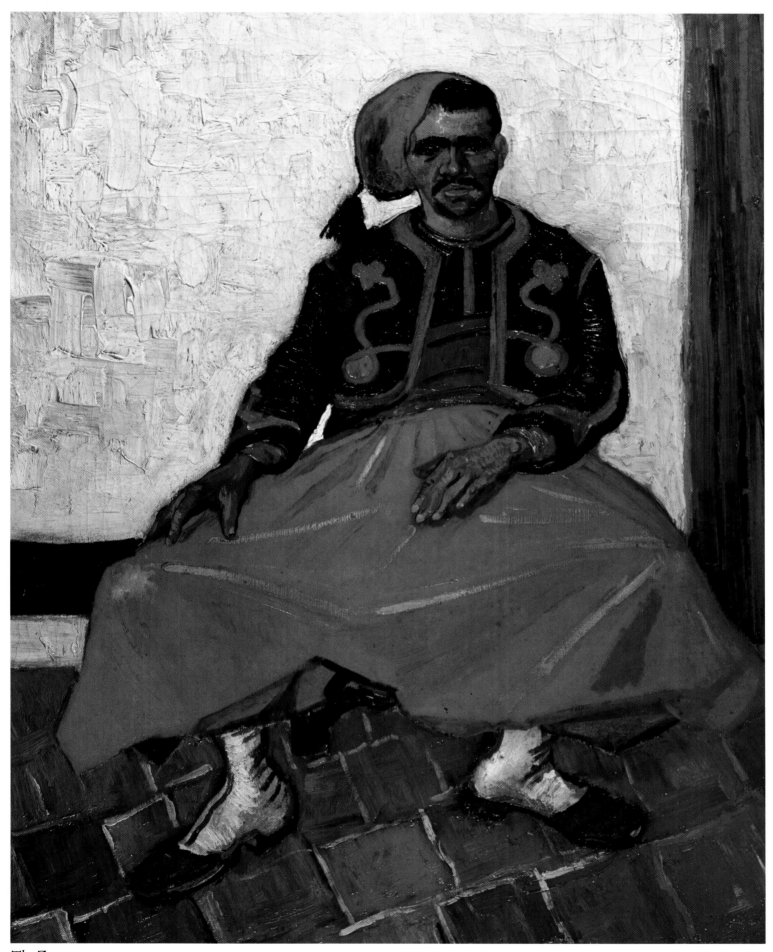

The Zouave

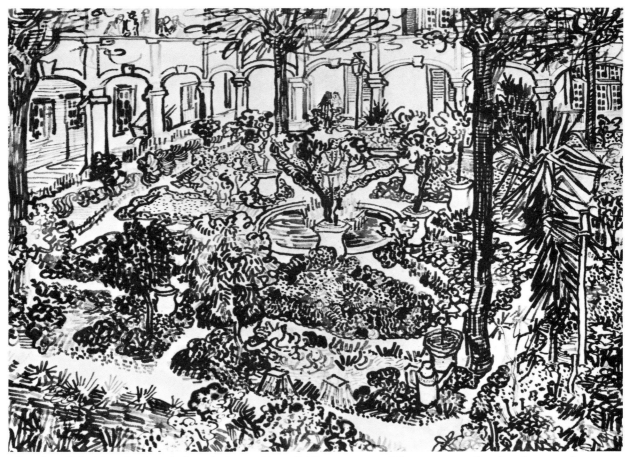

Garden of the Hospital at Arles. Arles, 1889. Rijksmuseum Vincent van Gogh, Amsterdam

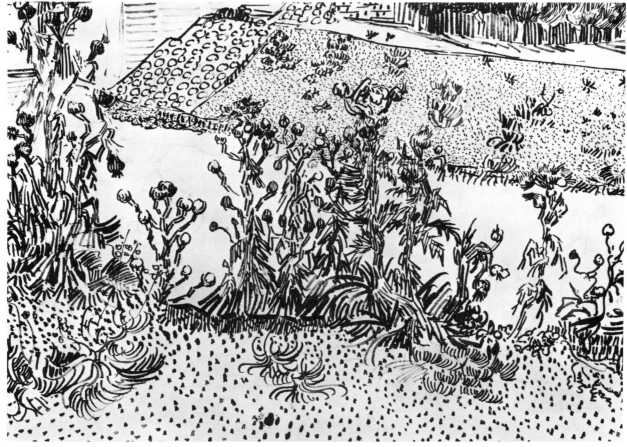

Garden with Thistles. Arles, 1888. Rijksmuseum Vincent van Gogh, Amsterdam

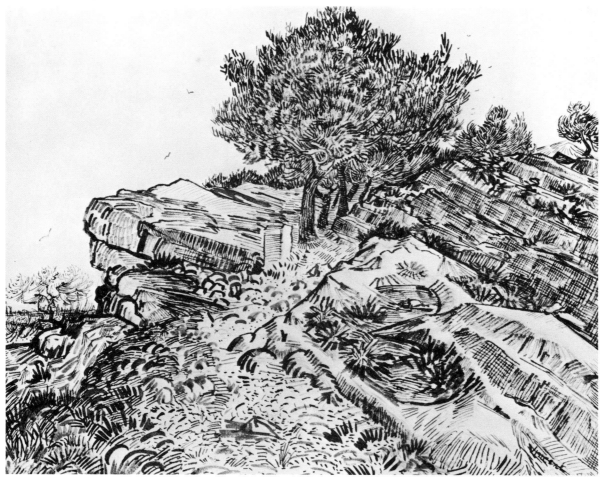

The Rock. Arles, 1888. Rijksmuseum Vincent van Gogh, Amsterdam

plications. Painters, Vincent included, exhibited there. He also often visited the painter Guillaumin.

The shop of the art dealer and paint merchant Père Tanguy, who exhibited some of Van Gogh's canvases in his show window, was a center where many like-minded younger painters could come together.

Paris drove all thought of the peasants out of Van Gogh's mind. Brush drawing appeared in the Montmartre still lifes and landscapes, which in other respects retained his Dutch palette. The shading brush manifested itself most fully in the brighter palette, while his drawings were altogether lighter and more colorful than before. The short strokes of the painting corresponded to a change in the line of his drawing. The black-and-white technique of The Hague, Brabant, and Antwerp, arising from sharp-dim contrasts and volume, made way in Paris for a thin, transparent style of drawing. He did more watercolors and drawings in colored crayon.

Although writers often curtly dismiss the Paris period as a transitional stage, this interlude was necessary to free him from the sometimes overaccentuated "heaviness" of his Dutch period: it deserves more study, if only for the extensive facts and adequate number of letters it supplies.

Paris saw the rise in importance of two genres in Van Gogh's work—the self-portrait and the still life. He had painted still lifes in The Hague and Brabant, and continued to do so in Antwerp (e.g., the skull with cigarette). In Antwerp, after one self-portrait in Nuenen, he seems for the first time to have

Continued on page 84

Old Peasant (Patience Escalier). Arles, 1888. Private collection

After Paris, the ideal of rural life once again became, in Arles, a positive force for Vincent. He recalled Nuenen, where he had wanted to be the painter of peasants. Everything was now less somber, but his desire was still to counter the "rice-powder and chic attire" of Paris with the harsh, rough grasp that open-air life had on a man. He felt that what Paris had taught him was disappearing, and that he was regaining contact with the period before he knew the Impressionists. "What a mistake that the Parisians did not have enough taste for rough things, for Monticelli in clay paste." In fact, what one meets here in Vincent is the urge toward an *art brut,* aimed at an effete civilization; in our own time, though in another form, the art of Tàpies and Dubuffet derives from this urge. He had wanted to paint an old farmer in whom he saw "a frightening likeness to my father," but to do it in a normal, partly caricature style. The man he finally painted was an old shepherd of the Camargue, who had become a gardener. The violent orange color is symbolic. He wanted to express the terrible aspects of the man in the glowing oven that is southern harvest time. Yet, Van Gogh complained, this exaggeration should not be taken wholly as caricature.

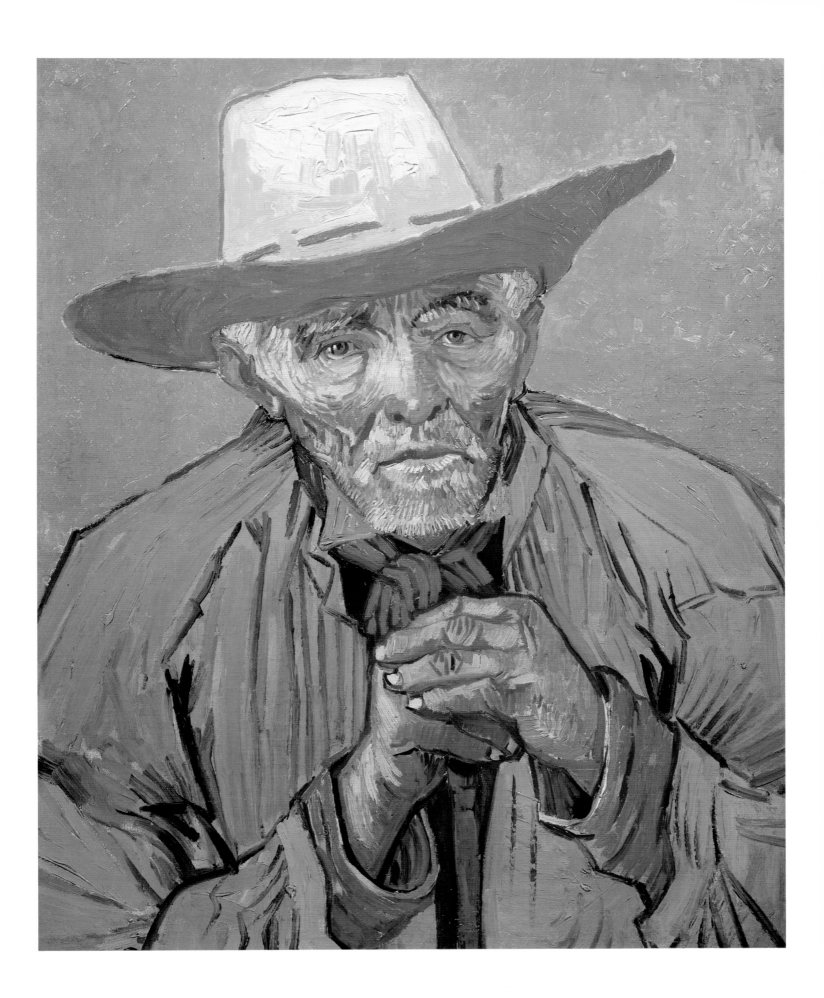

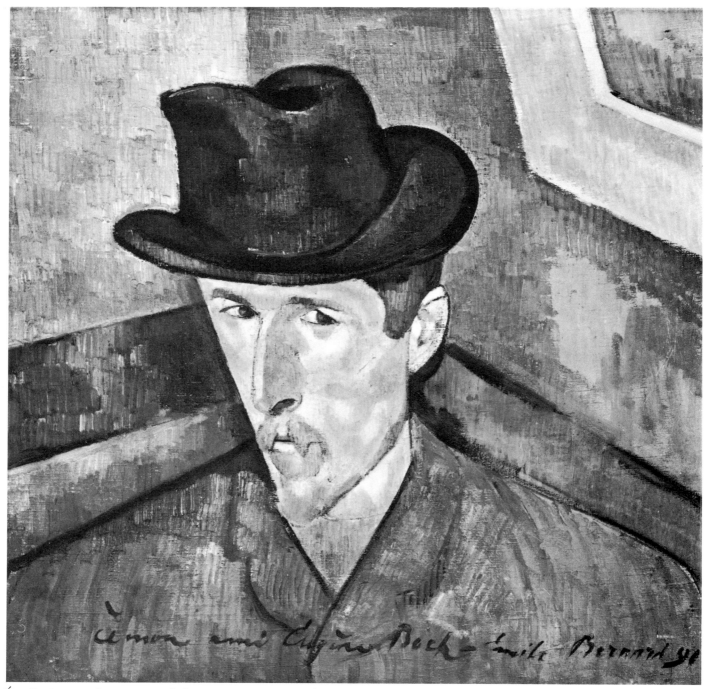

Émile Bernard. *Portrait of the Painter Eugène Boch*. 1891. Private collection, Tournai

The portrait always meant more for Van Gogh than for the nineteenth century in general. Even in Brabant the peasant heads had given him occasion to express an elemental life force. In Arles and Saint-Rémy his vision remained fixed upon reality but was often stylized by an ecstatic and mystical tension. Thus in the Belgian painter Boch he sees the poet, whom he wants to paint against a starry night; in Gauguin he sees another poet; and he dreams of Petrarch, who once lived in Provence. The postman's wife became *La Berceuse,* the mother image. Through thinking of the needs of common folk, he discovered saints in the people about him. His models were for him representative. But not every portrait is suited to this task. Roulin's children and the mother with child he painted simply, directly, and indeed Impressionistically. But he either liked to work the portraits into types or else saw himself in them and gave an interpretation that is heroic, going beyond the psychological. He created the antibourgeois portrait, but with the exception of the portraits of prostitutes (destroyed after his death) and of a few patients, he did not choose his subjects from among the outcast and the damned. His models were usually ordinary people living everyday lives, whose anonymity he raised to the realm of the profoundly human, whereas the later Expressionists deliberately chose as models the ravaged and the stricken.

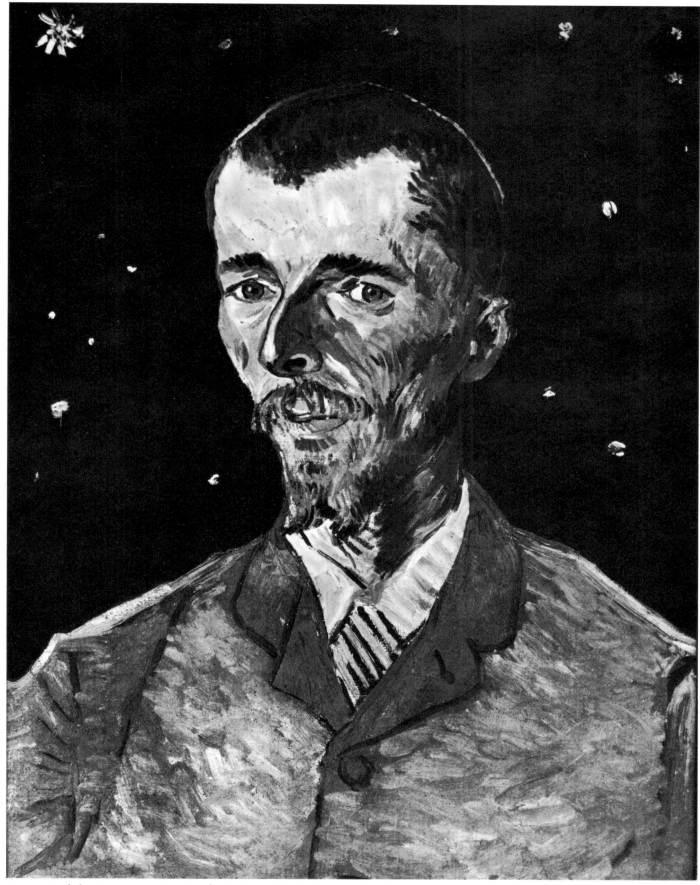

Portrait of the Painter Eugène Boch. Arles, 1888. Louvre, Paris

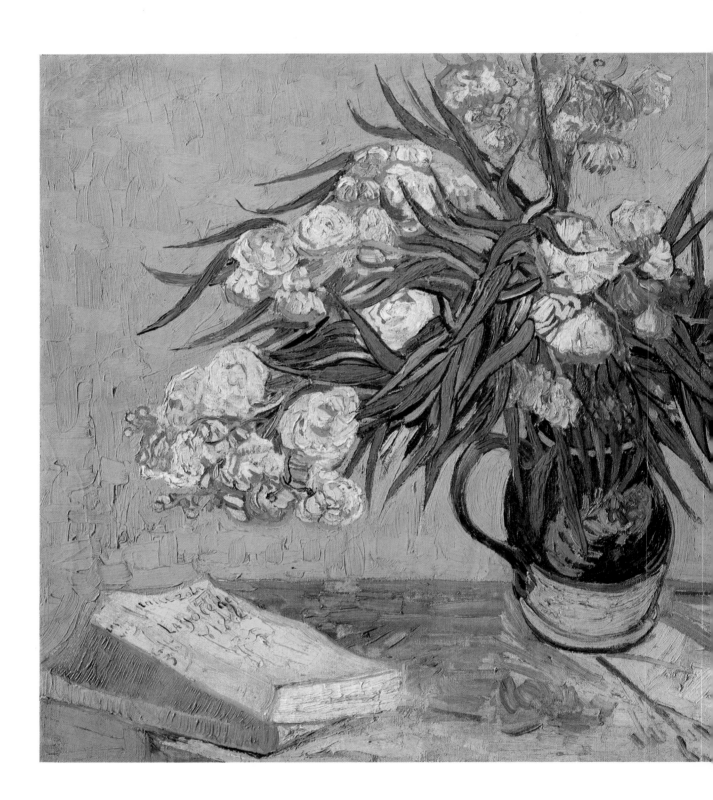

Oleanders. Arles, 1888. The Metropolitan Museum of Art, New York

Vincent painted flowers from his earliest years in Holland, and in Paris he was occupied especially with the color problems of such motifs. The oleanders were painted in Arles, and the two French novels on the left add another dimension to the study. The yellow-jacketed *La Joie de vivre* is the work of Émile Zola, a French Naturalistic writer who greatly influenced Vincent's human-artistic development. It is significant that in one of his early Dutch still lifes Vincent shows the Bible and this same novel, symbolizing the conflict between traditional Christian belief and modern values. At the time he painted the oleanders Vincent was reading Zola's novel *L'Oeuvre,* and was aware that as an artist of "austere talent" he could never hope for financial success.

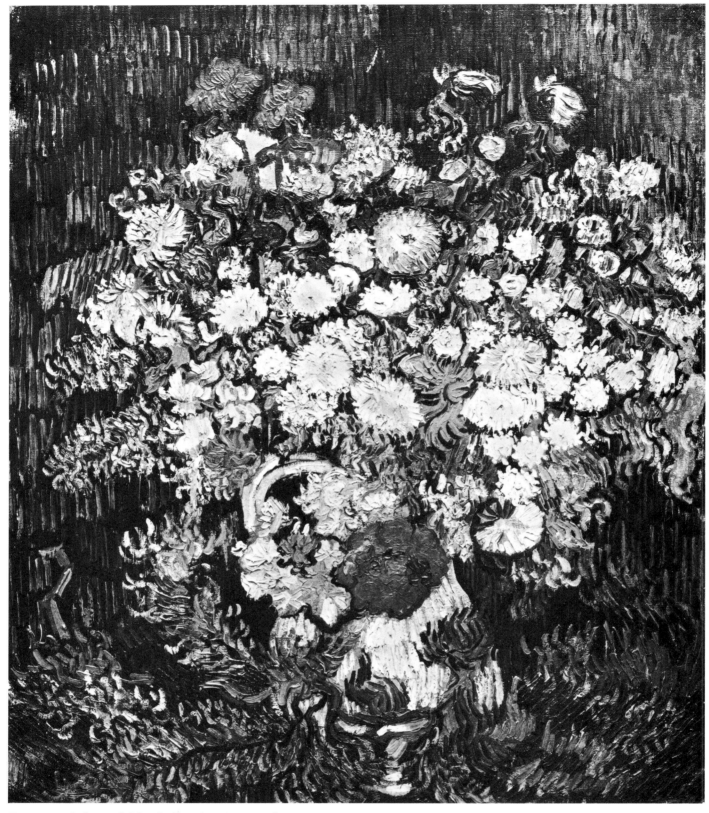

Bouquet. Arles, 1888. Collection Mr. and Mrs. W. Averell Harriman, New York

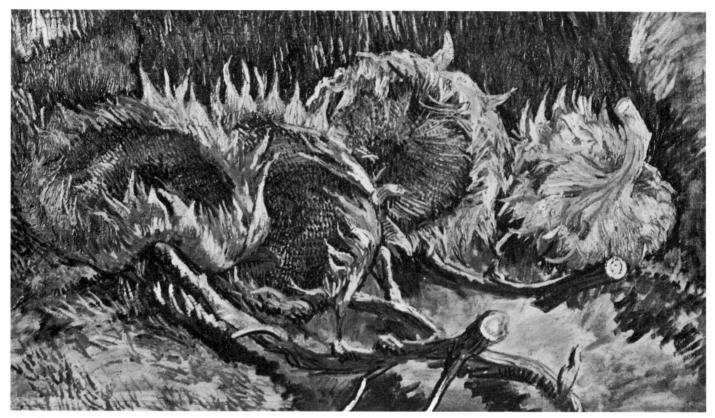

Sunflowers. Paris, 1887. Kröller-Müller State Museum, Otterlo

Sunflowers. Arles, 1888. Tate Gallery, London

The sunflowers, already begun in Paris (1887), became the symbolic motif with which Van Gogh wanted to decorate his "Yellow House" at Arles, a house of artists where he might receive Gauguin, and which might become the center for an artistic brotherhood who would determine the style of their time. This was the fourth sunflower study that he made at Arles. The various tones of yellow have a dominant and symbolic significance. The central closed form of the sunflowers, not yet disrupted by the open spiral, has affinities with the birds' nests from the Dutch period. He thought, too, of Monticelli's style of painting. In Paris he had seen the sunflowers quite differently; blue had then predominated and a restless red flamed in the yellow, the stress falling on the severed stalks.

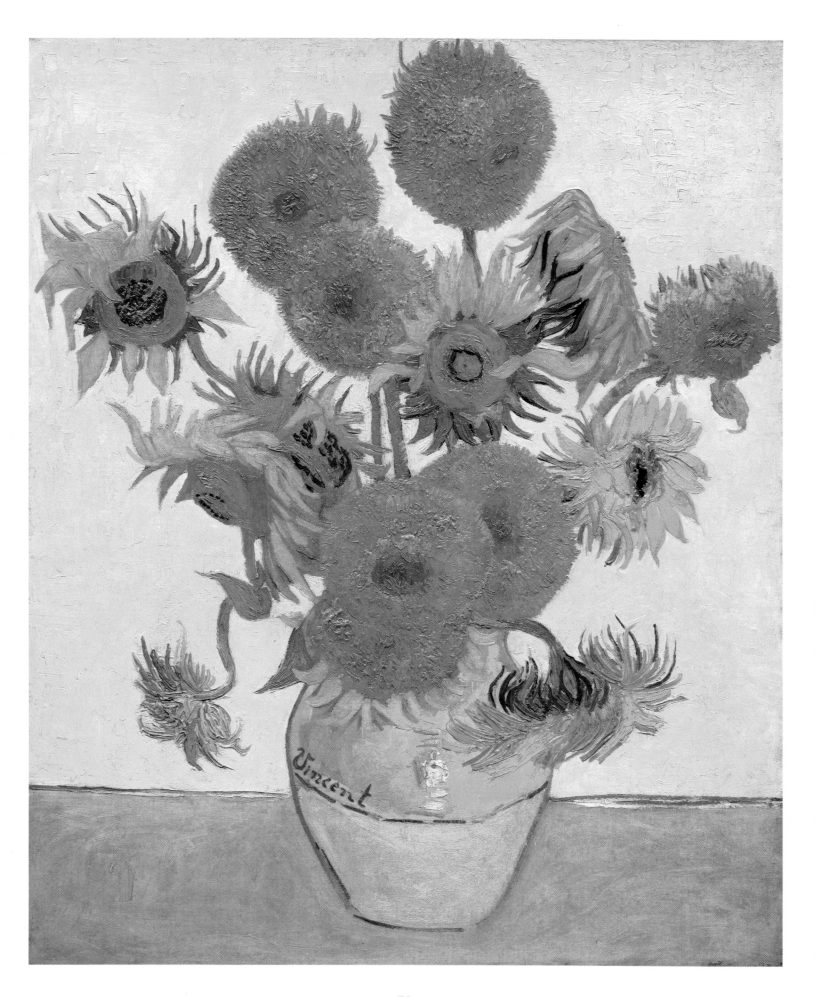

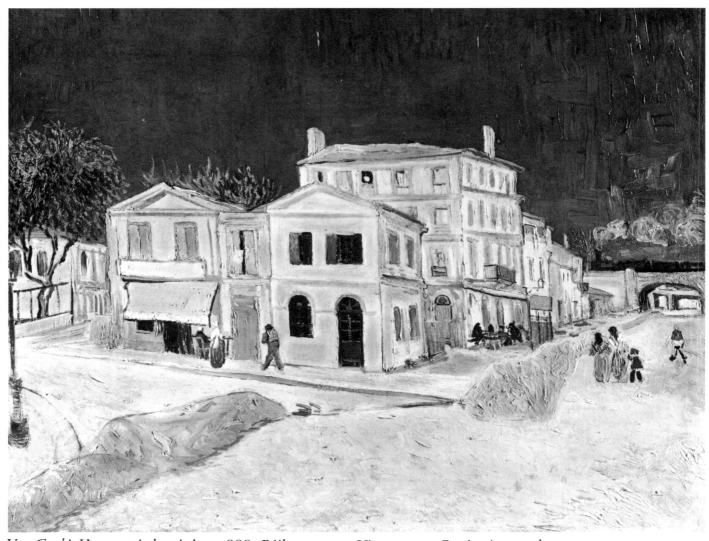

Van Gogh's House at Arles. Arles, 1888. Rijksmuseum Vincent van Gogh, Amsterdam

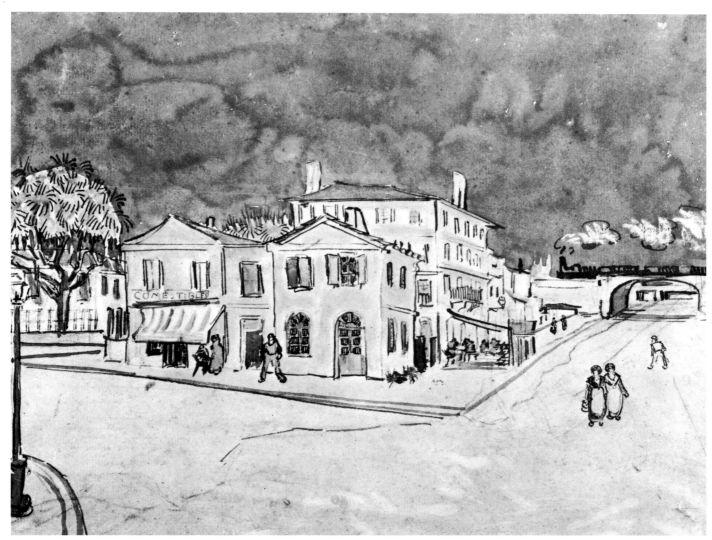

Van Gogh's House at Arles. Arles, 1888. Rijksmuseum Vincent van Gogh, Amsterdam

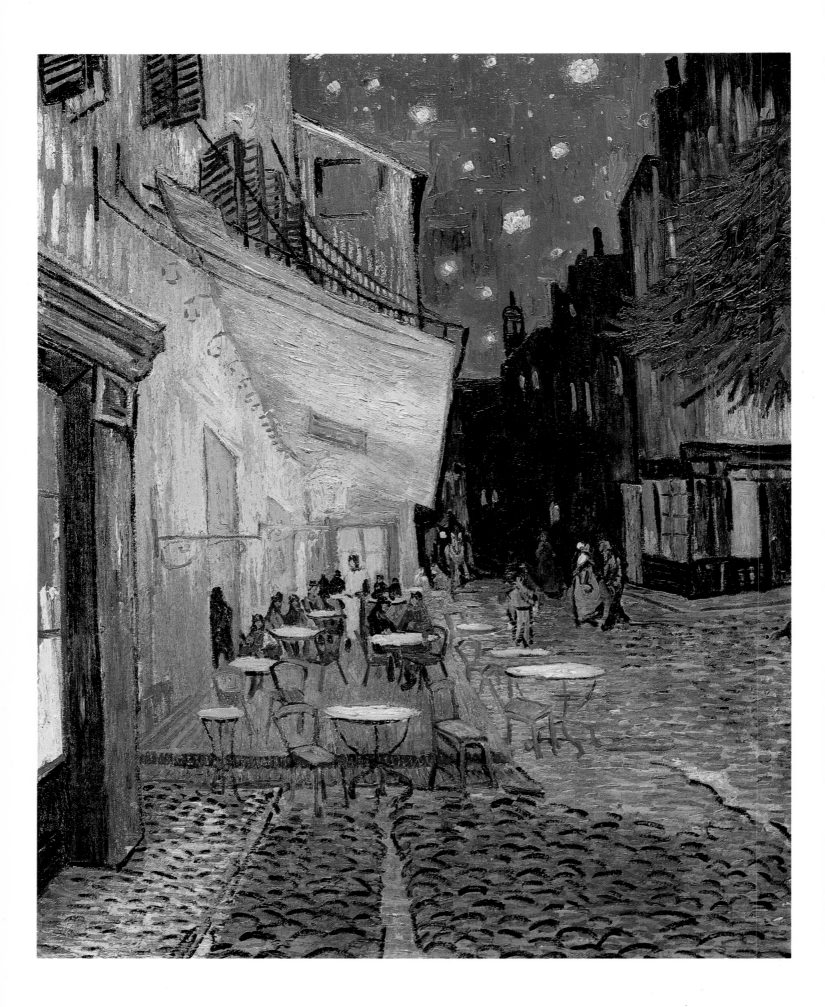

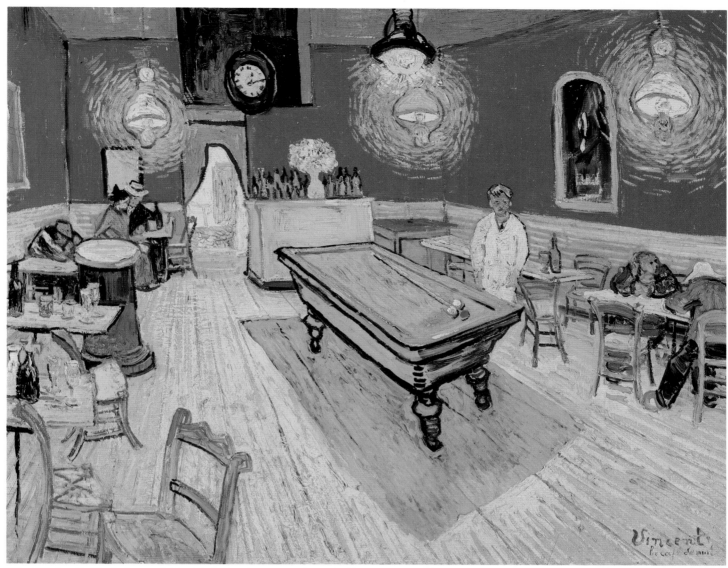

The Night Café. Arles, 1888. Yale University Art Gallery, New Haven

Sidewalk Café at Night. Arles, 1888. Kröller-Müller State Museum, Otterlo

For the first time, still before Gauguin's arrival, the element of sin and crime came clearly to the fore as a creative factor. Vincent even spoke of an exterior of Japanese gaiety and good nature *"à la Tartarin."* Feelings of his approaching ruin—by death or madness, or by crime—gained a hold on him. At the same time, he longed for the night atmosphere, the stars, and moonlight. These feelings were more than romanticism, for in this way his links with the primeval, nocturnal life forces gained symbolic expression. Often during this period he would paint throughout the night, for he wanted to realize this nocturnal reality not in his studies but on the spot. He used candlelight. The color in *The Night Café* is somber and poisonous. The perspective of the floor increases the spatial effect, while the billiard table accentuates the diagonal in the composition (Japan, Gauguin). The mood of despair which was suppressed in his other work, in which he wanted with gay, rich, precious color to avenge himself on a life that made him old and disgruntled, now broke through. *Sidewalk Café at Night* has the opulence of blossoming stars, in the blue night and the golden glow over the terrace. The street creates a varied rhythm. The lack of technical unity in this canvas is compensated for by the luxury of the colors.

begun a series of self-portraits. In Paris he made no essential alterations in the experimental flower pieces and still lifes with herrings and objects from everyday life—bread, glassware, vegetables, meat, and so on. His conception of space changed only with the advent of lighter coloring and shorter, pencil-like strokes. It seemed as if he wanted to be rid of the usual frontal conception and of the light-shade arrangement that gave backgrounds an indefinite depth. His angle of vision changed (e.g., the still life with torso, books, and flowers). More often now he looked down from above, the background becoming more positive and definite, more at one with the mounting foreground. In his use of volume, Degas's spatial vision and the Japanese woodcut have had their influence.

Manet, Degas, and the Impressionists had long since assimilated those Japanese influences which Van Gogh became aware of only in 1886 in Antwerp. But Van Gogh, a very recent and critical convert to Impressionism, had come to his own terms with Japan. Imitating woodcuts and introducing them in the background of a painting, as in the portrait of the art dealer Père Tanguy—such was the procedure he had always followed when he wanted to know something well: transcription and copying. But in just this way he felt the difference between what he admired and what he himself created. He was involved in two centers of orientation, Impressionism and Japanese art. Only when he had managed to reach a positive synthesis did he regain his old expressive power, albeit in a changed form.

Thus, via Japan and Impressionism, Paris acted, at first confusingly and negatively, to bring about a

Continued on page 89

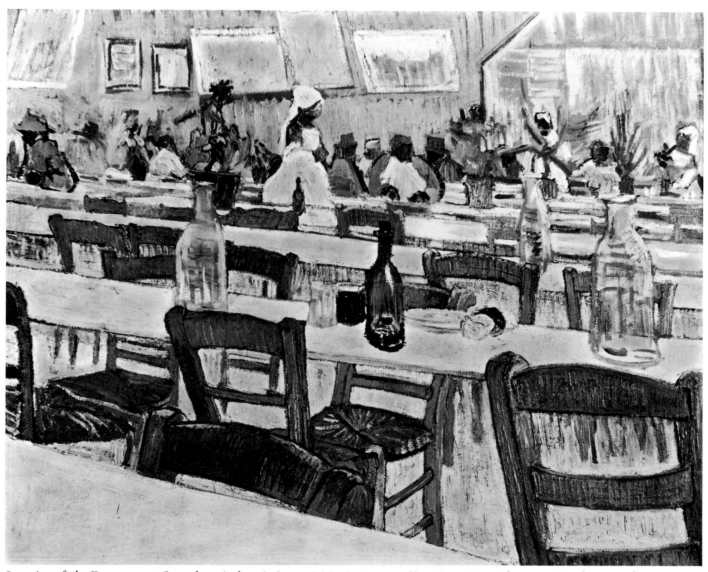

Interior of the Restaurant Carrel at Arles. Arles, 1888. Private collection, Providence, Rhode Island

Public Garden at Arles. Arles, 1888. Private collection

Van Gogh, who took little interest in the Italian and French Middle Ages and Renaissance, acquired some understanding in Provence of the rich past of that landscape. His admiration for Giotto, whose work he knew slightly from personal observation, became positive. The Japanese and Tartarin atmosphere gave way to the time of the Venus of Arles and of Lesbos. In the park in front of his house, where he would sit painting as early as seven o'clock in the morning, he imagined Dante, Petrarch, and Boccaccio. The poet in him once again lent movement and direct simplicity to his touch. The series was entitled "The Poet's Garden" and decorated Gauguin's room.

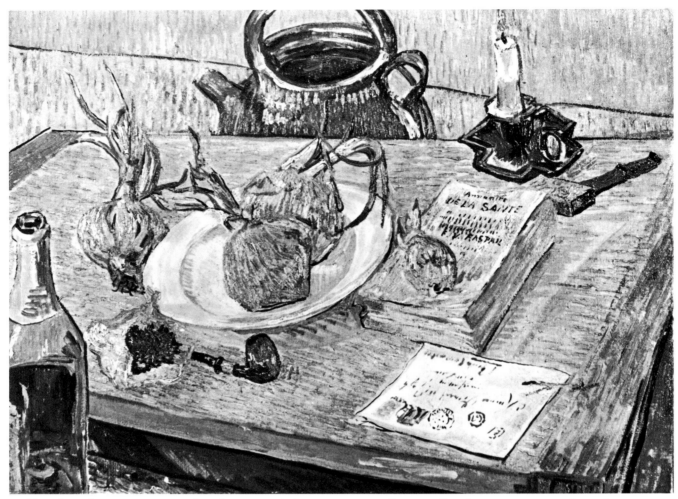

Still Life with Drawing Board and Onions. Arles, 1889. Kröller-Müller State Museum, Otterlo

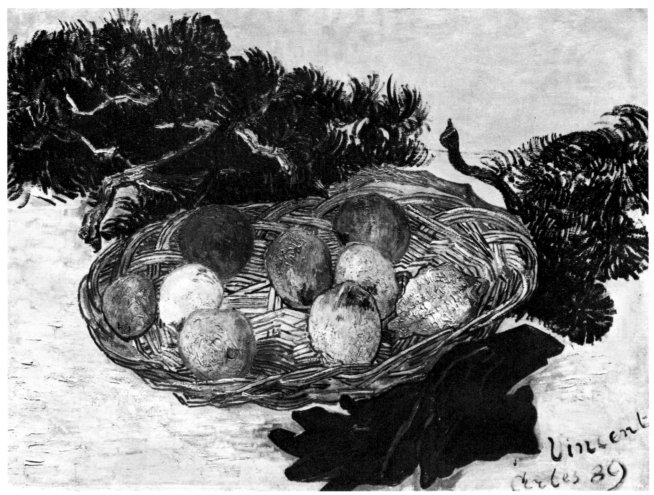

Still Life with Lemons and Blue Gloves. Arles, 1889. Collection Mr. and Mrs. Paul Mellon

positive revision and enrichment of what Holland had revealed in principle. His coming to terms with Seurat's divisionism plays only a subsidiary role. Seurat attracted him very much, but his analytic method of work and his carefully balanced values had nothing in common with Vincent's. On the other hand, Vincent clearly reflected Seurat in his choice of motif—landscapes with factories, little cottages— near the end of his stay in Paris and at the beginning of his Arles period. But even then these motifs were translated into his own unique rhythm and style. Presumably he sensed that in Seurat, too, Impressionism did not have an unquestioning advocate, and that further, its passing had been clearly heralded in the objectivization of painting.

The self-portrait, however, already well begun in Antwerp, attained in Paris a special importance. It is interesting to compare his own impressions with those of his contemporaries, who recorded Vincent's appearance in Paris in word and picture. Apart from the well-known pastel by Toulouse-Lautrec and the portrait by Russell, there are the pen-and-wash drawing by the English painter Hartrick, who also described him in words, and the short written impressions by Julien Leclerq, Guillaumin, Signac, Angrand, and André Bonger. They caught his exceptional features—his immediate reactions and unrestrained behavior—but they were mere sketches. In 1888, in a letter from Arles to his sister, Vincent gives in a roundabout way a brief but more complete account of his appearance, not by describing himself directly but by telling her of the Paris self-portrait with red beard

Continued on page 97

La Berceuse. Arles, 1888–89. Kröller-Müller State Museum, Otterlo

After Gauguin's dramatic departure, the influence of their tense life together continued to have its effect. The portrait as Van Gogh saw and glorified it, in the modern age, was a portrait of unusual realism, in which the likeness is internal rather than external. Gauguin placed man in a mythological environment, exotic or religious. He managed temporarily to force flat color and contour upon Van Gogh, introducing a distance between direct reaction and the object seen. *La Berceuse* was a mixture of Van Gogh's glorification of the mother theme, his desire to return to his earliest youth, and the Bernard-Gauguin folk-art influence. The lap and hands remained most like Van Gogh. The multicolored curtain emphasizes plantlike spiral and circular flower motifs. The stiffening which takes place in this qualitatively very uneven series of "Berceuses" disappears in the portraits made at Saint-Rémy, in which we find more life and an exploration of the person rather than the type.

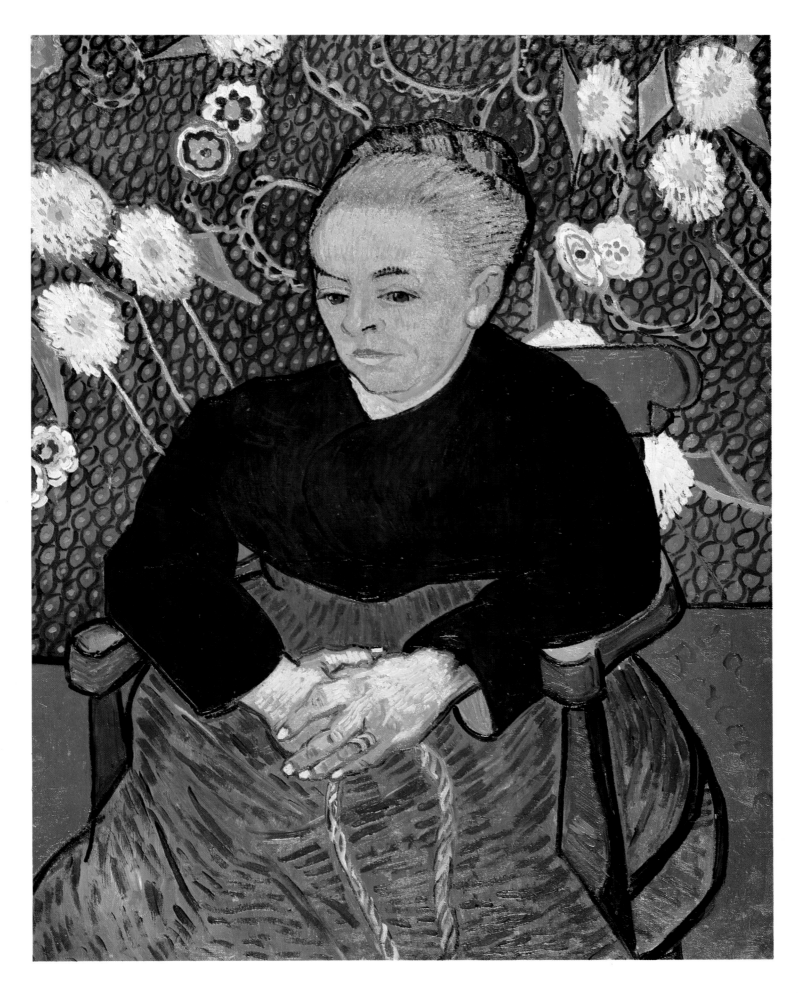

"Les Alyscamps." Arles, 1888. Kröller-Müller State Museum, Otterlo

The Bridge at Trinquetaille. Arles, 1888. Collection Kramarsky, New York

The structure of machines and buildings, indeed all constructions, fascinated Van Gogh from the time of his Dutch period. Contemporary painters, especially of the Hague School, looked at their environment with Impressionistic eyes. Form was a tone value, part of the general ambiance. This picture is more than an impression: it is a rhythm of spaces with a nearly architectural feeling for the stairs and the bridge construction.

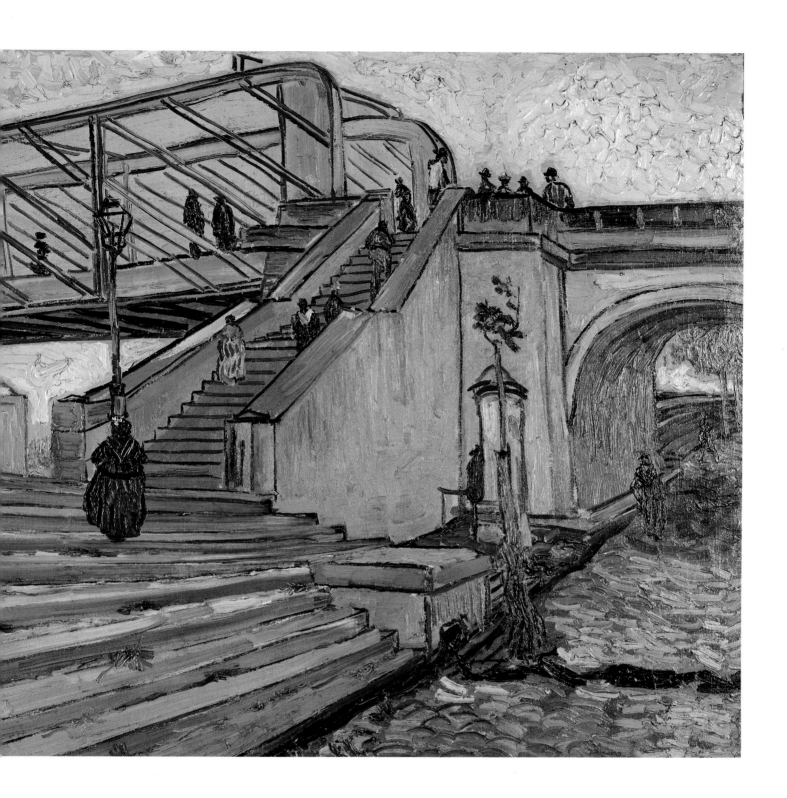

The Sower. Saint-Rémy, 1889. Rijksmuseum Vincent van Gogh, Amsterdam

—in Arles he had shaved off his beard and his hair—"A pink-gray face with green eyes, ashen hair, wrinkles on the forehead and a very red beard, rather dreary and untidy around the stiff, wooden mouth, but the lips are full, a blue smock of coarse linen, and a palette with lemon yellow, vermilion, cobalt blue and Veronese green. In fact all the colors but the orange beard are in the palette, only the whole colors however. The figure is set against a grayish-white wall."

This image of Van Gogh at work was the first of any significance which expressed without self-consciousness the thoroughgoing, direct intensity of his creativity. Before he went to Arles, it resulted in a series of portraits. More than self-observation, these portrayals contain unmerciful interpretation. First of all, there is a series of poignant small portraits with and without a hat, studies of psychological importance that give a disturbing image of the passionate, direct man that he was, rather than a feeling of the urgency of the painter's actions. The contradictory aspect of these small studies is that the intimacy which their size and brushwork create is counteracted by the sharp, lighter color and the averted, penetrating gaze of the manic eyes. The last Paris portrait was, in its pictorial approach to the psyche, unique in painting of that time (1887) and rivaled only by Cézanne, who approached self-portraiture in quite another way.

After seeing the final Paris still lifes and the self-portrait, one can scarcely maintain that, artistically speaking, Vincent's work in Paris came to a standstill. However, the city and his life with Theo had

97

Continued on page 104

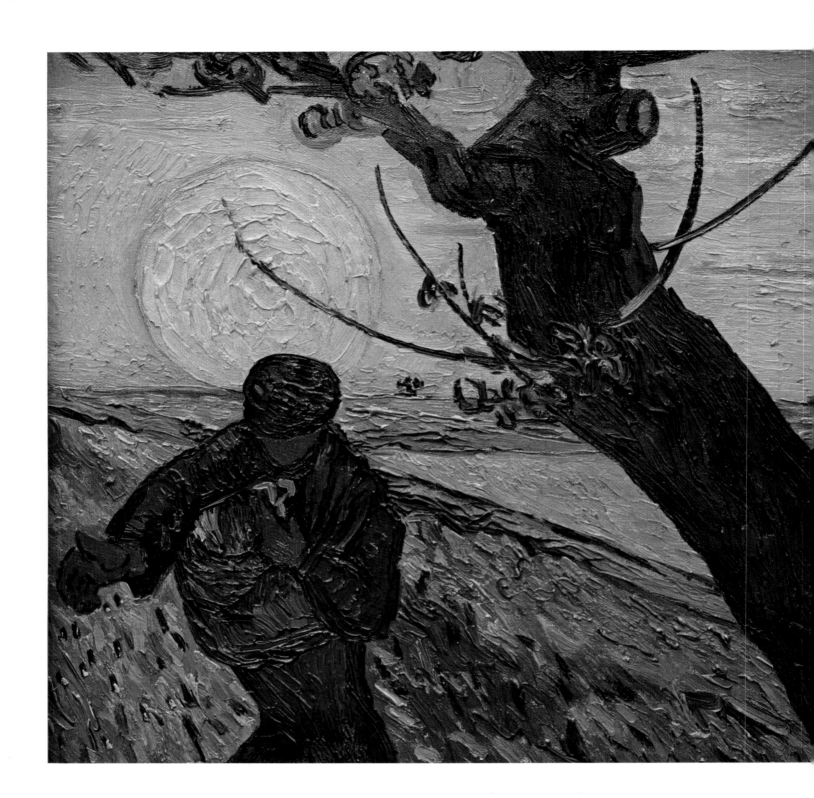

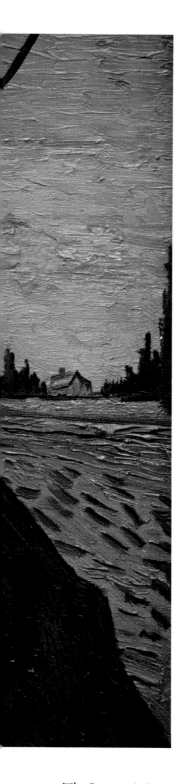

The Sower. Arles, 1888. Rijksmuseum Vincent van Gogh, Amsterdam

The motif of the sowing countryman occurred early in Van Gogh's Dutch period and was further strengthened by Millet's example. In Arles it underwent the influences of both Japan and Gauguin. The diagonal of the tree, for example, occurs in an analogous way in Gauguin's *Jacob Wrestling with the Angel* (1888). Only the stump of the broken-off branch on the right belongs to the typical Van Gogh tree image that developed in Holland.

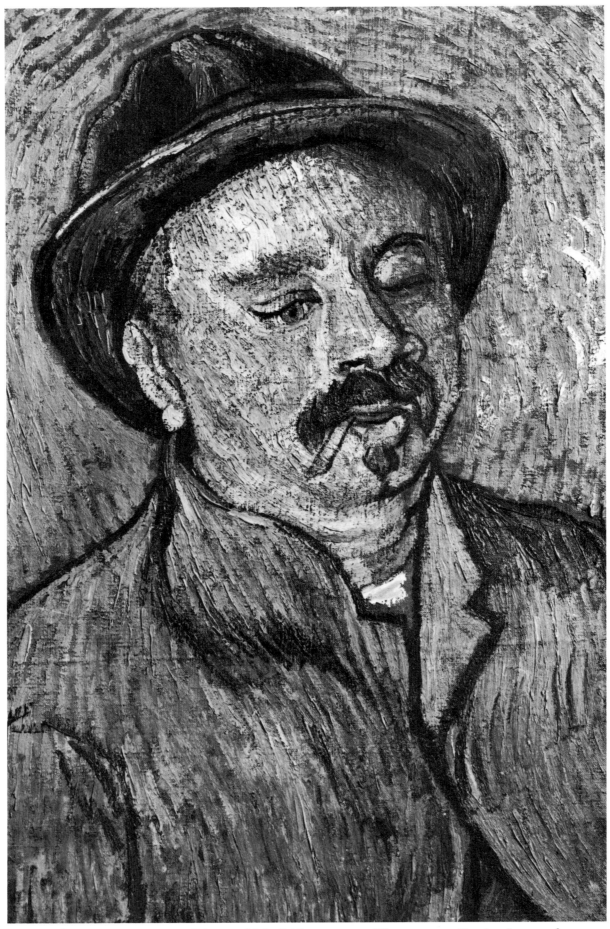

One-Eyed Man. Arles, Saint-Rémy, 1888. Rijksmuseum Vincent van Gogh, Amsterdam

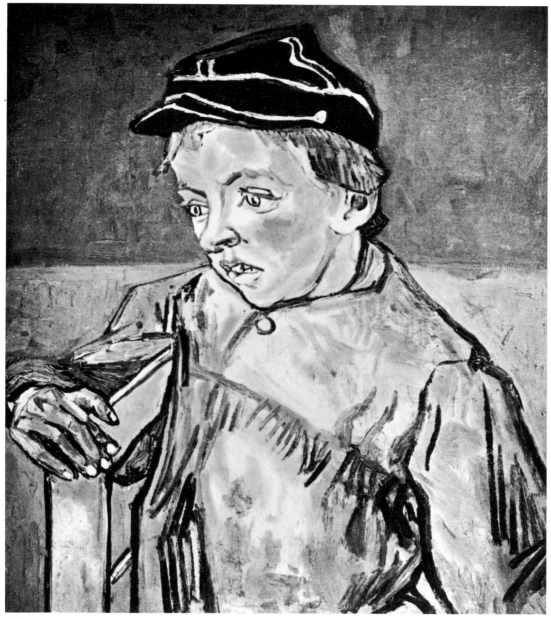

The Schoolboy. Saint-Rémy, 1890. Museu de Arte, São Paulo

Portrait of Armand Roulin. Arles, 1888. Folkwang Museum, Essen

It must have been a happy period for Vincent when he was able to paint portraits of an entire family (see letter 560), that of the postman Roulin. He painted the baby, the little boy, the sixteen-year-old son (Armand), and the postman himself and his wife, "all characters...all with a Russian look," he noted. The style of this portrait is very different from those he did in Paris: more positive, less nervous, less Impressionistic. The painting has freedom of line and color; without sentiment or apparent psychological analysis, it arrives at a remarkable intensity of visual and mental understanding.

Overleaf left

Madame Roulin and Her Baby. Arles, 1888. The Metropolitan Museum of Art, New York

As a baby would obviously not be a quiet sitter, Vincent has a more Impressionistic style here than in the structurally stronger portrait of Armand Roulin. The background is yellow, at that time his most significant color—symbolizing love, warmth, friendship. The house he rented for himself and Gauguin, dreaming of a center in which artists could live and work together in the South, was called the Yellow House, and in his series of sunflowers yellow was also dominant.

Overleaf right

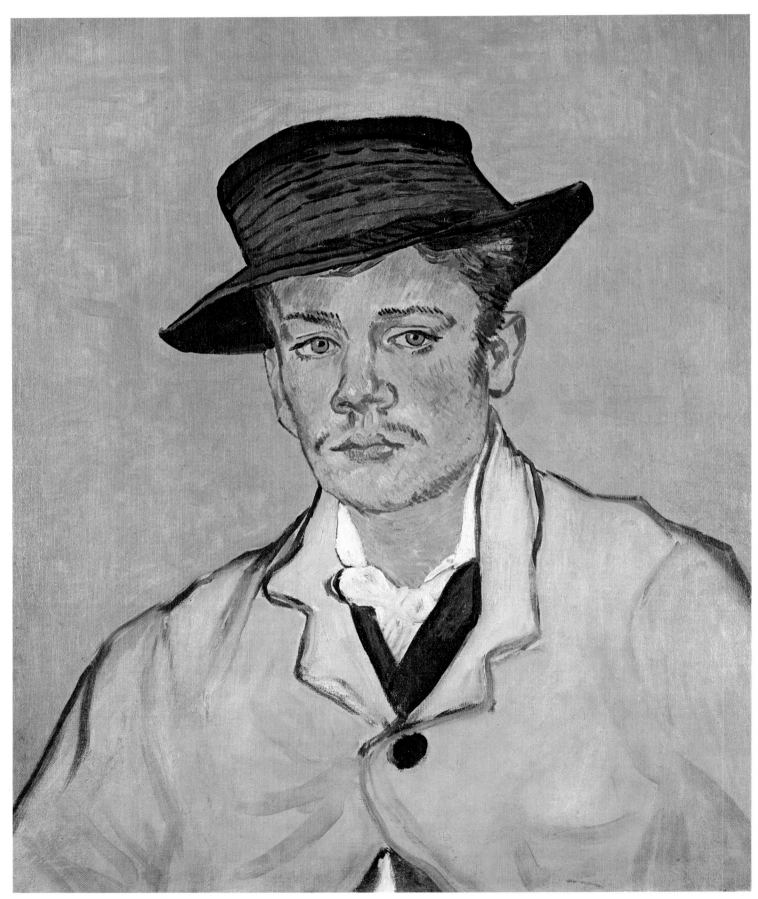

Portrait of Armand Roulin

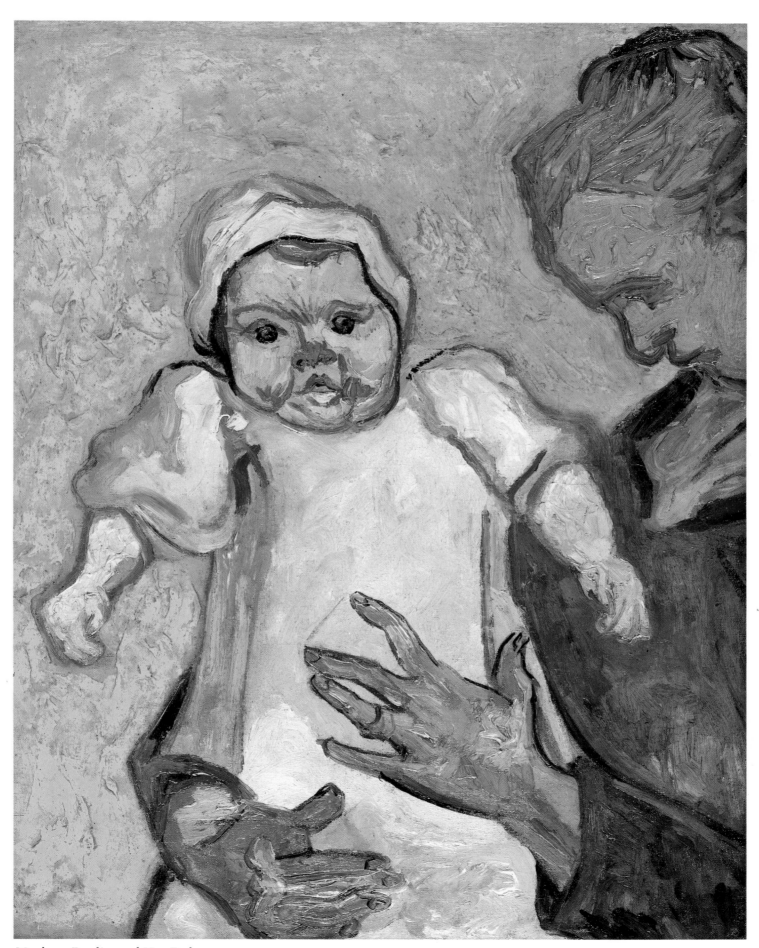

Madame Roulin and Her Baby

exhausted him, and the tension again became unbearable. Although Theo had long known that Vincent wanted to go to the Midi, his brother's actual decision to leave came as a surprise. Vincent's departure for Arles in February, 1888, when two feet of snow lay on the ground, had the look of an escape.

Although he continued to paint still lifes in his fine, light, almost tender Parisian style, the rural and simple life at Arles gave him new security. He recovered unconsciously something of his country roots, and with them a feeling of shelter. In a small house he founded a center where artists might work and live—"The Yellow House," 2 Rue Lamartine. He came to know the family of the postman Roulin, who reminded him in some ways of his parents. The themes which inspired him at Arles came from a background that was fertile but complex. From this point on, it becomes increasingly clear that these themes had an ambiguous character, difficult to distinguish or classify.

The man from the North is all ablaze for the South. His stay in Paris having temporarily cut him off from what he had achieved in rural surroundings in Brabant, where his ideal was to become the painter of peasant life, Vincent found two solutions in Provence. His flirtation in Paris with Japanese art became a marriage in Arles: the quality of the light and the countryside replaced the more artificial world of the woodcuts. The knowledge he drew from them was converted at Arles into his own painterly terms. But he was able to bring this miracle about because of the favorable and familiar working conditions of the small provincial town. When he arrived in Arles he thought again of Breda, the little Brabant

provincial town. He returned "home," and his landscape motifs, conditioned by his Dutch recollections, produced a metamorphosis of Japan and Provence. In Arles his Dutch recollections were pictorially more closely defined, but he remembered less his contemporary Holland than the older seventeenth-century Holland of Ruysdael, Hobbema, Van Ostade, and Salomon Koninck.

Amid all the lyricism of the South—the sun, the mistral, the women of Arles, Alphonse Daudet, the olive and cypress trees, and the ancient countryside—the old power of the unforgettable North of his youth reasserted itself, and he recalled his first great motifs, landscapes and peasant figures. He wrote to Bernard in June, 1888 (B 7): "I cannot hide from you that I do not hate the countryside, having been brought up there—whiffs and memories of other times, aspirations toward this infinity, whose symbols are the sower and the sheaf, still enchant me now as they did then." But this feeling did not produce a revival of his earlier work. Instead it became a burning homesickness until he began his journey back from Saint-Rémy to Auvers.

Before that stage was reached, an apparent balance evolved: his sensuous awareness of form seemed to double in power. On the whole he saw the early spring, and the summer that swiftly followed it, under the influence of Japanese vision. The ecstatic tension and the powerful realism of his direct observation were so great that the light Impressionist techniques of Paris had to give way to a more severe use of line and color. He devoted himself to landscape, but in his heart he wanted to do portraits,

Continued on page 108

Promenade at Arles. Arles, 1888. Hermitage, Leningrad

Gauguin painted a similar scene at Arles (Art Institute of Chicago, Coburn Collection), but it differs greatly from Van Gogh's. In a letter to his sister, Vincent described the canvas in detail. The painting shows how strong the hold of the past and the North was becoming, for the canvas is filled with a somber homesickness. As in a dream the female figures appear; they bear no direct likeness to his mother and his sister, yet he knew that it was they. Do you understand, he asked his sister, how one can be so poetic just by arranging colors well, in the same way that one can say comforting things with music? Serpentlike lines creep into the composition—bizarre, farfetched lines (a latent, modern Mannerism). Van Gogh consciously transposed reality into a dream atmosphere. Gauguin by contrast is much more decorative.

L'Arlésienne (Madame Ginoux). Arles, 1888. The Metropolitan Museum of Art, New York

November, 1888, is the month of some of his great portraits. As in the painting of the Roulin baby, Vincent used citron-yellow as background, with the dark-blue figure silhouetted against the yellow. Painted in three-quarters of an hour, the portrait is nevertheless far more than an impression: it has the sure touch of a vision in which sensibility and intelligence are fused.

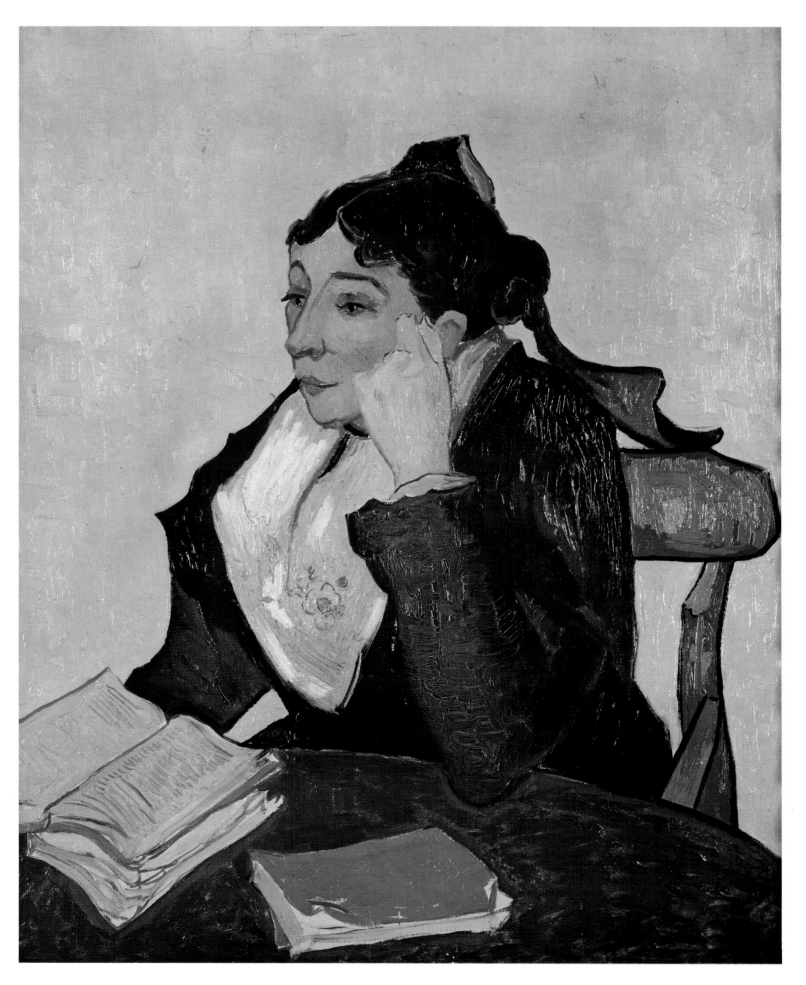

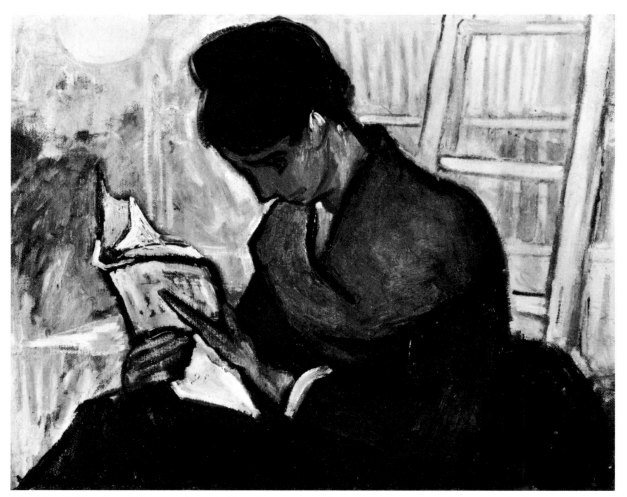

The Novel Reader. Arles, 1888. Collection Mr. and Mrs. Louis Franck, Gstaad, Switzerland

to paint people. In these subjects he saw the great task for his own time and for the future. Just as he had glorified the peasants at work in Brabant, he now wanted to see man in an exalted reality. He told Bernard that he was busy in Arles on a figure that he regarded as a definite improvement over the heads he had done in Holland, among which he mentions *The Potato Eaters.* He wanted to rediscover the old capacity for saintliness in a man of his own time, and to place him in the venerable glimmer of metaphysical light. He strove to make this light seem bound to no one age, as if it could belong to any century; Vincent looked for the spirit of the old Christians in the faces of the *petite bourgeoisie* of his time. He wrote of this in the institute at Saint-Rémy, after he had made the portraits of the Roulin family and *La Berceuse* in Arles. He says that such were his intentions, but that they were not wholly successful.

He was ripe for a style of art and a century which had previously been remote to him: Giotto and his period. It is noticeable that from this point on he did not quote from Giotto casually, but with deliberate emphasis. He read Dante, Petrarch, Boccaccio, Giotto, and Botticelli, though previously he had never bothered with Italian culture. Giotto is for him "the ever-suffering," "the great invalid," who seems to be living in another world. Van Gogh traveled with Gauguin to the museum at Montpellier, and there saw a small Giotto. It portrayed the death of a holy woman—so painful, so ecstatic, and so human in its expression that he felt it to be "as modern [nineteenth-century] as Delacroix, if he were not a

Continued on page 115

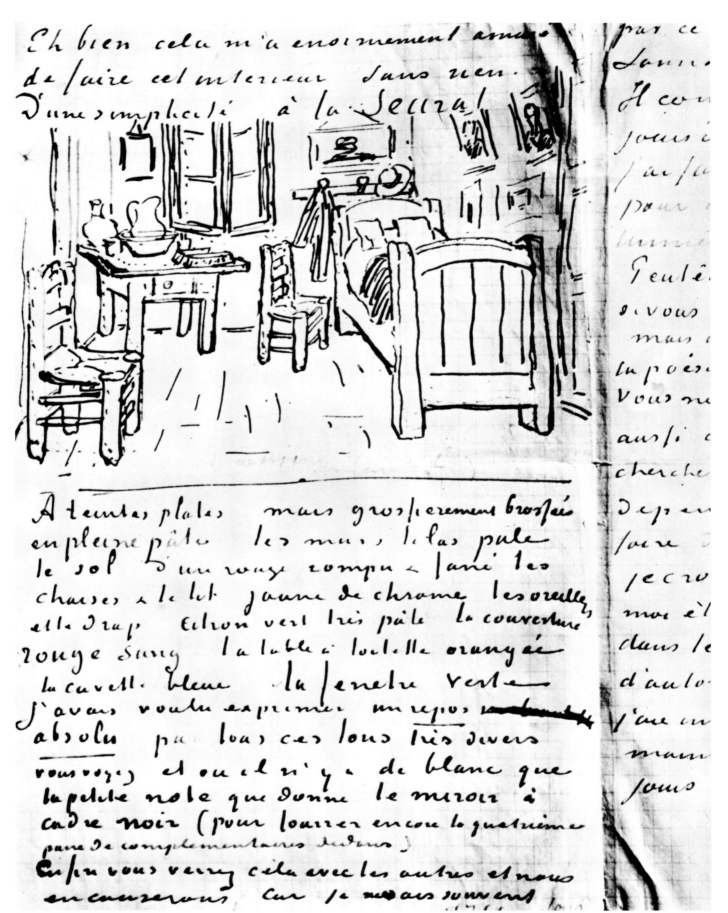

Van Gogh's Bedroom (detail of letter No. 554). Arles, 1888. Rijksmuseum Vincent van Gogh, Amsterdam

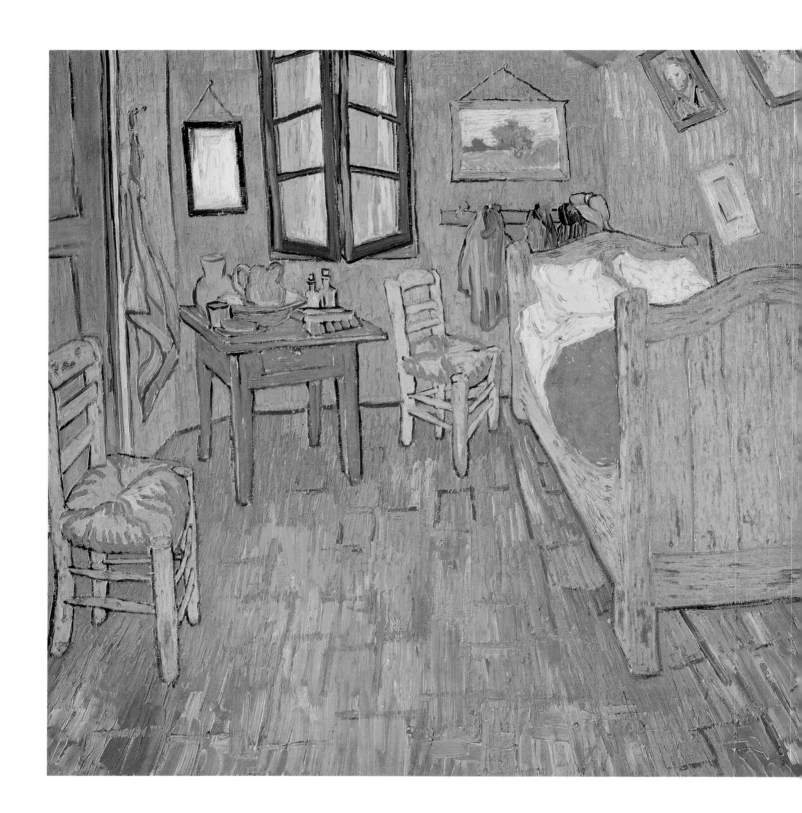

Van Gogh's Bedroom. Arles, 1888. The Art Institute of Chicago

Van Gogh made three versions of his bedroom at Arles. Sketching it in letter 554, he told Theo that the color was "to do everything . . . to be suggestive . . . of rest or sleep in general." The work was done ". . . by way of revenge for the compulsory rest I was obliged to take."

The relationship between the painter and the objects and space he depicts is very complicated. The reality of the objects is not stressed, but rather their role. Perhaps our recognition of the mastery of color and design is due to the psychic tension of the painter, to the fact that he sees the objects in the room only as part of his inner life—although we cannot be sure whether they are meant to protect it or to project it.

Van Gogh's Chair. Arles, 1888–89. National Gallery, London, on loan to the Tate Gallery, London

In The Hague (1881-83) Van Gogh wrote (letter 252) of an empty chair as the symbolic motif of a departed person, spurred on by an English illustration by Luke Fildes in the *Graphic*—Fildes had come into Dickens' room on the day of his death and had seen an empty chair. During Van Gogh's tense existence with Gauguin he painted Gauguin's empty chair in green and red (night effect) and his own empty chair (*"ma chaise vide à moi"*) in the yellow colors of day. Nordenfalk sees in this an unconscious forecast of Gauguin's departure. The transitional light Van Gogh sought is typical. He wanted to connect bright colors by gaslight. And the simultaneous urge toward night, the moon, and blue had for months been a source of conflict. But typically, just as in the portrait of the Zouave, the pattern of space, especially in the perspective of the floor, is subjected to deformation.

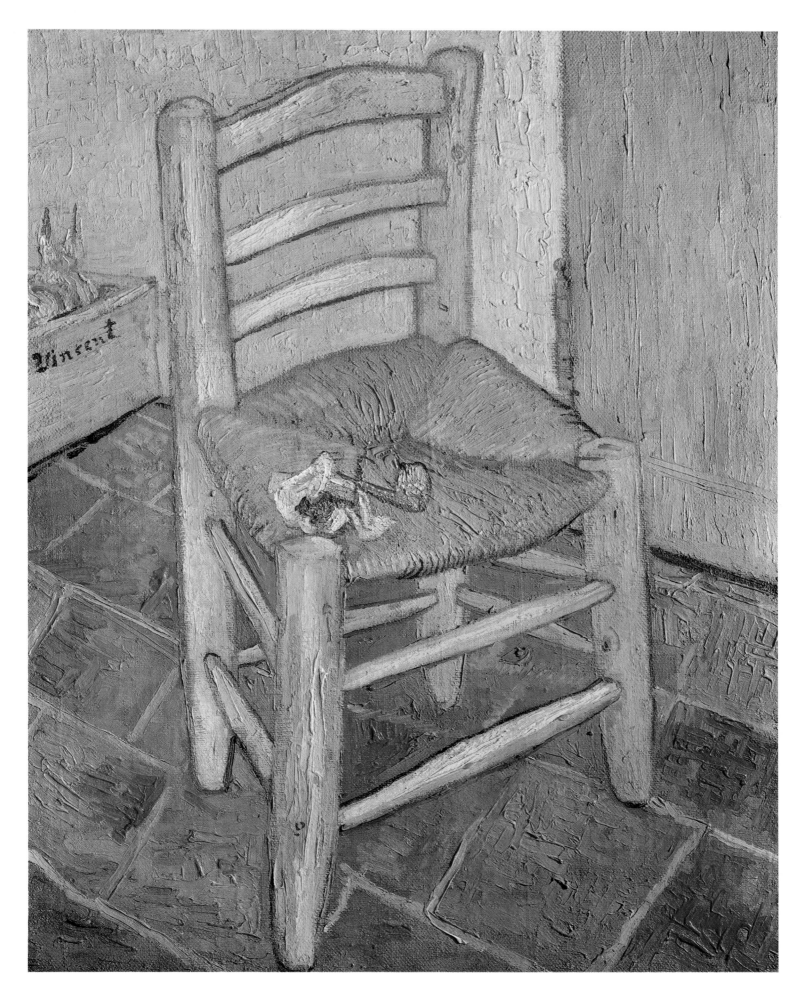

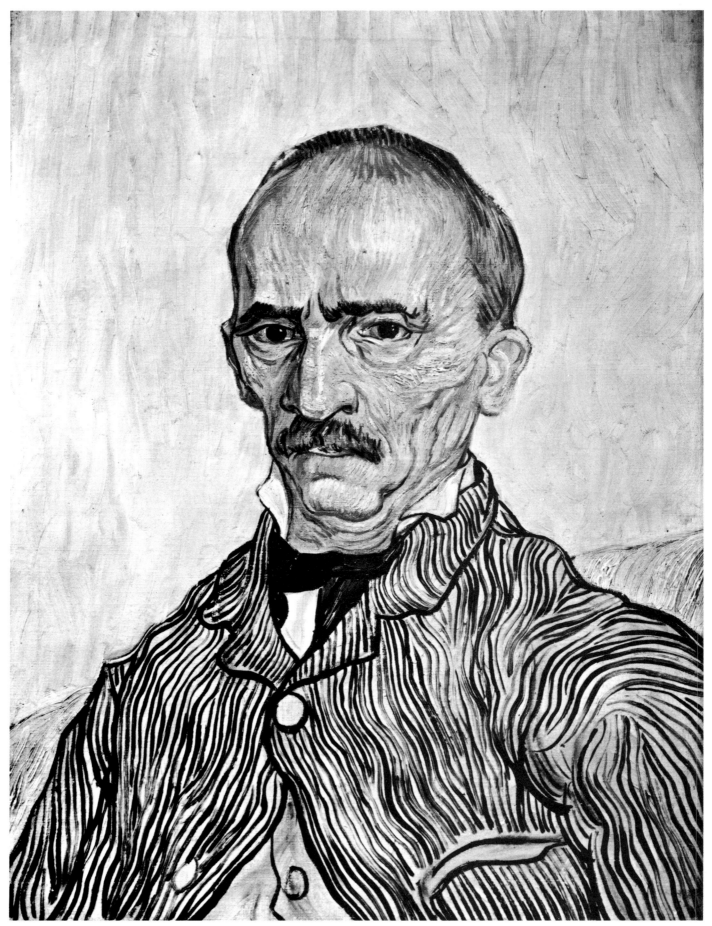

Portrait of the Head Guard at St. Paul's Asylum. Saint-Rémy, 1889. Collection Mrs. G. Dübi-Müller, Solothurn, Switzerland

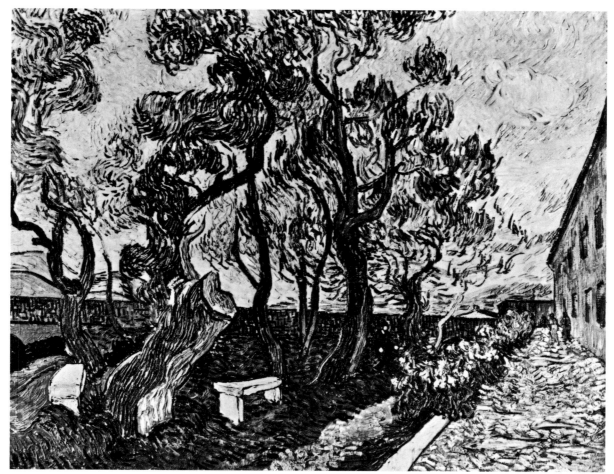

Garden of St. Paul's Asylum. Saint-Rémy, 1889. Folkwang Museum, Essen

primitive." Even the girls he saw at the seaside on his trip to Saintes-Maries reminded him of Giotto and Cimabue, so slim and upright, rather sad and mysterious. Another element took its place among his fiery colors to represent the quiet, fine, and gray, but at the same time very violent, Giotto.

Van Gogh was still painting nearly four landscapes to every portrait. But we must recall that he felt himself more suited to portraiture. In the summer of 1888, another sign of the increased formative power of his observation under the force of inner tension was the new vigor of his drawing. His hand had never been so firm, nor his sight so clear; it was as if the birth of the world and all its objects were taking place again through his creative energy. The symbol is then the circle.

With a masterly touch, sometimes again using a reed pen, he drew—in his letters as well—landscapes, gardens, and parks, either with or without figures, and portraits, still lifes, and sunflowers.

In Arles, as if under the ecstatic vision of the reality of the human figure, a new treatment of, and interest in, the earlier painters grew around the figure of Giotto. Not only his recollections of the Dutch seventeenth century and of the Japanese prints, but also a feeling for classicism entered the composition of the landscapes. Before Vincent himself was ready to manipulate this development, he needed, as always, a figure in whom he could see this feeling embodied and from whose position he could then advance. He found this figure in the aging muralist Puvis de Chavannes, who painted a pastoral, late-Greek, and nineteenth-century harmony of figure and landscape, free of the prevailing Impressionist

vision. A number of painters—Seurat, Maillol, and especially Gauguin and the Symbolists from Bernard to Denis—were attracted to this man; but no one would expect an affinity between Van Gogh the Expressionist and Puvis. Yet in Arles, together with a siege of memories of Holland and thoughts of Giotto, there developed a significant undercurrent of love for Puvis de Chavannes. The elements of Art Nouveau or Jugendstil which the later drawings reveal are closely linked with this homage.

Van Gogh's work from his fifteen months in Arles may be divided into three phases: that preceding Gauguin's arrival in October, 1888; the two months of Gauguin's stay; and the period from his departure until Vincent's internment in the Monastery of St. Paul at Saint-Rémy (May, 1889). The themes of the spring and summer were devoted to the landscape near Arles.

In fact, apart from excursions to Saintes-Maries via the Camargue, to Tarascon, to Fontvielle, and with Gauguin to Montpellier, Vincent never went far from Arles. Most of his subjects he found at the edge of town, on the road to the ruins of Montmajeur, or on the road that gives views onto La Crau. He exaggerated his colors and sought, for example, a blue even more intense than that of the sky. His yellow, which he had used in Paris, combined his symbolic masculine feelings for the circle, the sun, warmth, and love. The tendency to formal distortion had decreased in Paris, and did not reappear until Gauguin came to Arles. Vincent's lyrical raptures over the spring and summer, seasons which sometimes overwhelmed and sickened him, sharpened his senses—not only his eyes, but his ears as

Continued on page 126

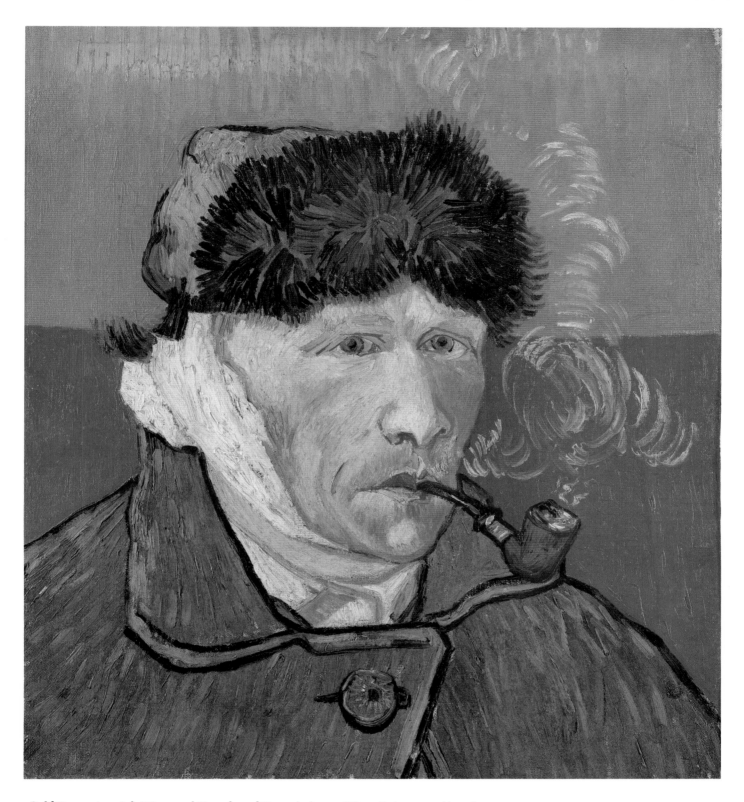

Self-Portrait with Pipe and Bandaged Ear. Arles, 1889. Private collection

This famous picture of Van Gogh as he saw himself after he had cut off part of his ear is open to a number of interpretations. Indeed, we are in danger of overaccentuating the picture's psychic and symbolic meaning and forgetting its great pictorial qualities. He himself was well aware of the latter, as he wrote Theo (letter 580): "You will see that the canvases I have done in the intervals are steady and not inferior to the others."

H. R. Graetz (in *The Symbolic Language of Vincent Van Gogh,* p. 146) calls attention to the borderline of the lower red and upper orange part of the background. This line, at the level of the eyes, and the spirals of smoke, he says, stand for Vincent's rise into the spiritual sphere. From a strictly pictorial point of view, however, the use of green, red, and orange results from the color analysis of his time, his discussions with Gauguin, and his personal experiences. The horizontal line has a special relation to the expression of the eyes and the fur cap.

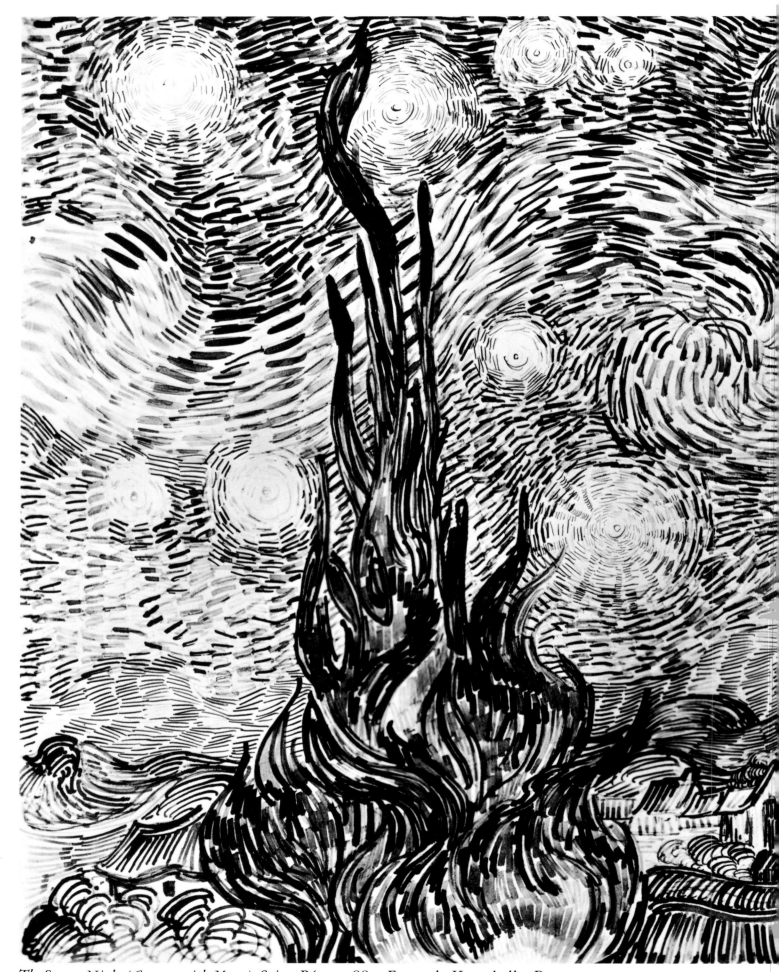

The Starry Night (Cypress with Moon). Saint-Rémy, 1889. Formerly Kunsthalle, Bremen

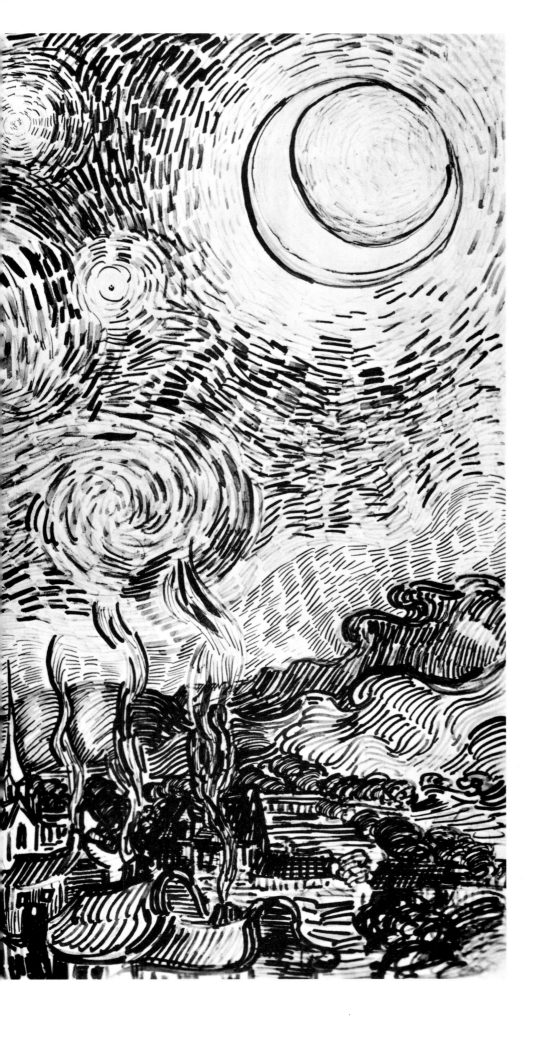

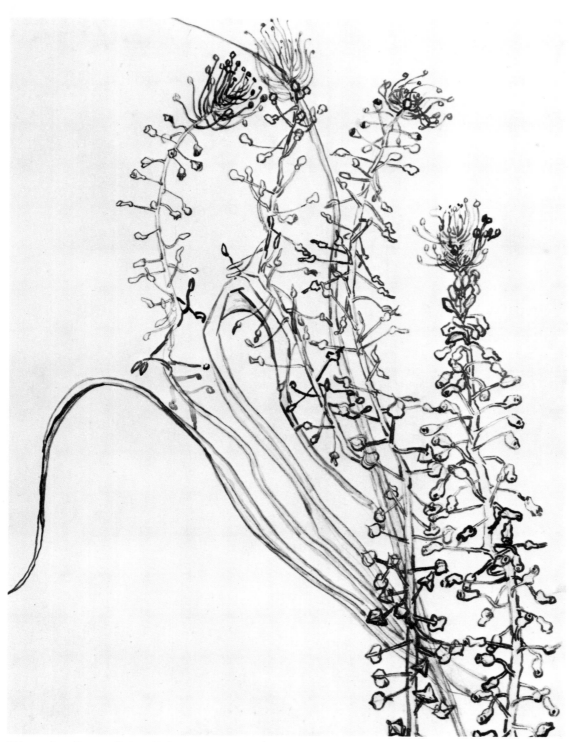

Flowering Stems. Saint-Rémy, 1890. Rijksmuseum Vincent van Gogh, Amsterdam

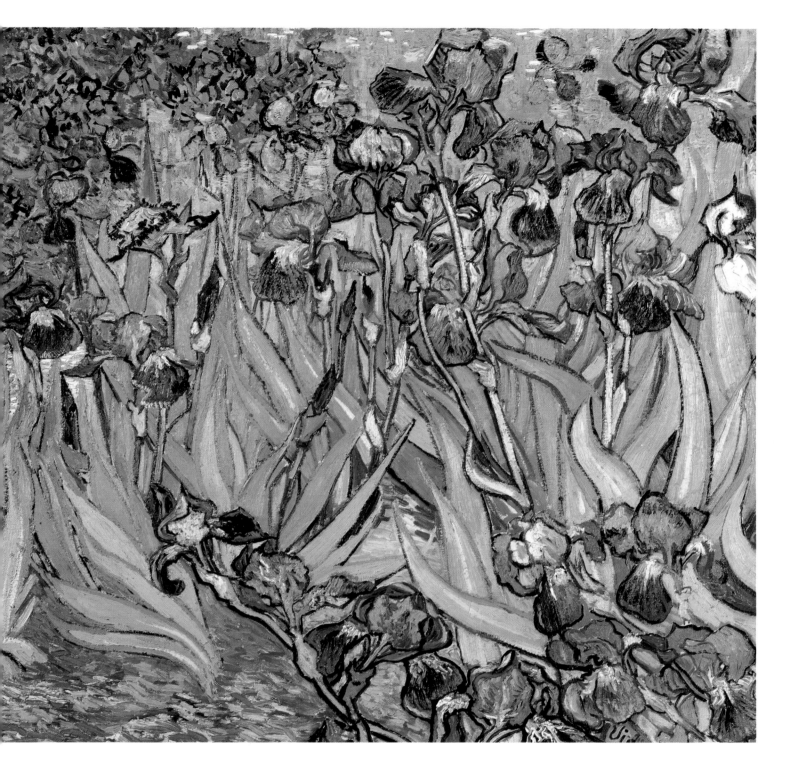

Irises. Saint-Rémy, 1890. Joan Whitney Payson Gallery of Art, Westbrook College, Portland, Maine

Vincent's first letter to Theo after his arrival in the asylum of Saint-Rémy (letter 591, May, 1889) tells that he is working on "some violet irises and a lilac bush," two subjects from the garden. When he left about a year later, he painted irises again, one study against a pink background and another against a "startling citron." The whole surface of the earlier painting, shown here, is covered with a profusion of strong colors and a rhythm of sharp pointed leaves.

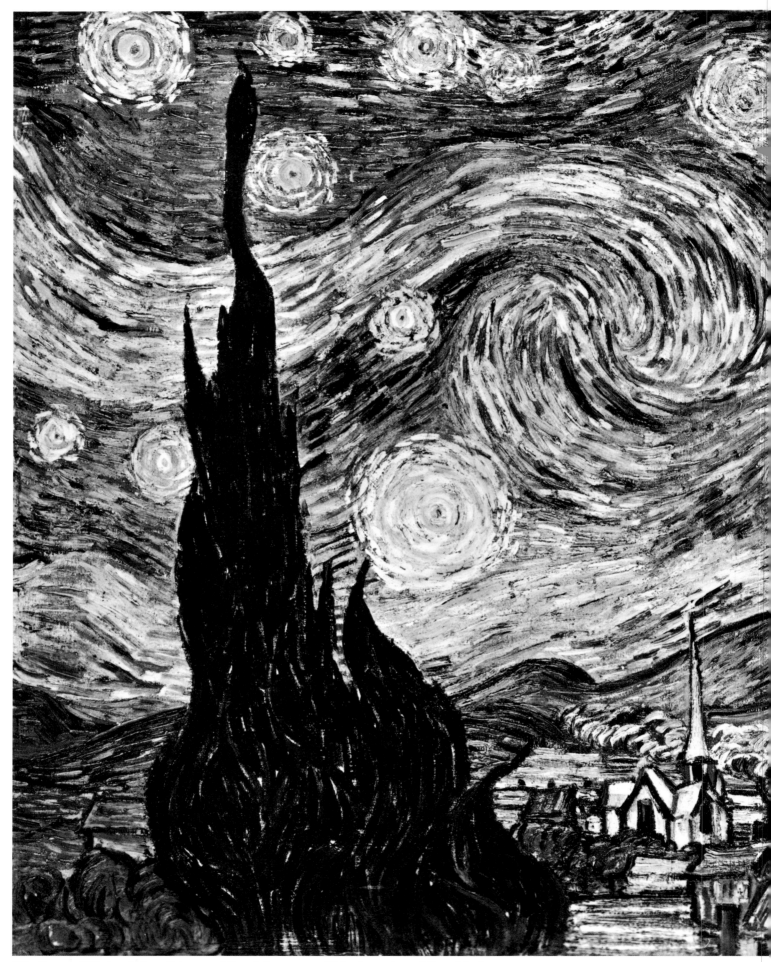

The Starry Night. Saint-Rémy, 1889. Museum of Modern Art, New York

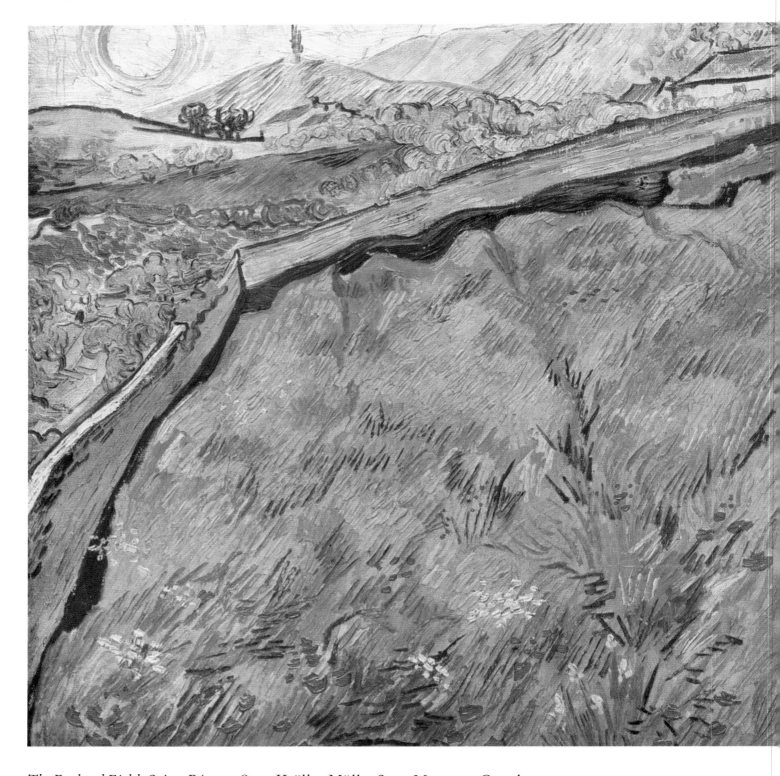

The Enclosed Field. Saint-Rémy, 1890. Kröller-Müller State Museum, Otterlo

At one time this painting was identified with the one Van Gogh mentions in his letters of November and December, 1889; it was also said to have been exhibited with the *Vingtistes* in Brussels in 1890. But now it is thought that it was done during the late Saint-Rémy period (March–April, 1890), just before Vincent left for Auvers-sur-Oise.

The long wall divides the picture in two parts: beyond are the hills, the olive orchard, and the houses, with the rising sun; the larger area is the big yellow-greenish field with its red flowers. The character of movement in this landscape is mainly due to the relatively short lines representing the field and the long, steady brush strokes of the wall.

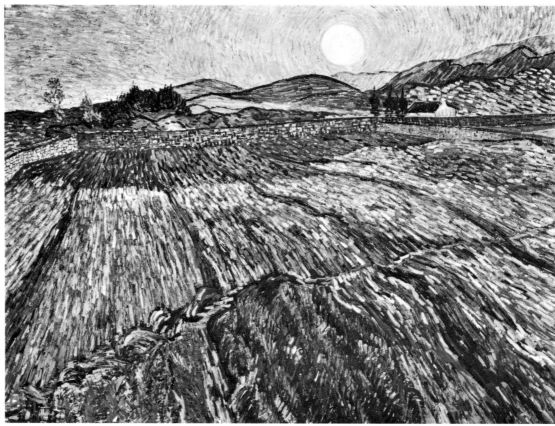

Landscape with Ploughed Fields. Saint-Rémy, 1889. Formerly collection
Mrs. Robert Oppenheimer, Princeton, New Jersey

well. He was extremely excited by bird calls—including those of storks—and by the chirp of the cricket. There is something quite Italianate in his depiction of parks and landscapes. The commonplace little park nearby he termed "The Poet's Garden," thinking of Petrarch, who had lived in southern France near Avignon, and of Gauguin, the new poet to come. His power of expression did not require striking deformations so much as powerful lines and more intense color. The series of sunflowers begun in Paris gained a restless plastic power which deviated from his lighter, sketchlike brushwork. In their form the Arles sunflowers remind one of the birds' nests which he had collected and reconstructed in Brabant. The nest, its shelter and protection, is related to the cottage with the mossy roof. In 1885 he had called the cottages "human nests," similar to wrens' nests. From Etten to Saintes-Maries and finally to Auvers, this cottage theme stayed with him.

He continued the sunflower series because he wanted to decorate the "Yellow House" in Japanese style, using the flowers as a motif of gratitude. By "Japanese style" he meant the contrast between large canvases and small rooms, and vice versa. What did the little house look like? He wrote his sister that it was painted on the outside in a fresh, buttery yellow with green shutters that glared in full sunlight, beside a small green park with plane trees, pink laurels, and acacias. The inside was whitewashed and had a floor of red brick. Above was the intensely blue sky. It was a house, he said, "in which I can live and draw and breathe and contemplate and paint."

Toward autumn, before Gauguin's arrival, his output was vast. The full-face portraits of the Roulins, a Zouave, a girl with black hair and a soft, yellowish complexion, present bold color contrasts and, at the same time, a nontragic view of humanity which connects these portraits psychologically and distinguishes them from later portraits. He sees his subjects as good French types, though for him they have also some Russian aspects. He lived with these people and especially liked Roulin, who spent much time in the cafés and was, though more or less a drunkard, natural and intelligent.

The starry sky became a new motif. He compared it to Guy de Maupassant (because *Bel Ami* begins with the description of a starry night in Paris), thus roughly indicating what Vincent was intent on creating in September, 1888. He wanted to paint the night in the evening or after dark, without using black and without further sketching during the daytime. He made long nocturnal sittings of from six to twelve hours and then slept in the daytime—sometimes for twelve hours at a stretch. The canvases followed each other at short intervals.

He managed well enough with a candle or by gaslight, and he didn't mind that in the darkness he occasionally chose the wrong color. The paintings of the café terrace and the interior of the café originate from the same desire to render the night.

He found the night café one of his ugliest paintings, equivalent to *The Potato Eaters,* but of deep significance. The emotional impact of the clashing colors is immense and intensified by the heightened

Continued on page 140

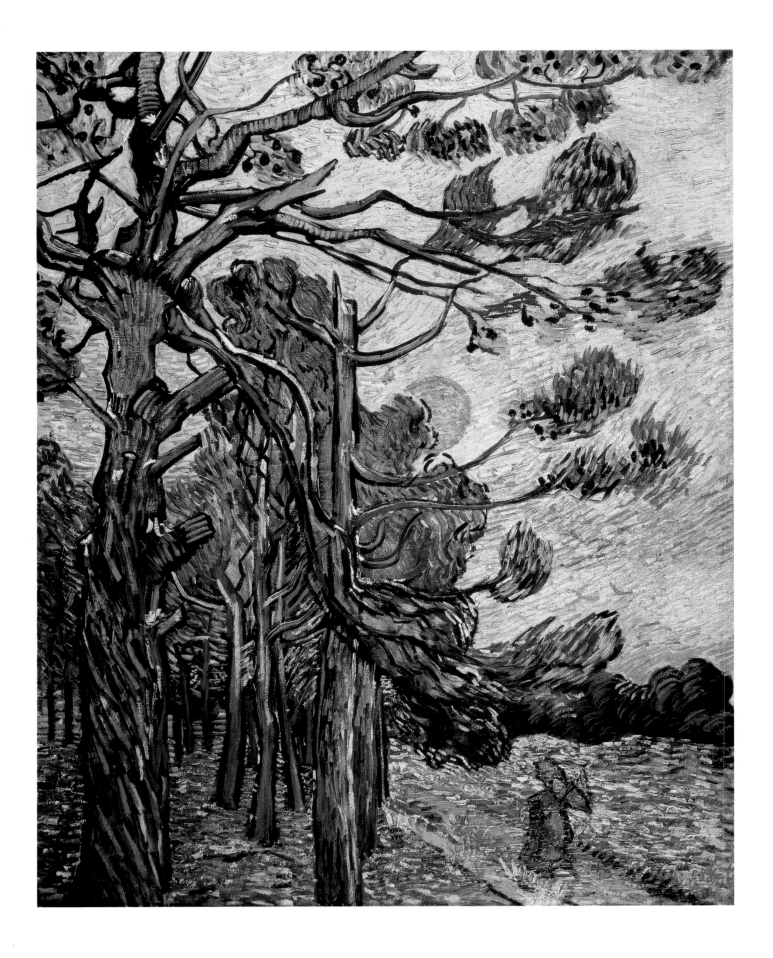

Storm-Beaten Pine Trees Against a Red Sky. Saint-Rémy, 1889. Kröller-Müller State Museum, Otterlo

Working on this picture, Vincent wrote (letter 617), "... there is a mistral. Toward sunset it generally grows a little calmer, then there are superb sky effects of pale citron, and the mournful pines with their silhouettes standing out in relief against it with exquisite black lace effects. Sometimes the sky is red...." Rare are the pictures with such unity of striking color and short, nearly graphic, rhythmical brush strokes. The result is a terrible movement all over the surface, the image of a struggle against destructive forces.

Portrait of the Artist. Saint-Rémy, 1889. Private collection, New York

The self-portraits were perhaps the best realization of the vision of modern man at which Van Gogh aimed. Here he is indeed the rapidly aging, tormented man. That a painter should reveal himself so unmercifully would seem impossible for any preceding age. The day of Freud was approaching. If one thinks of Rembrandt's last self-portraits, one does not see awe before the majesty disclosed to him, but rather restrained suffering, twilight colors, and a controlled touch. Van Gogh has in this portrait a fierce, aggressive color and a touch that spare nothing, not even the spectator. Here we have not distance and not awe, but a wounded and hunted being with a fierce feeling for life.

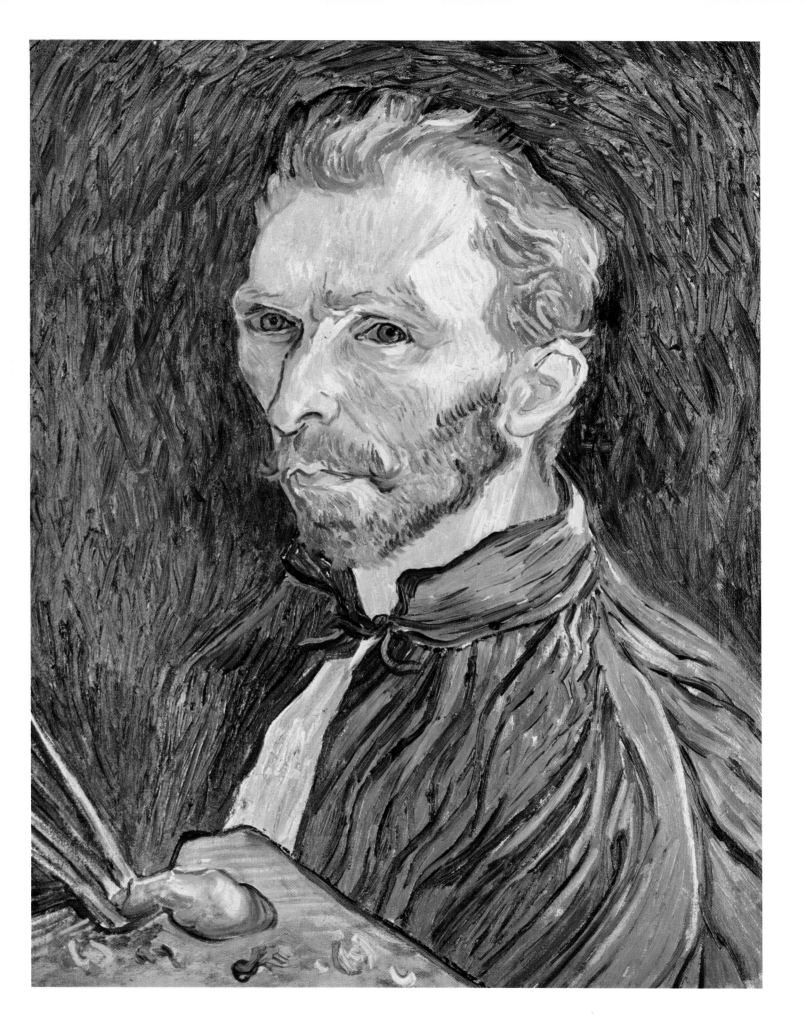

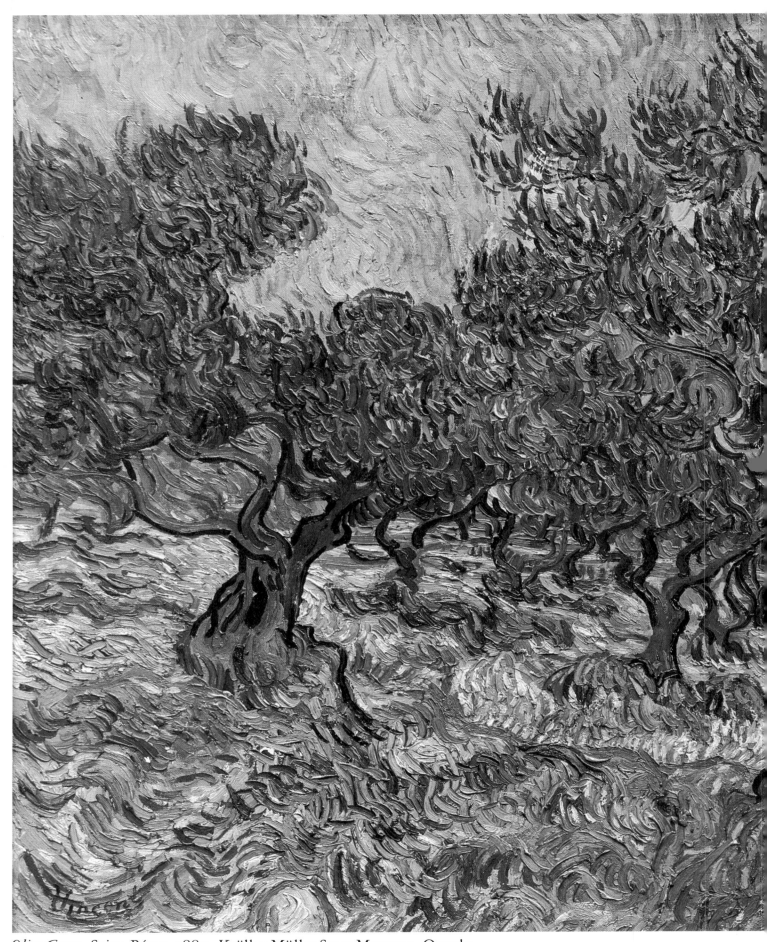

Olive Grove. Saint-Rémy, 1889. Kröller-Müller State Museum, Otterlo

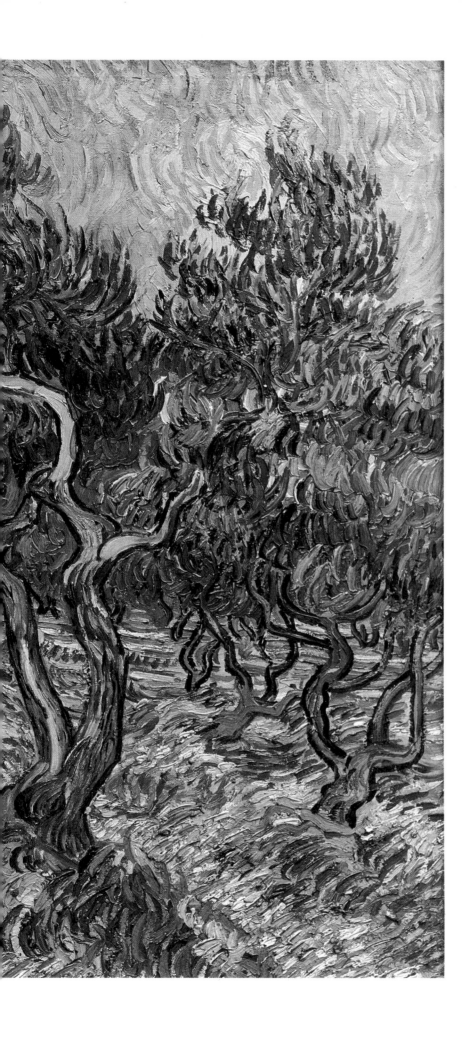

Wheat Field with Cypresses. Saint-Rémy, 1889. National Gallery, London

There are three versions of this wheat field at Saint-Rémy, and if Vincent hadn't written (letter 608) that he had made two smaller copies, it would be difficult to say which was painted first. This one is the original work, and decidedly the most fresh and direct; the others have less detail, emphasizing the general movement. The clouds with their curling lines and the gold-yellow stream of the field move from right to left. The mountains are like pale-blue waves and form the diagonal main line of the composition, culminating at the right in the dark flame of the cypresses. All these dynamic elements accentuate the baroque character of this picture.

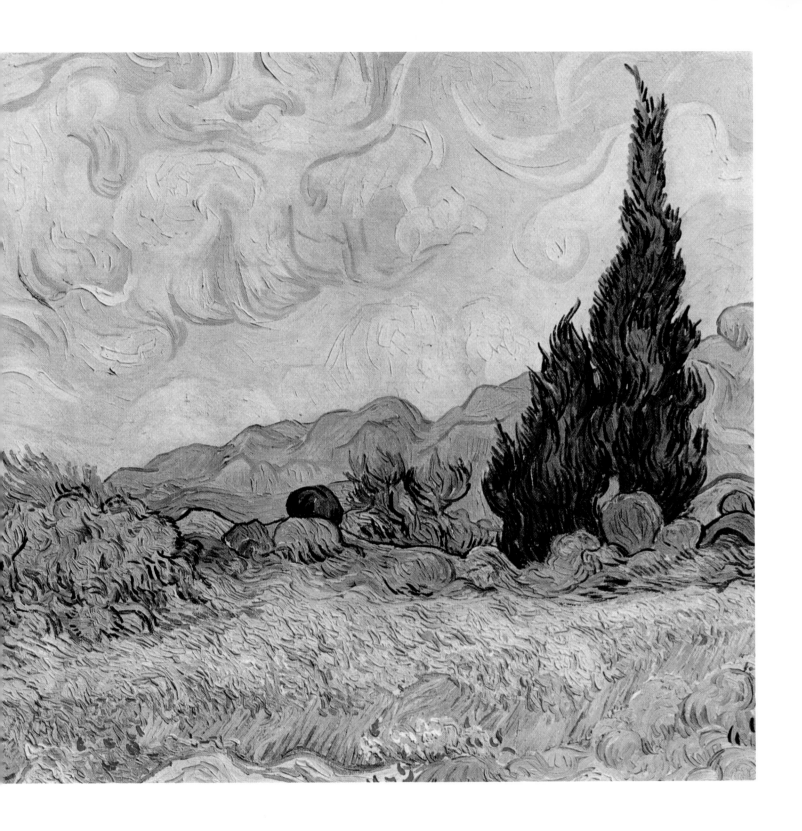

Wild Vegetation. Saint-Rémy, 1889. Rijksmuseum Vincent van Gogh, Amsterdam

Wild Vegetation (detail)

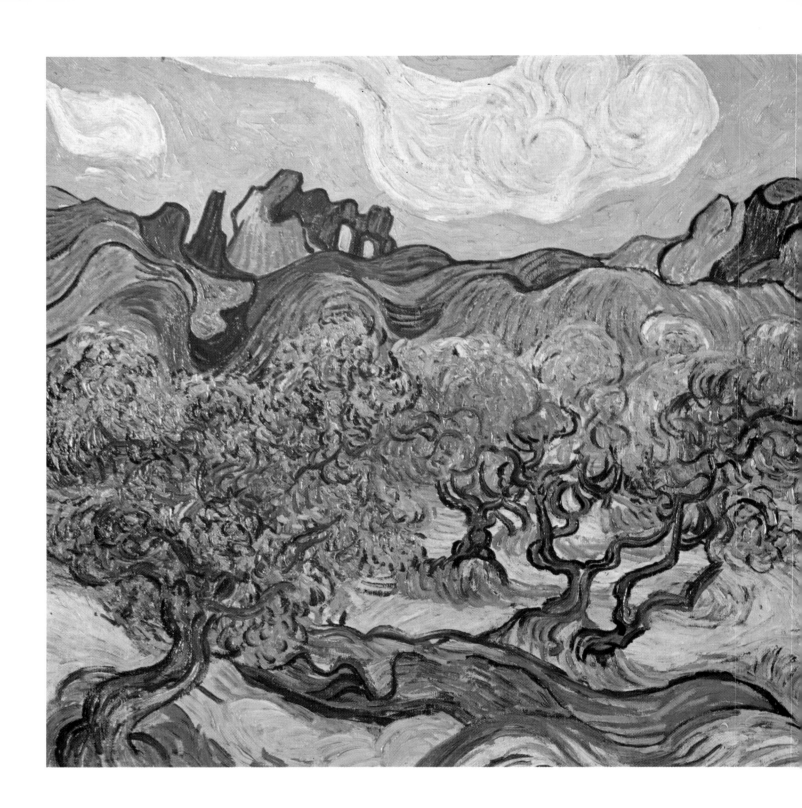

Landscape with Olive Trees. Saint-Rémy, 1889. Private collection, New York

Already in Holland and Belgium Vincent had been struck by the expressive humanity of trees. In Arles and Saint-Rémy his feelings were directed to the image of the olive grove, and then the cypress (which for him represented darkness), at first out of reaction to Gauguin and Bernard, who wanted to paint Christ in the Garden of Olives. He preferred to paint religious and Biblical motifs in a present-day reality. The olive tree became a symbol. He saw in the plucking of the olives the eternal cycle. He had magnificent color visions in Provence and expected that Puvis de Chavannes would in the future paint the meaning of the olive tree. This almost mystical ecstasy in the garden took on positive form in his lyrically painted landscapes. The wavy lines and the refined colors ascend into a tender, silver gray-blue in *Olive Grove,* while in *Landscape with Olive Trees* the mountain landscape above the trees is transformed into a powerfully plastic current which ends in a rising cloud of spiral movement.

perspective. Everything indicates a profound change. He was greatly excited by reading Dostoevski and spoke of the terrible human passions which his various reds and greens were to express. With a tender pink, a blood-red, the red of wine lees, and a contrast of greens and pale sulfurs, he painted a hellish furnace, an incubator for the crime and frenzy that haunted him. When it was finished, he realized he could not offer the painting to the café owner for payment of his bills.

Gauguin's arrival brought further changes. Before Gauguin arrived, Van Gogh began using Christian motifs—Christ with the angel on the Mount of Olives, for example. His correspondence with Bernard about Gauguin's motifs, and those of Bernard himself, both of whom had restored to painting the motif of Christ, already constituted a violent dispute, which he then continued with Gauguin in person.

As far as content was concerned, Vincent opposed the idea that it was still necessary to convey religious sentiment by representing the figure of Christ. He removed this connection—already a step toward abstraction—from his work. Continually he returned to the olive garden, saying that it must be possible to reach profound religious expression, with or without the olive pickers in the scene. The olive trees themselves were sacred, antique presences which could be painted in the spirit of Puvis. The trees of the ancient South, so like the earliest Christian landscape, could carry the human meaning he had striven for in his early painting of the willows of Holland. He began to see the olive trees in a

symbolic-realistic light that richly irradiated his being, leaving him gently sensitive to the soft rustling of their leaves.

Under pressure from Gauguin, Van Gogh tried working on intellectual themes but felt they were not right for him. In a canvas that was to commemorate the garden at Etten, showing his mother and sister taking a stroll, bizarre lines writhe like snakes, dominating the entire composition. Under Gauguin's exciting influence and different orientation, Vincent time and again did his best to follow his friend's forceful advice. His colors became flatter, thanks less to Japan than to Gauguin. In his Japanese ecstasies before Gauguin's arrival, he had had freer movement and more intense color. *La Berceuse* and *Woman Reading a Novel* are two examples of the so-called abstractions he attempted during Gauguin's stay. The work lost the characteristic directness which usually breaks through Vincent's premeditation and makes it so vitally enjoyable. This loss made the paintings of this period more reticent; but he turned away from abstraction, and eventually condemned such work.

It is clear that some sort of explosive force would be needed to jolt Van Gogh from this reticence—and, further, that damage might result, given his inadequate emotional armor. The sickness of the past years showed itself now in his quarrel with Gauguin, and in his self-mutilation. He cut off the lobe of one ear and had the wound tended to by a woman from a brothel in Arles. A footnote to this pathetic event (given by J. Olivier to V. W. van Gogh) is that Vincent may have attended bullfights

Continued on page 153

Cart with Horse. From a sketchbook. Rijksmuseum Vincent van Gogh, Amsterdam

Road with Cypresses. Saint-Rémy, 1890. Kröller-Müller State Museum, Otterlo

Before Vincent left Provence to travel via Paris to Auvers, he painted—with the thought that it might later serve as a reminder of Provence—a romantic evening landscape with a cypress and, as he described it in a letter to Gauguin, a star shining with exaggerated brilliance. The crescent moon is small; the path is crossed by two solitary walkers and a small carriage. It is a work that in style anticipates Auvers. The atmosphere of the sun has given way to lunar symbolism. The spiral movement is still there but counteracted by the chaotic short strokes of the corn and by the flowing perspective of the path. It is a rich and anxious work, full of the chaotic beauty of the southern night sky, the dark power of the cypress, and his longings for home and a return to inner peace and shelter.

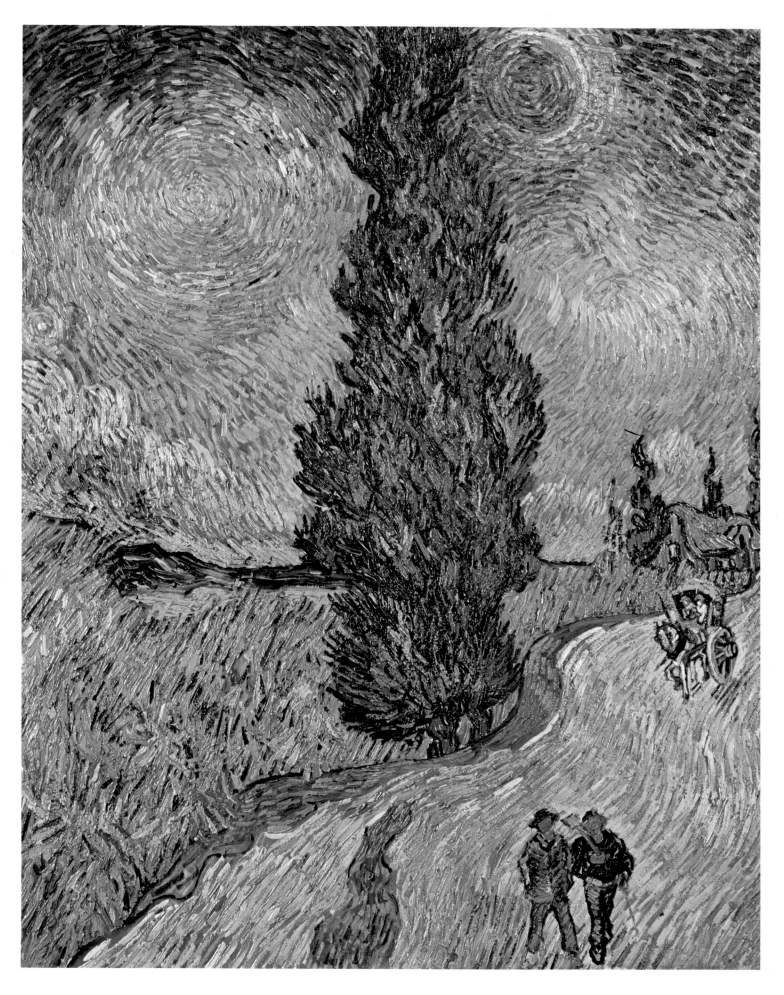

Snowy Landscape. Saint-Rémy, c. 1890. Rijksmuseum Vincent van Gogh, Amsterdam

The Good Samaritan (after Delacroix). Saint-Rémy, 1890. Kröller-Müller State Museum, Otterlo

As a patient in the asylum at Saint-Rémy, Vincent was not always well enough to work outdoors. He began to use the works of other painters as subjects for his own paintings, trying to be as exact as possible but interpreting as a musician does, "translating . . . into another tongue." For this painting he used a lithograph of a painting executed by Delacroix in 1850. He did not really copy, for his color and brush strokes were his own. This was apparent in Philadelphia in 1953, when this picture and the Delacroix painting were exhibited together.

Overleaf left

Pietà (after Delacroix). Saint-Rémy, 1889. Kröller-Müller State Museum, Otterlo

Vincent here worked from a lithograph by C. Nanteuil after a painting by Eugène Delacroix. He also made another copy of this picture. Knowing that he would continue to suffer crises in the future, he still could write: ". . . my brain [is] so clear and my fingers so sure that I have drawn that *Pietà* by Delacroix without taking a single measurement. . . ." The Christ of the *Pietà* is the same type as the red-haired Lazarus of *The Raising of Lazarus* (after Rembrandt). It is sometimes said that both are self-portraits and reveal a kind of self-identification. Vincent was undoubtedly subject to religious ecstasies, but these were not lasting, nor did they specifically affect his painting or drawing; his letters never refer to any relationship between the motifs of Christ and Lazarus and his own condition. Perhaps we can overdo such interpretations, for Van Gogh always disapproved of Bernard's and Gauguin's modernizing of Biblical themes.

Overleaf right

145

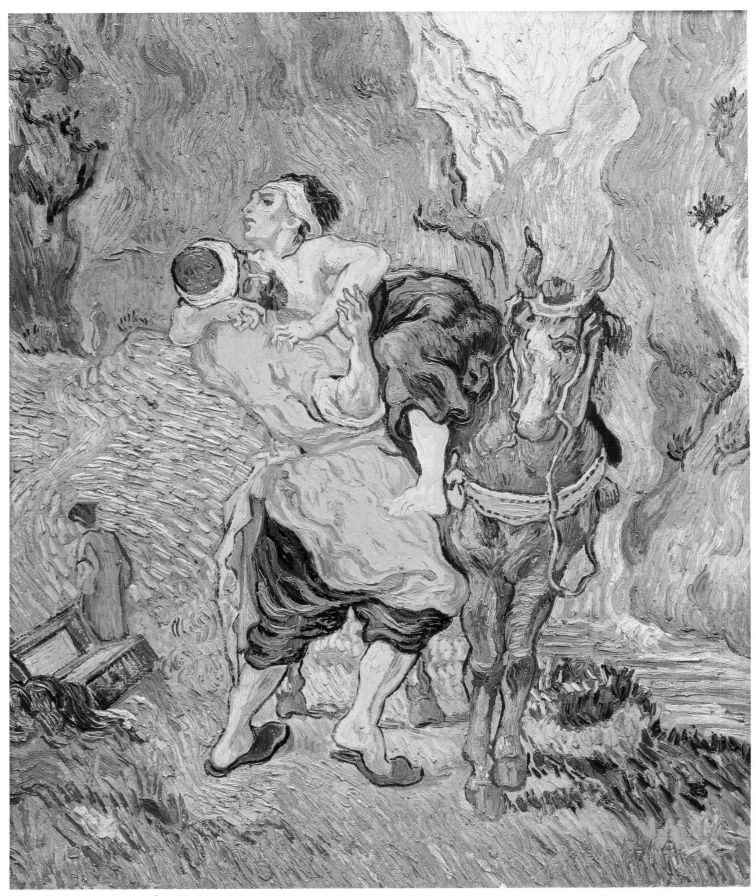

The Good Samaritan (after Delacroix)

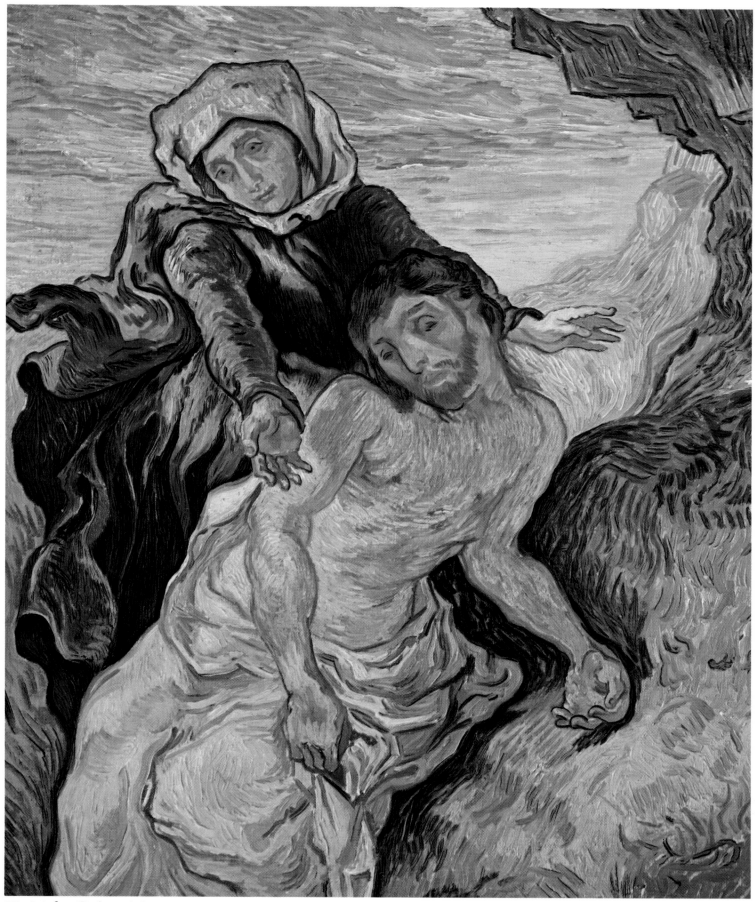

Pietà (after Delacroix)

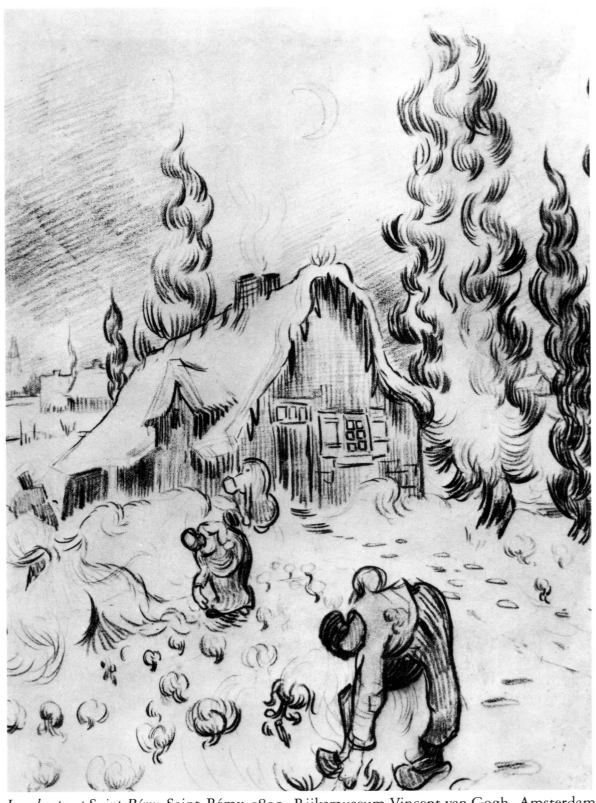

Landscape at Saint-Rémy. Saint-Rémy, 1890. Rijksmuseum Vincent van Gogh, Amsterdam

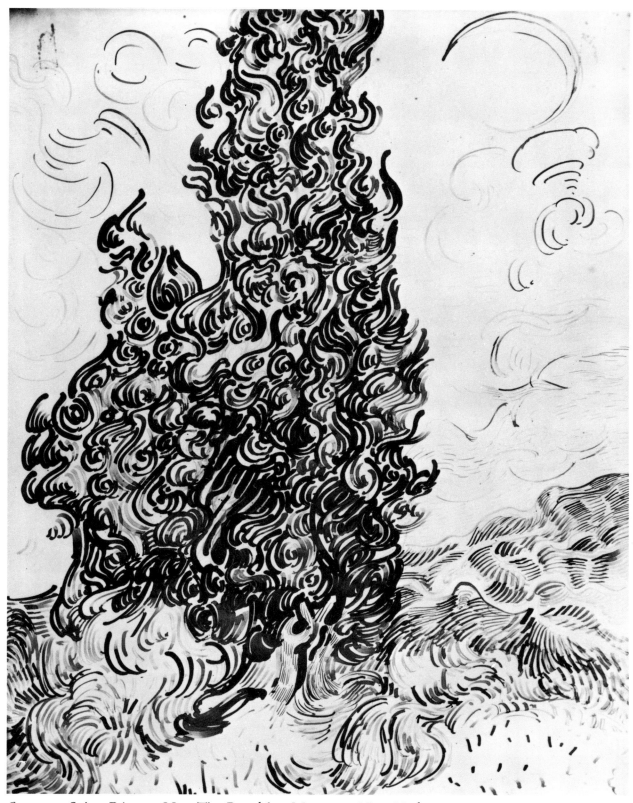

Cypresses. Saint-Rémy, 1889. The Brooklyn Museum, New York

Prisoners' Round (after Gustave Doré). Saint-Rémy, 1890. Pushkin Museum, Moscow

Vincent said that he had tried to copy *Le Bagne* by Doré and that it was very difficult. By "copying" he meant transferring into another language—that of color. He chose the Doré plate called *Newgate* from a book about London, which appeared in 1871. Comparing the plate with the painting, one is amazed not so much by the oft-asserted freedom which he allowed himself, but rather by the painstaking exactitude with which he copied the prisoners, line for line, down to the slightest detail. Some have claimed to recognize Van Gogh in the bareheaded man, but Doré has virtually the same figure. Only the signature and the color are unmistakably Van Gogh's, giving every form an altered accent. Otherwise he was faithful to Doré's original. The color reminds one of the emotive picture of the North which prevailed in Van Gogh, especially during the last period at Saint-Rémy. The bluish green of Brabant dominates in the painting.

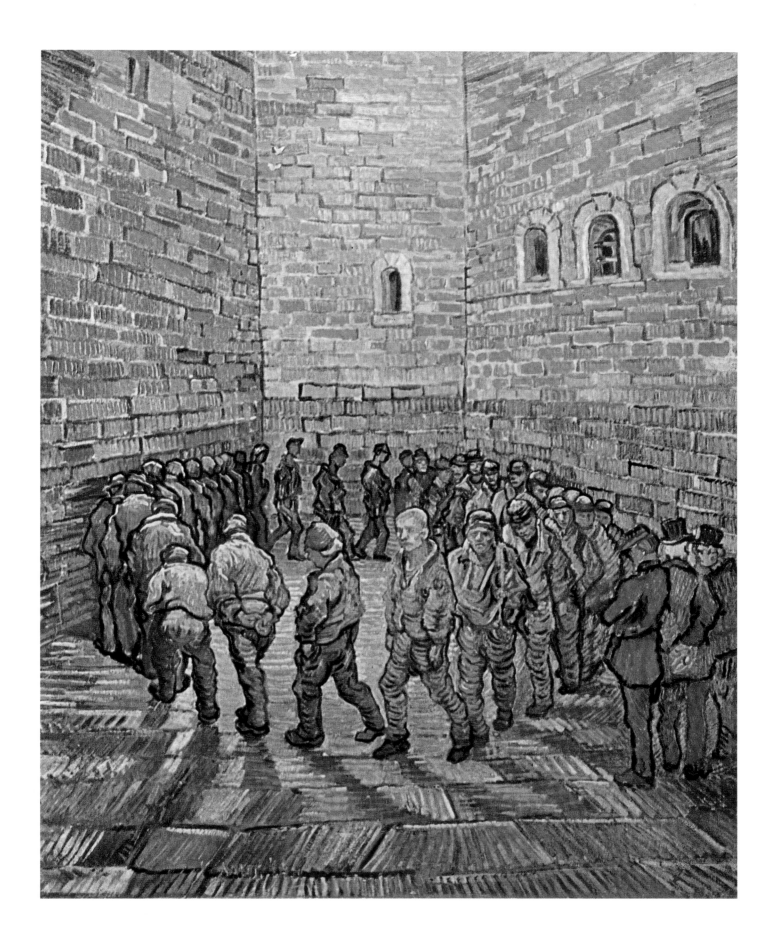

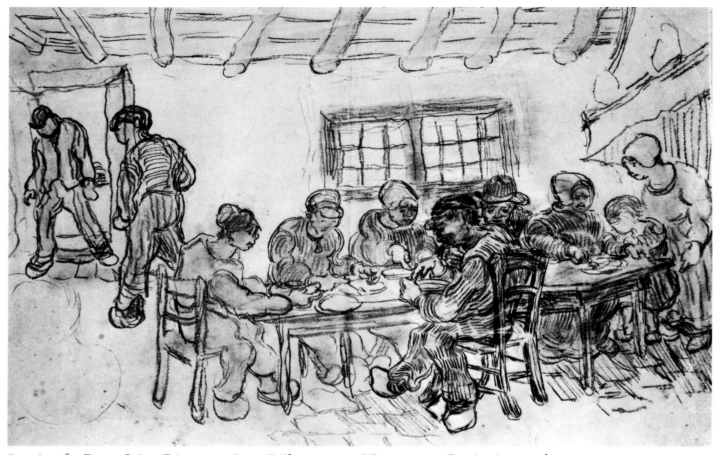

Interior of a Farm. Saint-Rémy, c. 1890. Rijksmuseum Vincent van Gogh, Amsterdam

in Arles and noted that the reward given a matador for skillfully killing the bull was a severed ear, which the matador then bestowed on his sweetheart.

All details aside, one may say that Van Gogh had now entered the arduous years of his most unfathomable suffering. He was nursed briefly at the Arles hospital, returned to his cottage, recovered, relapsed, and recovered again. The doctors hesitated, the inhabitants of Arles took action, and Vincent, realizing that he had best enter a mental institution, chose the beautiful old monastery of St. Paul in the wonderful countryside near Saint-Rémy. But only those who have suffered similarly can know what he endured, once he had taken this decision. Poetry is actually more terrible than painting, he once said, for painters can at least keep silent. Perhaps the life he had led before had to a certain extent prepared him for this test. Perhaps his vast creative urge, full of the rich artistic resources linked to that urge, made his confinement at the monastery bearable. Whichever it was, his brief periods of freedom concluded always with his inevitable return.

Only Antonin Artaud understood these ordeals and wrote about Vincent's work with them in mind.

In any case, they did not stem the creative flood, for his output increased enormously. Moreover, one need only compare the canvases of the starry nights and the night café (Yale University Art Gallery) with the *Still Life with Easel* or with *The Dormitory at the Hospital in Arles* (Collection Oskar Reinhart, Winterthur) to realize that his painting recovered qualitatively after Gauguin's departure and the

Continued on page 160

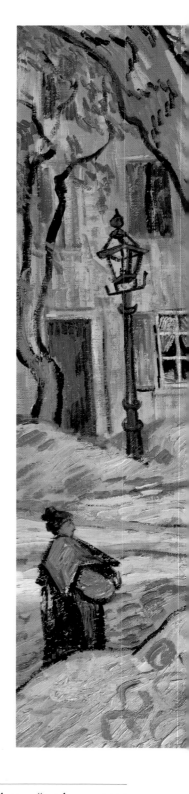

The Road Menders. Saint-Rémy, 1889. The Cleveland Museum of Art

This subject originated in a study from nature; from it Vincent made the version shown here, "perhaps more finished." Of course he did not copy himself, but changed details and proportions; a closed window in the first study becomes an open window, and the two road menders become three. Undoubtedly there is a more direct feeling of tension in the original under the spell of the monumental giants. Once again we are reminded of the enormous significance and individuality of trees in Vincent's art. In the early Dutch period he had written: "There was drama in each *figure* I was going to say, but I mean in each tree" (letter 319).

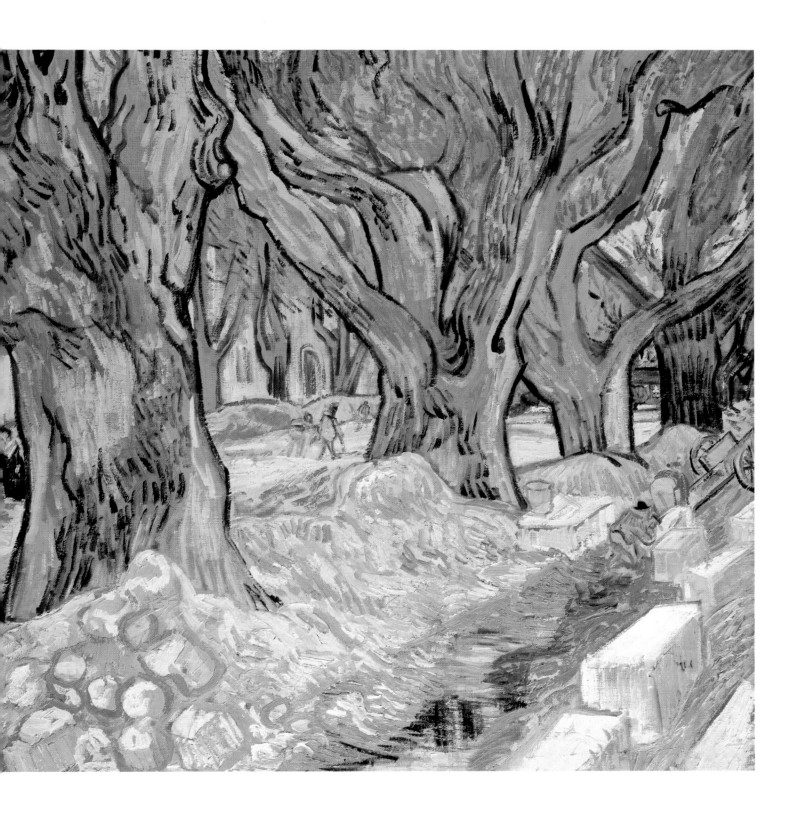

On the Road. Saint-Rémy, c. 1890. Rijksmuseum Vincent van Gogh, Amsterdam

Studies. Saint-Rémy. Rijksmuseum Vincent van Gogh, Amsterdam

Cypresses with Two Figures. Saint-Rémy, 1889. Kröller-Müller State Museum, Otterlo

Vincent sent this picture to the young Albert Aurier after the publication of Aurier's article, the first serious study of Van Gogh's work during his lifetime.

Mrs. Kröller bought it directly from Aurier's heirs, the Williams family, at Châteauroux. Theo described it as having "the richness of a peacock's tail" (letter T33), and today it is recognized as one of Vincent's best paintings. This is one of the worked-over pictures that bears a certain relationship to the style of his beloved Monticelli, with whom he often identified himself. But the spirals, the curling clouds, the impression of awe and terrible movement are entirely Vincent's as he felt himself to be at Saint-Rémy.

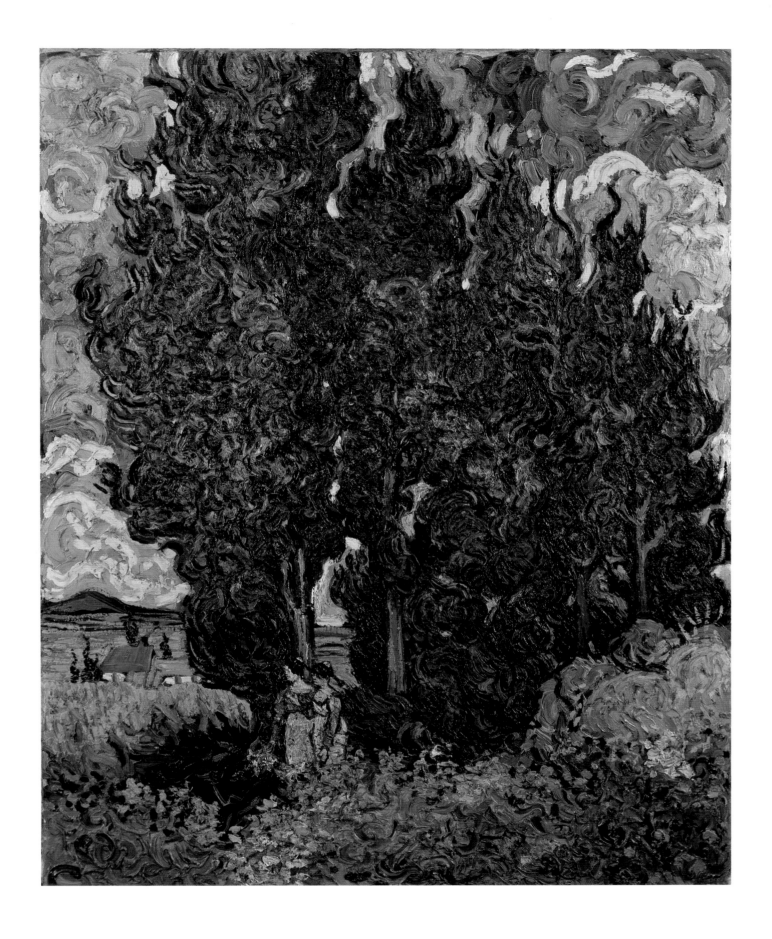

catastrophic turn his life had taken. He resumed the *Dormitory* study in the autumn of 1889 at Saint-Rémy. His reading of Dostoevski's *The House of the Dead* provided the occasion for this. His removal from the yellow house to St. Paul's Monastery was tragic, the collapse of an inspiring ideal, but his style and his power seemed unimpaired. The thread which held everything together remained unbroken.

Saint-Rémy shows us how the double nature of the motifs could still increase in power. What one (for the sake of convenience) terms "symbolism" is in fact a complicated struggle between two realities. The reality of his surroundings—the monastery, the patients, the attendants, the landscapes which he sees from his cell or the room assigned to him as a studio, and the countryside around the monastery—came to his consciousness in lines and color which belonged to the strong Van Gogh tradition. The other reality lay deep within him, and was the sum total of his youthful experiences and the later period in the North, when he began to paint. This reality, too, had its own power, and affected his presentation. It re-created for him the fatally seductive, gray picture of the North that reasserted its rights; in terms of art, it made him cling to Giotto and to Puvis de Chavannes, who had come to stand next to Delacroix in Vincent's estimation. Puvis is the meeting place of past and present.

These two worlds of images combined. The circle became a spiral; then the spiral broke and dissolved. There is no better example of the process that continued without interruption from Saint-Rémy to Auvers-sur-Oise than the picture Vincent consistently evoked of moss-roofed cottages and ivy-covered

trees. Earlier, on the heaths of Brabant, Drenthe, and in Calmthout (Belgium), these had attracted him as offering inner shelter. He found and drew them again in Saintes-Maries and later in Auvers. He compared moss and ivy to diseases such as cancerous tumors that attach themselves to old things, to what they love, and live upon. Tumors attach themselves to affectionate people. Once he feared that he himself was suffering from cancer. He attached himself to Theo, and Theo to him. His mysterious disease, the symptoms of which are buried in the past, can no longer be identified. But those who noticed Vincent's reaction to Theo's engagement and marriage, and to Jo van Gogh's pregnancy, saw how these events influenced Vincent's insight into the reality of his own position and future, which was materially and morally dependent on Theo's help. For Theo to form his own family and beget an heir increased the oversensitive Vincent's feeling of isolation and uselessness, despite the talk of their all living together.

Thus the ivy and the moss of Vincent's old world, with its thousands of fine tentacles, grew again in the land of olive trees and cypresses around Provence and Auvers-sur-Oise.

The peculiar ash-gray tints of his work during this time, deriving from his memory of the North, dominated the forms in which he perceived the world around him, but did not result in his most successful pictures. The struggle was carried on against ever-changing odds.

When negative influences had the upper hand he even, in diametrical opposition to his former exalta-

Continued on page 164

Portrait of the Artist. Saint-Rémy, 1890. Louvre, Paris

The last self-portrait from Saint-Rémy does not show Van Gogh against a background, but caught up in a symbolic whirlpool. In the fall of the folds of his clothes the rush to a spiral movement is likewise evident. The difference of opinion concerning its date—the time at Saint-Rémy or at Auvers—is settled by Florisoone in favor of Saint-Rémy, while Jean Leymarie says it was done on the way to Auvers, when Van Gogh spent four days in Paris. He was very busy there and saw many people, and it seems scarcely conceivable that he had the opportunity to create this impressive self-portrait. Stylistically it belongs entirely to the spiral period. The spiral is a primeval symbol of movement, which does not belong to sun-worshiping but to the sphere of the moon. It is the eternal cycle, which reveals itself in the fertility of woman, in agrarian life, and in the four seasons. The image of the stars at night and of the harvests, which made him think of death, had gained a hold on his creativity. In Auvers the spiral line changed, broke down, and even disappeared; the order of the whirlpool disintegrated.

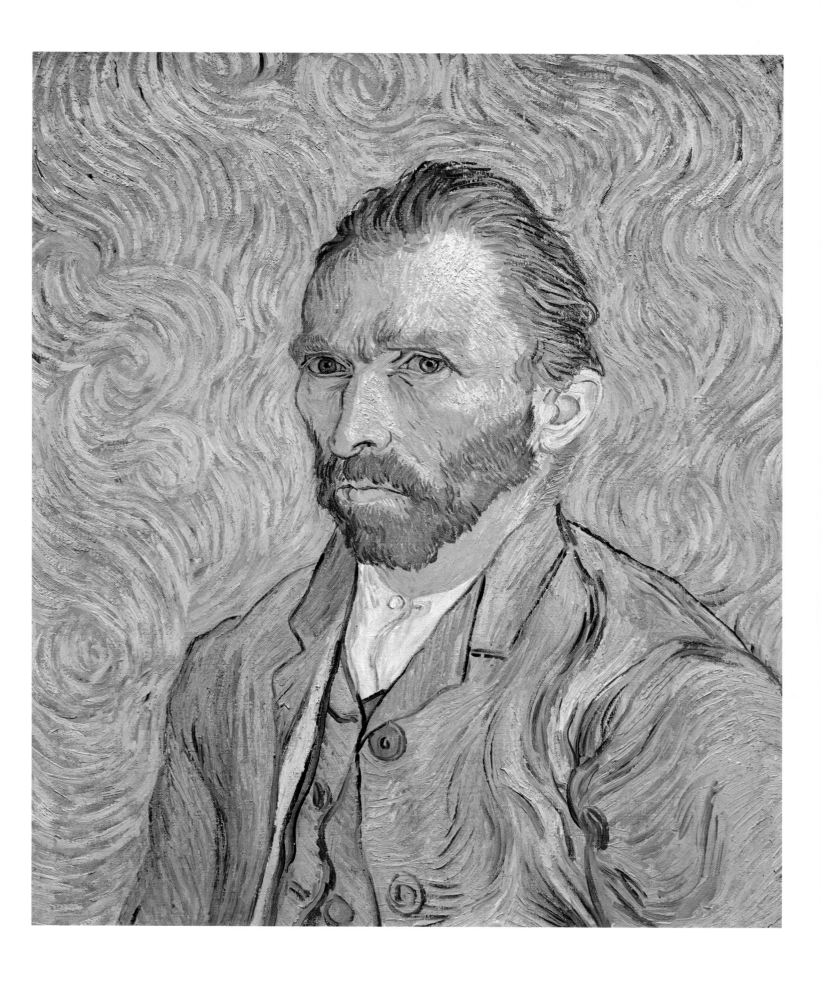

tion, went so far as to renounce the Midi. Were he to start anew, armed with his present experience, he would not look to the Midi (letter 602). This is a fatal sign of his doubting the inner necessity of things, a mistrust, too, of the new reality which he had believed awaited him in the North, now that everything he loved was gone. Once he had inwardly accepted the idea of return, he looked for motives which would dispel his sense of defeat. Whenever the positive power of direct experience revived, he produced landscapes of controlled energy unprecedented at that time.

Some almost unbearably tragic canvases, in reddish-brown, somber green, and searing red, contain crippled and stricken pine trees: the whole of Van Gogh's being, torn and lightning-scorched, lies exposed like a terrible wound. His views of the olive grove were slightly less direct but no less telling. It is precisely when he used olive trees as a medium that he was most successful in connecting his perceptions of landscape, already very complex, with the indescribably searing silvers and grays, which have an effect that is not softening, but rather penetrating and rousing when reinforced by the dynamism of the lines. This manner of drawing, with oil as well as with graphic media such as crayon, developed from a circular toward a spiral movement, to which Vincent subordinated every observation.

Clearly an inner power had entered his hand during that first summer he settled at Arles—a power as forcible as that which opened his senses to the external world. Those who realize that this change did not happen accidentally will be able to identify some of the tensions necessary for Vincent to convert,

Continued on page 169

164

Portrait of Dr. Gachet. Auvers, 1890. Louvre, Paris

Portrait of Dr. Gachet. Auvers, 1890. Collection Kramarsky, New York

The identification with Dr. Gachet at Auvers of which Van Gogh speaks was of a psychic nature. Gachet asked Van Gogh to paint him in the style of the self-portrait that the latter had made just before departing for Auvers. Vincent wrote in an unfinished letter to Gauguin: "Now I have a portrait of Dr. Gachet with the broken-hearted features of our times." The nineteenth-century portrait underwent here a total renewal. From the point of view of space, the portrait diverges entirely from the customary conception of perspective, as it does from other Van Gogh portraits. The body forms a diagonal which, moreover, in respect to the rising table surface and the line of the hill, comes across to the front. The foxgloves in the glass strengthen that tendency and the spatial weakness. The same spatial expression can be seen in other canvases from Auvers (for example, *Still Life with Flowers* and *Dr. Gachet's Garden*). It is important to compare this portrait with its replica in the Louvre (disputed by some on inadequate grounds). Van Gogh made many replicas, which varied greatly in quality (see, for example, the variants of *La Berceuse* and others). In the second portrait there is a variation in the expression—the eyes are looking in another direction—a simplification of detail—no books, no glass, only the foxgloves—but an equal spatial weakness. The remarkable coloring of both portraits withdraws the portrait from any definite lighting. The blue of the night effects dominates with a symbolic expressiveness.

166

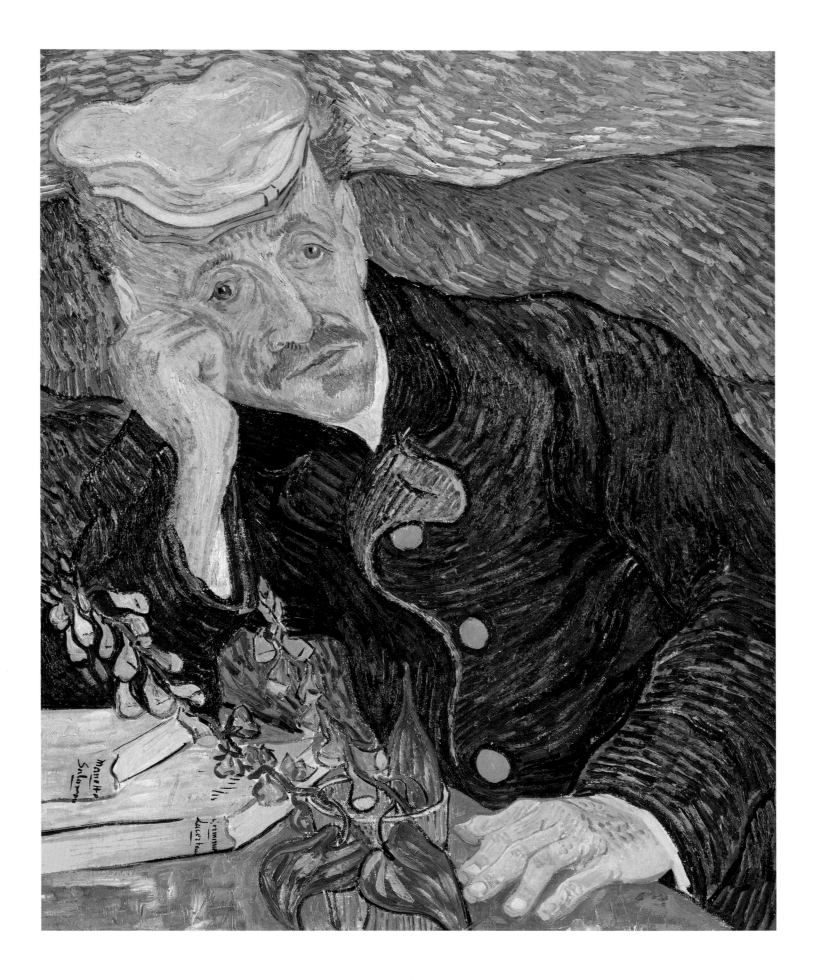

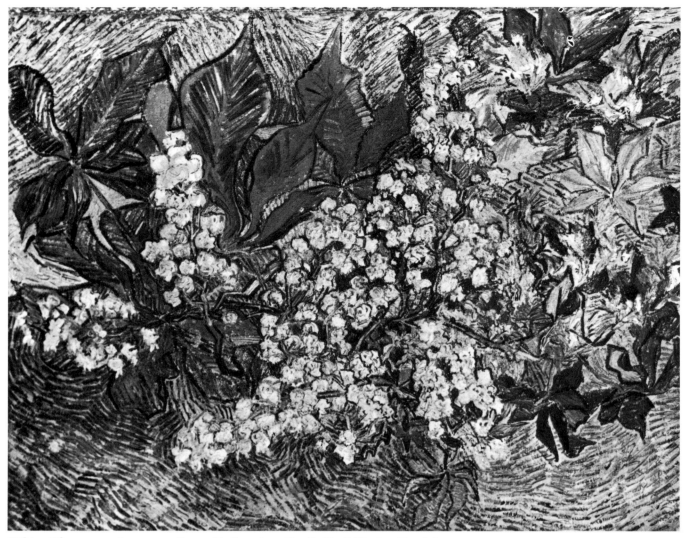

White Chestnuts. Auvers, 1890. Collection Emil G. Bührle, Zurich

given his own brand of directness, an observed natural scene into this open spiral movement, restless but perfectly ordered.

He then went on from the olive trees to the more difficult cypresses. Moreover, he managed to handle the color problems of this ecstatically rotating world. It is tempting to describe these paintings in high-flown language as cosmic raptures, signs of an obsessed hand which was forced into one rhythm by two worlds; but let us restrict ourselves to considering the actual themes.

Between the last self-portrait he made in Paris and the final self-portrait, made before he left Saint-Rémy in 1890, scarcely two years had elapsed. The movement of the Parisian portrait is judicious, more controlled in color than in line. The space is bare, limited, tangible. The movement in the late portrait from Saint-Rémy is both more flowing and less limited. He described the blue as the fine blue of the Midi, and the clothes as a light lilac. Space is no longer limited, there is no wall as background; he stands instead in a substance of rotating light. He is an exalted person, as subject to one dominant rhythm as the cypresses and the olive trees, which are at one with the ground they grow on and the space that surrounds them. It was as though Van Gogh, particularly in drawing, had found in one central theme a basis for his vision which would, in its various forms, convert a static world view into a dynamic one.

En route from the institution at Saint-Rémy to Auvers-sur-Oise, in May, 1890, Van Gogh passed through Paris, where he spent some days with Theo, Theo's wife, and their young child. He visited the

Continued on page 173

Peasant Girl. Auvers, 1890. Collection Dr. H. R. Hahnloser, Bern, Switzerland

Perhaps this portrait of a peasant girl and the ones he did of Mlle. Gachet at the piano and of Dr. Gachet are the best of Vincent's work at the end of his short life. He was much occupied with color problems. Orange or red spots are used in this portrait and that of Mlle. Gachet. As for the background of wheat and flowers, he wrote that he would like to paint portraits against such lively yet tranquil settings, "... a whole of green tones, which by its vibration will make you think of the gentle rustle of ears swaying in the breeze: it is not at all easy as a color scheme" (letter 643). Analyzing the dots, circles, stripes, and some curving lines (the straw hat), we admire the richness of the pure pictorial qualities.

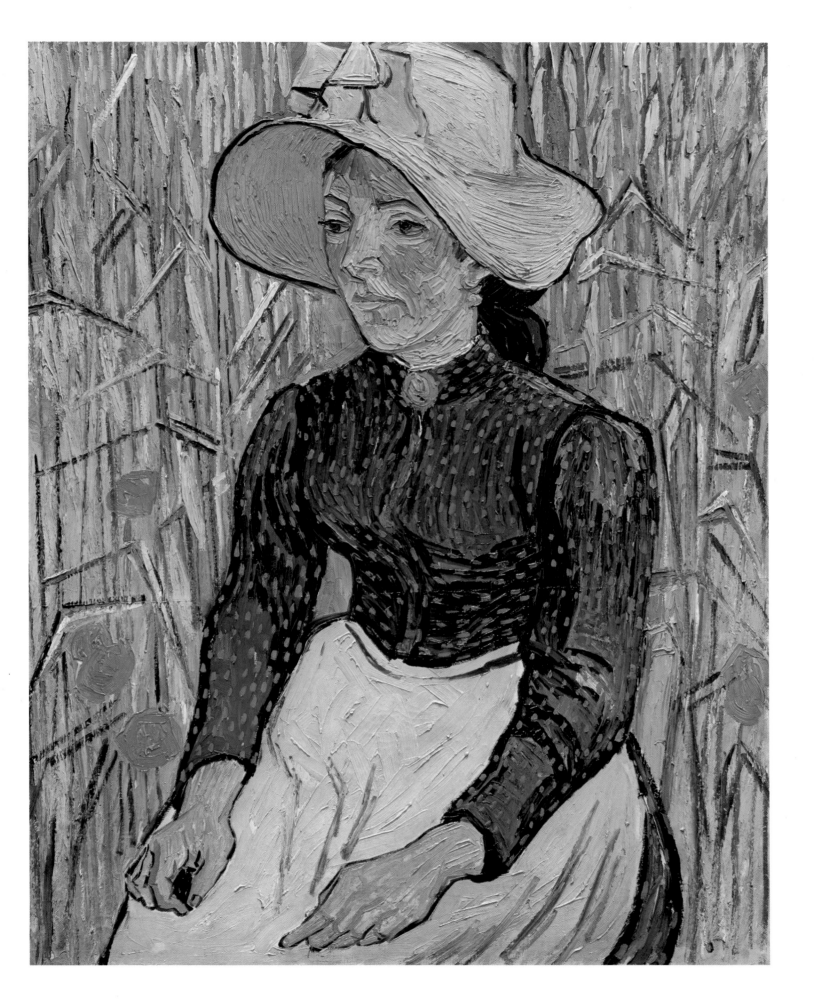

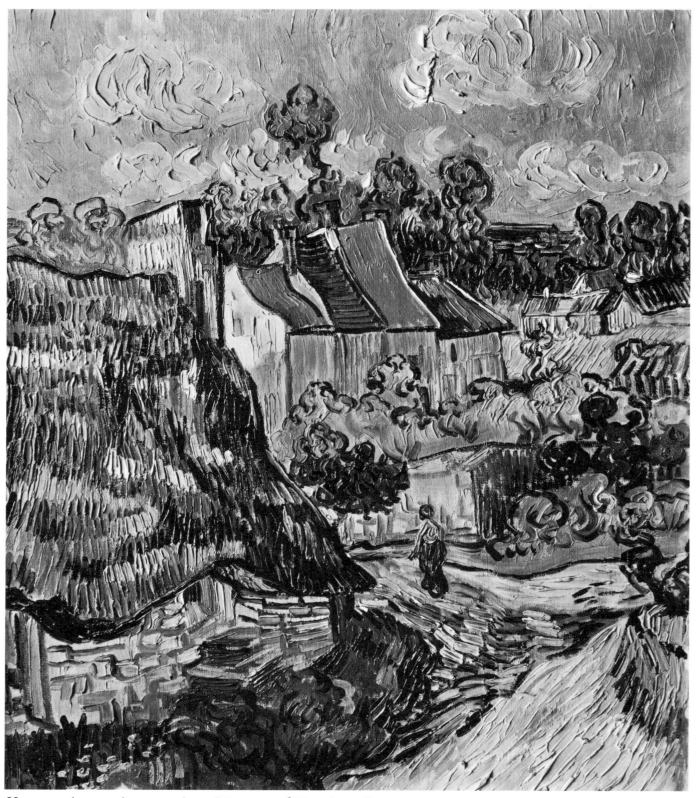

Houses at Auvers. Auvers, 1890. Museum of Fine Arts, Boston

Spring Salon on the Champ-de-Mars and was extremely impressed with a large canvas by Puvis de Chavannes entitled *Between Art and Nature*, a painting (intended for Rouen) showing men (artists) and women in an Arcadian landscape. Vincent thus reveals once again what one could detect at the beginning of his artistic career: that though he took little notice of social conventions and academic art, he nevertheless was part of a great living tradition.

In the two remaining months at Auvers, his creative tempo increased still more. His work was more uneven than in Saint-Rémy. The line is sometimes weaker and more flowing, the color paler and softer, like a prelude to Art Nouveau and the decorative symbolism then developing in the circles of Bernard, Sérusier, and others. The spatial connections in these paintings are sometimes extremely unstable—as if the rotation of the rushing forms was subordinated with difficulty to a space still dependent on principles of perspective. Thus the long white figure of a girl, the daughter of Dr. Gachet, floats like a ghost through an overgrown garden. He sometimes disturbs the order, even in already fierce, moving paintings, by violent angular accents. Space as such gives way to an almost demonic expressiveness, which lends some of the landscapes, and the portrait of Dr. Gachet, a visionary power.

He found much understanding in Dr. Gachet's milieu. After the death of his wife, Gachet, who had practiced in Paris, lived with a son and daughter in a house crammed with objects that were curious, if not always beautiful. There were also paintings, for Gachet knew many painters who worked in the

Continued on page 180

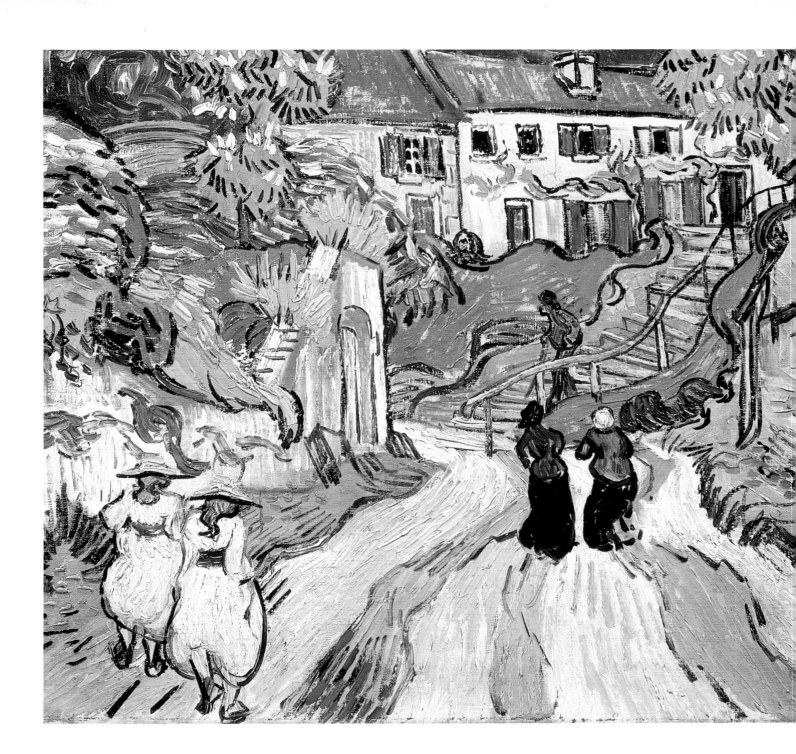

Stairway at Auvers. Auvers, 1890. City Art Museum, St. Louis

The effectiveness of this lively landscape is due mainly to the light, subtle coloring and to the flowing, wavy line. This line is no longer held in check by the symbolic spiral movement, and reflects Vincent's increasing admiration for Puvis de Chavannes. As contour, it occasionally takes on a decorative character essentially foreign to his nature. The work is full of contrasts; the edges of the road are rich in conflicting lines which scarcely follow the forms. However, the houses with their dominant horizontals bind together the whole and conjure up the disquiet which manifests itself most clearly in the cramped figures.

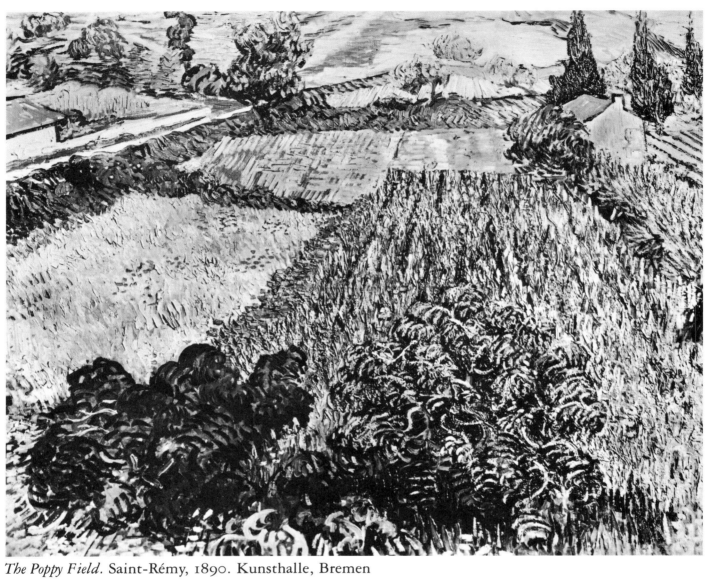

The Poppy Field. Saint-Rémy, 1890. Kunsthalle, Bremen

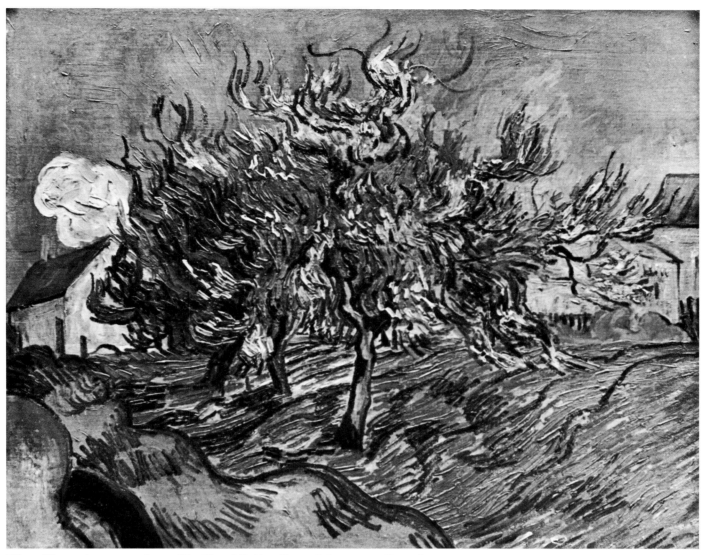

Three Trees. Auvers, 1890. Kröller-Müller State Museum, Otterlo

The Church at Auvers. Auvers, 1890. Louvre, Paris

The period at Auvers was short and violent, and Vincent's work extremely varied in quality. During that turbulent time the little Byzantine-Gothic church at Auvers had the value of a symbol, in which memories of the church of his youth and of his father were linked with the reality before him. He even thought of what he had painted at Nuenen, and saw a difference only in the color. For us, however, the difference is infinitely greater. The church stands out in bright color against an almost night-blue sky. The form is dynamic in structure, like an organism that has sprung from the soil. It has grown beyond Impressionism into a vision, related in its violence to the *View of Toledo* by El Greco.

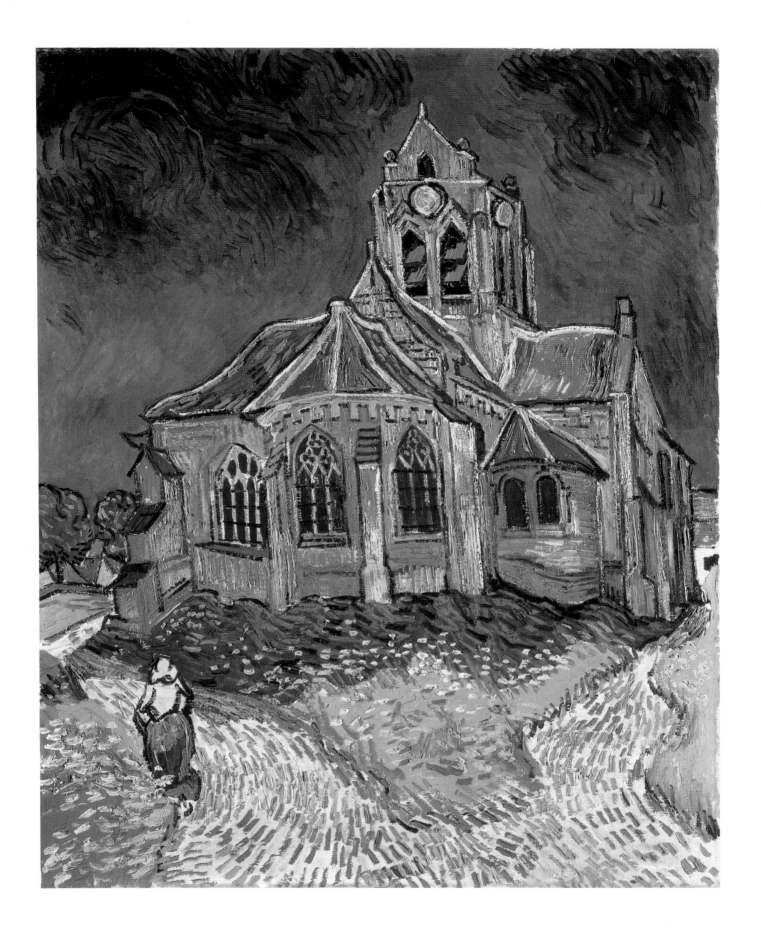

district, and he himself painted and etched. Vincent recognized himself in this man who was to look after him in consultation with Theo. He saw Gachet as nervous and bizarre, and yet as a new brother. Gachet requested that Vincent paint a portrait of him, in the style of the last self-portrait from Saint-Rémy. Two versions are known: one in the Kramarsky Collection, New York, and the other in Paul Gachet's collection, which was presented to the Louvre.

The diagonal lines of the figure behind the rising red table-top, against the deep cobalt-blue ridge in the background, give instability to the space. The old frontal vision is broken. Van Gogh approaches here the Manneristic perspective of Tintoretto. This can also be seen in the landscapes executed at Auvers. The one in the Bremen Museum, for example, has all the best qualities of those painted in Saint-Rémy. The structure, as much as the detail, possesses amazing firmness; the color is rich and ripe. The landscape from a Viennese collection also has the earlier qualities, though the colors are somewhat milder and the line more flowing. The field with crows in an oblong format (*à la* Puvis) deviates from these and, from a spatial standpoint, has broken with the perspective formula. The signature is extremely irregular, and the sensuous power of the forms is no match for an inner, almost savage, unrest. The rotating whorls dissolve into short stripes, occasionally changing direction and seemingly governed by some uncontrolled rhythm.

Writing to his sister in June, 1890, Vincent summed up all that had moved him in Auvers. The

letter concerns a canvas representing the old church there, at the fork of a road, that reminded him of his painting of the venerable towers and churchyard of Nuenen. They are almost the same, he said, although the color in this later work is probably more expressive, richer and fuller. In 1885, the Nuenen painting had symbolized a meditation on life and death. At Auvers, he could not do otherwise than draw together the threads of the past and present. He deforms the little church, modeling with a plastic power, and thus lifts it above reality, creating an apparition rising from the ground against a deep cobalt blue, possibly a night sky. The landscape and church stand in a flood of light like El Greco's Toledo rising from the hills, a frightening vision in the threatening sulfurous light.

In this work, Van Gogh's innermost feelings were fully expressed by the modeling in color and light. Re-creation of the past, which he certainly experienced sitting near the Auvers church, drew him equally toward a direct view of reality, accelerated by the alternate light and dark color, and by the perspective. Thus, indeed, the end is to be found in the beginning.

Auvers was to have been a resting place on his return to the North: an interruption in the polarity of the Midi and his Northern origins, the opposing poles of sun and warmth versus darkness and turmoil, which forged his fierce spirit. Instead, it proved to be the journey's end.

His death came at half past one in the morning of July 29, 1890, in the bare attic of the Café Ravoux. He had shot himself in the chest two days before, behind a dung heap in a farmyard near Auvers—not,

Continued on page 185

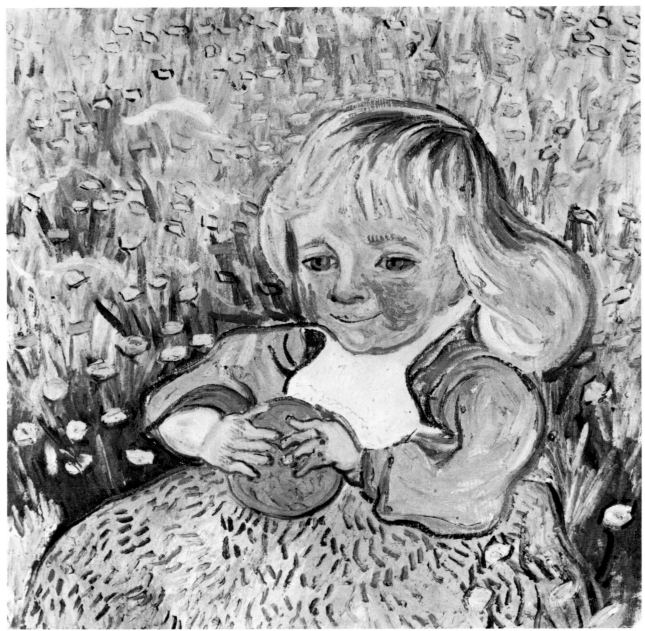

Child with Orange. Auvers, 1890. Collection Mrs. L. Jaggli-Hahnloser, Winterthur, Switzerland

Mademoiselle Ravoux. Auvers, 1890. Private collection, Switzerland

Van Gogh had painted, at least three times and by preference in profile, the young daughter of the proprietor of the café where he first lived in Auvers. In Arles, thinking of Giotto and Cimabue, he had admired various types of girls. He looked upon the modern portrait as an expression of the age, and in Puvis de Chavannes he found support for the admixture of old and new and for graceful appearance. He discovered magnificent colors in the women's costumes. His impressions were very complex: the significance of the blue has a timeless intensive value which can no longer be attributed to either the day or the night. On the other hand, the skin tints and the hair have become lighter. The powerful horizontal strokes of the surroundings make the space undefined but accentuate the vertical aspect of the sitting posture of the girl in blue.

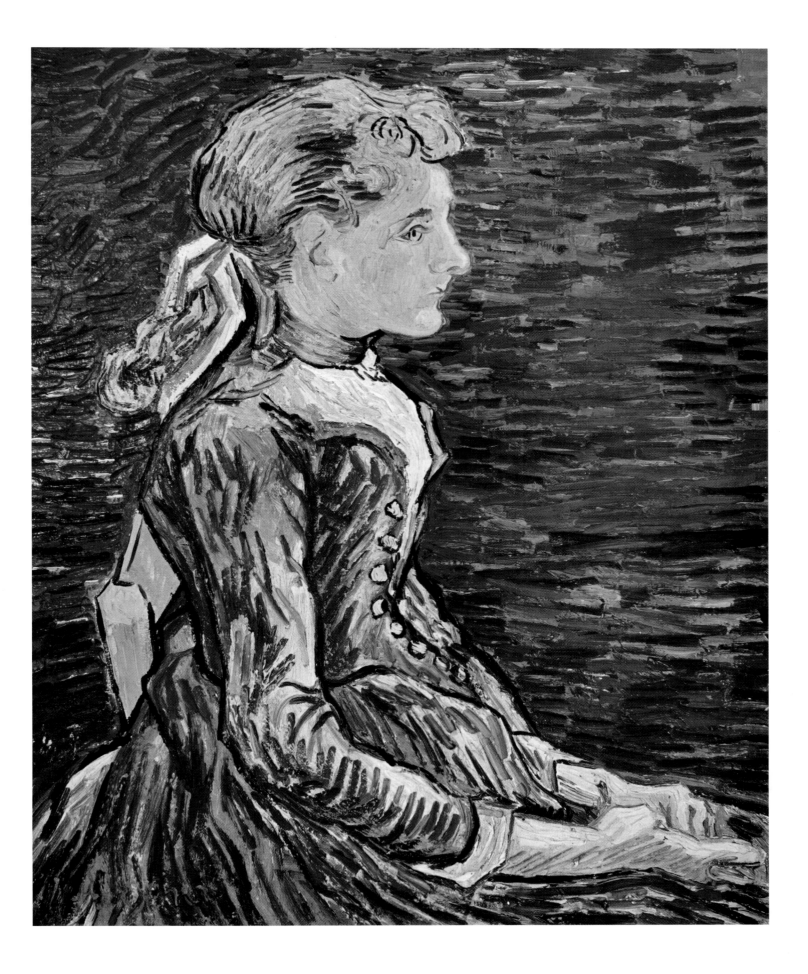

Vincent

Theo van Gogh

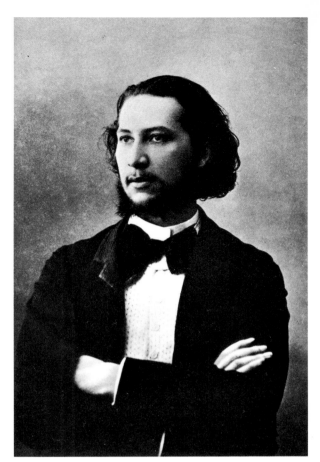

Albert Aurier

as it was said, in the fields. Gachet, who was away at the time, was informed and, against Vincent's wish, sent a note to Theo. Leaving immediately for Auvers on July 28, Theo came to sit beside his brother, sometimes alone, sometimes with Gachet and Gachet's son Paul. At last, Vincent had reached the state of serenity he had so longed for.

Informed of his death by Émile Bernard, Aurier wrote to Theo: "Such men as he never completely die. He leaves behind him an *oeuvre* which is part of himself and which, we are sure, you and I, will one day make his name live again and for eternity." From Arles, Vincent had once written: "What lives in art and is eternally living is first of all the painter and then the painting."

Crows Over the Wheat Field. Auvers, 1890. Rijksmuseum Vincent van Gogh, Amsterdam

The horizontally protracted format of a landscape series from Auvers typifies what inspired Van Gogh in relation to the admired Puvis de Chavannes. In Paris this format (often standing) was due to Japanese influence, but in Auvers it shows that Puvis had become the ideal of serenity for which he was looking. The intangibility of that kind of picture, the nostalgia for the North and his earlier life, had a decentralizing effect. As Meyer Schapiro and, later, Novotny have pointed out, he was fighting the old basis of perspective. He attempted to combine the expression of movement with expression of perspective—which only led to conflict. In *Crows over the Wheat Field* the earlier wavy, flowing lines and spirals have disappeared. The short, angular, broken lines, applied in a feverish rhythm, are connected solely by color. The emotion is supreme and on the point of deserting the world of things.

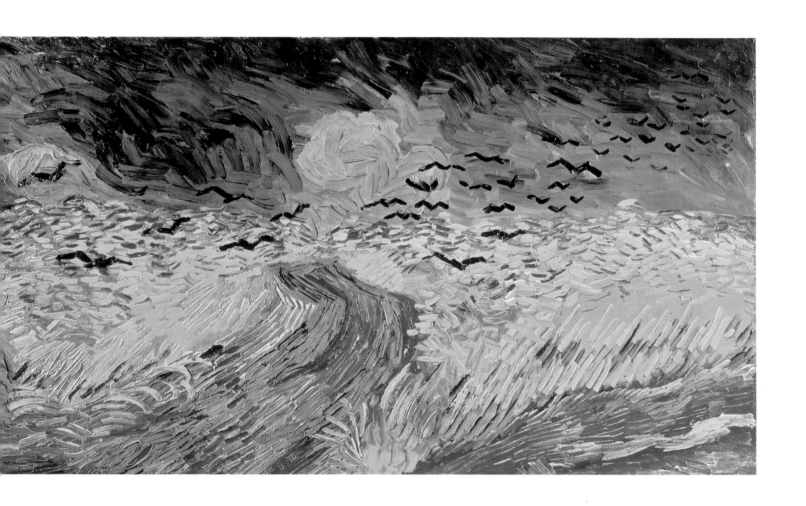

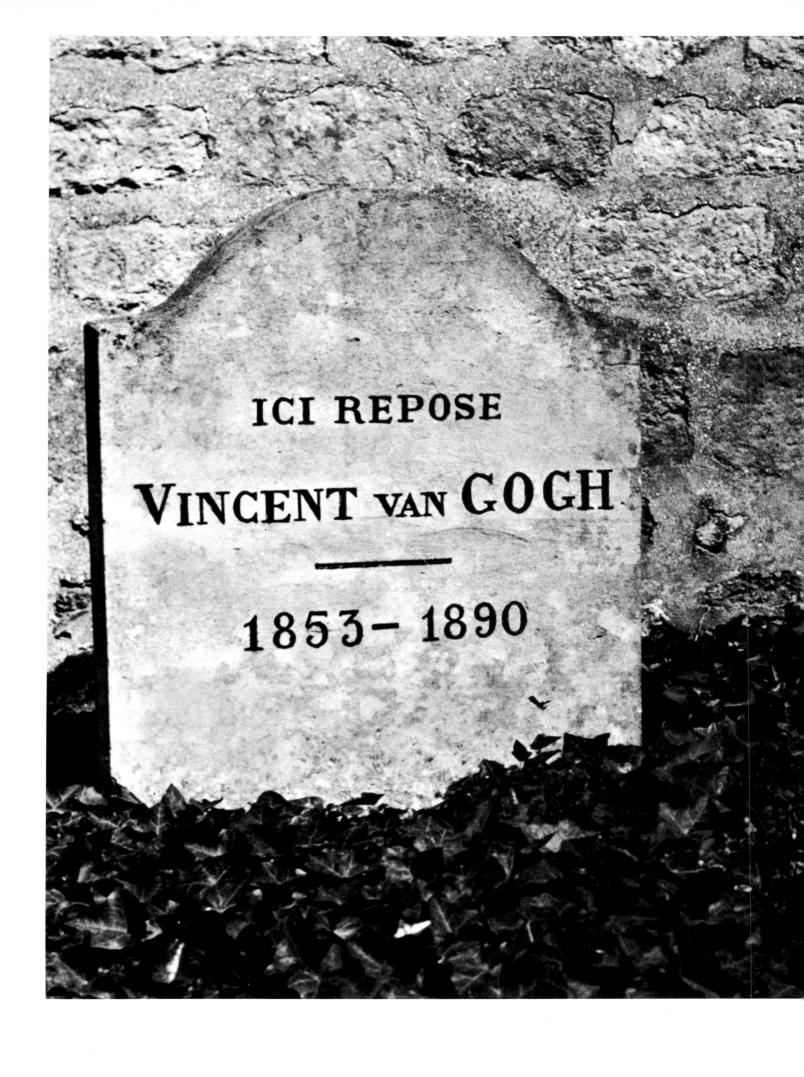

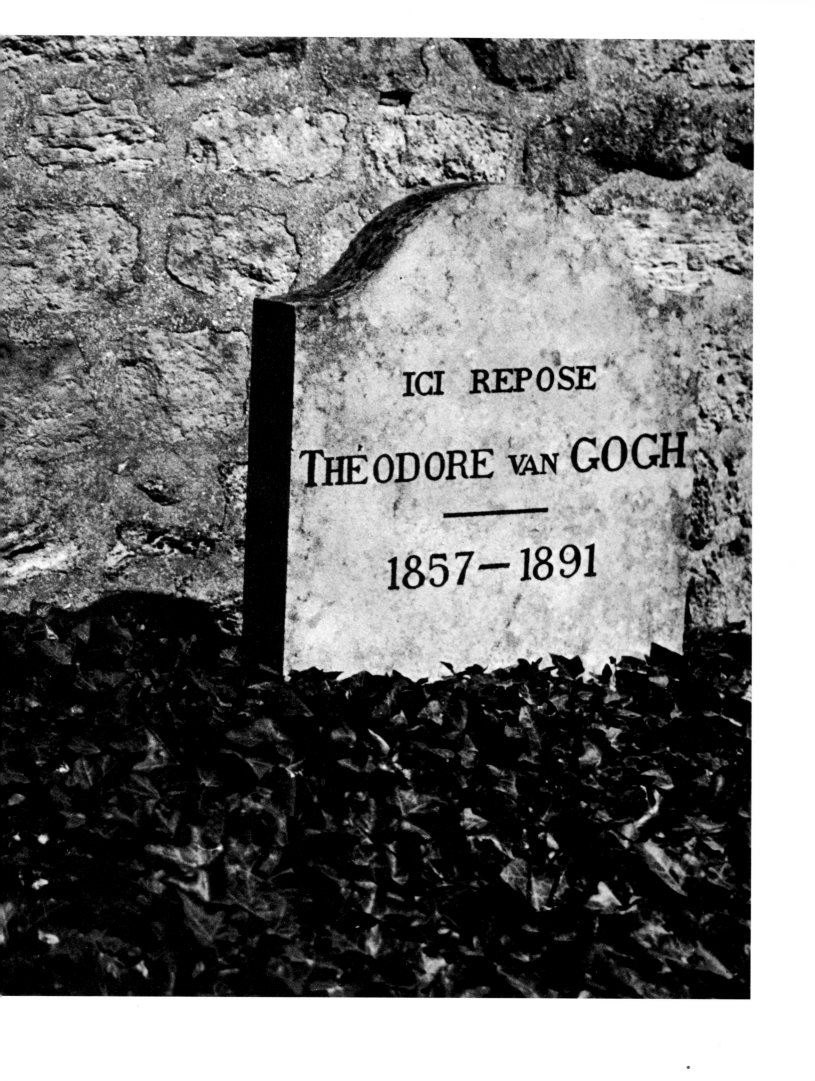

Chronological Summary

16th century. Early records establish the name Van Gogh in the Netherlands. Family coat of arms: a bar sinister with three roses.

17th century. Forefather Vincent van Gogh, 1674–1746.

18th century. A sculptor Vincent van Gogh, 1720–1802.

19th century. Grandfather Vincent van Gogh, 1789–1874, was a clergyman. Of his eleven children, three became art dealers. Theodorus, also a minister and the painter's father, married Anna Cornelia Carbentus. A stillborn son, Vincent, was born to them on March 30, 1852.

March 30, 1853. Exactly a year later, Vincent Willem was born at Groot Zundert, in the province of North Brabant near the Belgian frontier.

May 1, 1857. Theo's birth at Groot Zundert. Vincent attends a boarding school at Zevenbergen from 1864 to 1868. His first artistic impressions are formed at the house of his Uncle Vincent, an art dealer at Princenhage.

1863. Childhood drawings by Vincent.

1869. Employment at the Goupil fine-art gallery in The Hague.

1873. Theo is trained at Brussels for the fine-art trade and Vincent transferred to London. Many drawings from his neighborhood and along the Thames Embankment. Unrequited love for Ursula Loyer, daughter of his landlady. First symptoms of inner disturbance.

1874. Vincent goes to Goupil's Paris headquarters in October. In December returns to London, where he leads a solitary existence.

1875. Transferred back to Paris. Dismissed on April 1 because of difficulties with management and clients. Following his strong religious bent, he immerses himself in the Bible.

1876. Assistant at Mr. Stokes's boarding school, first in Ramsgate and then in Isleworth. Subsequently he becomes assistant schoolmaster and curate at the Jones Methodist School. His periods of depression and religious aspiration continue.

1877. Vincent works at Blussé and Van Braam's bookshop in Dordrecht. Then moves to Amsterdam to prepare for university examinations and the Ministry, after his father's example. Studies Greek and Latin; reads a great deal, including Michelet and Dickens; copies out Thomas à Kempis' *Imitation of Christ*. He aims to humble himself and strengthen his religious convictions by acts of self-mortification. This same resolve, however, makes him impatient with the academic requirements of theology, which he subsequently abandons.

1878—79. After a three-month course in Brussels, he obtains evangelical work at Pâturages in the Borinage (a mining district of Belgium) and then a temporary appointment at Petites Wasmes. His desire to put his Christian ideals into practice—to sacrifice everything, including the dignity of his position, for his suffering fellow men—causes him to be relieved of his duties and results in further religious crises.

1880—81. He becomes conscious of his vocation as an artist when confronted by extremes of human misery. Continues sketching, copying Millet. A foot journey from Cuesmes to Courrières (Pas-de-Calais) to meet the painter Jules Breton. Hardship and disappointments. In the autumn he leaves for Brussels, where he continues to work until April, 1881 (anatomy, perspective). Contact with the painter Van Rappard, with whom he will later carry on an important correspondence. April through November, 1881, he sketches workers, peasant women, and the landscape at Etten, where his parents reside. The infatuation for his niece K. Vos (widowed with a small son) increases family tension, and he despairs of ever attaining married life. Worsening relations with his parents compel him to leave home.

December, 1881—December, 1883. In The Hague he develops his drawing and painting, at first under the guidance of Anton Mauve, a landscape painter of The Hague School. Admiration for English illustrators, whose work he collects. The emotive and expressive qualities of color gain impor-

tance. He draws with a perspective frame of his own design and seeks his models among the common people. Lives with Christine Hoornik and her child; his dreams of domestic life are further shattered by her behavior. Vincent leaves in the autumn of 1883 for the poverty-stricken province of Drenthe, but after two months there returns in December to his parents at Nuenen in Brabant.

December, 1883—November, 1885. Continuing difficulties with his family. His father dies March 26, 1885. Vincent paints the laboring peasants. Influenced by Michelet and Zola (especially *Germinal*), he sees society in a state of bourgeois decay and considers its vital force to reside with the laboring class. After one of Delacroix's theories, line and color and form are determined, if necessary at the expense of anatomical accuracy, by the character he wishes to express. *The Potato Eaters* and three landscapes are expressive masterpieces of his Dutch period.

November, 1885—February, 1886. Antwerp. Fascinated by Rubens, nineteenth-century Belgian painters, and Japanese prints. Inspired by the scene around the docks, the sailors and prostitutes. His lessons at the Academy lead to conflict with the instructors.

March, 1886—February, 1888. Paris. Lives with Theo on Rue Laval and later on Rue Lepic. Through his brother, Vincent meets many painters, especially the Post-Impressionists. Working at the studio of Cormon, he at first retains his Dutch palette, which had become brighter at the end of his Nuenen stay. Then Impressionism and Neo-Impressionism alter his drawing, touch, and color. Japanese art, first encountered in Antwerp, becomes a more visible influence. He practices, but unsystematically, the divisionism of Seurat and Signac.

February, 1888—May, 1889. Arles. Vincent leaves Paris abruptly, fleeing the discord he causes in his brother's life. In Arles, stimulated by a new landscape and glowing climate, wants to form an artists' co-operative; project begins with "The Yellow House," Rue Lamartine, which he shares with Gauguin. Provence is the symbolic fulfillment of his desires, his Japanese vision. Friendships develop with the Roulin family, Lieutenant Milliet, the Belgian painter Boch, and Mme. Ginoux. At first he continues with his latest Paris style, but modifications appear in the spring, and after his trip through the Camargue. Gauguin's arrival in October has an explosive effect. On December 23, Vincent's derangement becomes manifest. After a clash with Gauguin, he mutilates his ear. Gauguin summons Theo to Arles. Vincent is taken to a hospital, and Gauguin returns to Paris with Theo. Vincent remains unstable, and the neighbors are wary of his presence. On the advice of Dr. Salles, he asks to be admitted to the mental hospital at Saint-Rémy (May 9, 1889). On April 17, 1889, Theo marries Jo Bonger. Theo's new family is a factor in Vincent's developing mental disorder.

May, 1889—May, 1890. Saint-Rémy. In his painting, movement and symbolic meaning play an increasing role. A series of pictures derived from personal memories causes change in his palette. Giotto and Puvis de Chavannes are much admired. He works out of doors and in the cloisters. Painting from reproductions of Doré, Delacroix, Millet, Daumier, etc., sometimes a substitute for outdoor work.

May 21—July 29, 1890. Auvers-sur-Oise. Vincent travels to Auvers, stopping at Paris for a visit with Theo's new family. He has a growing homesickness for the North. At Theo's again in July, he sees Lautrec and Aurier. In the Café Ravoux at Auvers, he lives under the partial supervision of Dr. Gachet, a physician, amateur painter, and friend of painters. Vincent works impetuously and unevenly, doing his best work in landscape and portraiture. Les Vingtistes at Brussels exhibit five of his canvases, of which one is sold. On July 27, 1890, he shoots himself in the chest and dies two days later, aged thirty-seven. Theo dies on January 25, 1891, in the Netherlands, broken in body and spirit, and is buried next to Vincent by the churchyard wall in Auvers.

Author's Note

The publisher's desire to reissue this work of mine as it originally appeared in 1968 caused me some initial qualms. Having kept up with the flood of publications about Van Gogh over the years, I could not ignore the fact that my own views, not only about Van Gogh but also about the final quarter of the last century in general, were changing—or at least alive—enough to make me consider rewriting. Yet the dangers of such a course soon became apparent.

When the volume was first commissioned by the founder of the publishing house, Harry Abrams, he wanted neither a popular, nor a romanticizing, nor an art-historical analysis of Van Gogh and his work. What he was looking for was a lively account based on sound knowledge of the facts. It could be a subjective interpretation, and scholarly details should be confined to the commentaries to the illustrations. He said he would like the whole article to be written "in one breath," as it were.

It so happened that I was able to meet this far from simple requirement during a sea crossing from New York to Rotterdam. Without books and in the absence of any temptation to interrupt the writer's *élan* by checking references and adding footnotes, I experienced an undisturbed concentration that was never to be recaptured. Checking came afterward.

Any endeavor to rewrite now would result in changing the emphasis, though not the views expressed, about the structure of the artist's personality. The rhythm of the original piece, in fact the true essay form, informal and succinct, might well disappear. In the end, nothing but a wholly unchanged reprint seemed honest or justified.

The literature published in recent years, with a number of contributions by younger scholars, fortunately includes many studies of details, corrections of facts, research relating to the various environments in which Vincent lived. Occasionally, such studies are only remotely con-

nected with Van Gogh. Essential questions remain unanswered or open to further research. All too often interest comes from the wrong quarter—above all in Vincent's psychological syndrome, the episode of the mutilated ear, the suicide, and Theo's role.

The various periods of Van Gogh's artistic creativity have provided art historians with fewer problems than usual, or with problems of a nature different from those normally found in artists' lives. His own and Theo's letters, as well as a few written by his parents, other members of his family, and later on by several artists who were in close touch with him at various times, have proved to be of rare value. The important period preceding his life as an artist is documented in *Documentary Biography* by A.M. and Renilde Hammacher (London, 1982). It is only for his Paris period that documentary evidence is scarce. In this respect, Bogomila Welsh-Ovcharov's *Vincent van Gogh: His Paris Period, 1886-1888* (Utrecht, 1976) has, at least in part, increased our understanding of those years. In my opinion, Vincent's short and violent period at Auvers still invites reconsideration; we need a more profound understanding of those confusing rapids leading to his abrupt and self-determined end.

In his paintings, drawings, and letters, Van Gogh left behind sources of psychic and aesthetic energy with the potential, even in this final quarter of the century, still to be activated in and by us.

Anyone wishing to read further will find a detailed bibliography in the new edition of J.-B. de la Faille's *catalogue raisonné, The Works of Vincent van Gogh: His Paintings and Drawings* (New York, 1970). This bibliography has been revised and supplemented with recent data in Jan Hulsker's *The Complete Van Gogh: Paintings, Drawings, Sketches* (New York, 1980).

A.M.H.

List of Illustrations

In the following list, colorplates are indicated by an asterisk preceding the title. "F" refers to J. B. de la Faille, *L'Oeuvre de Vincent van Gogh,* Van Oest, Paris and Brussels, 1928 (catalogue of paintings and graphic works). "H" refers to J. B. de la Faille, *Vincent van Gogh,* Hyperion, Paris, London, and New York, 1939 (revised catalogue of paintings). "JH" refers to Jan Hulsker, *The Complete Van Gogh: Paintings, Drawings, Sketches,* Abrams, New York, 1980.

Self-Portrait. Paris, c. 1887. Oil on canvas, 16½ × 13¼". F 345, H 406, JH 1249. The Art Institute of Chicago. The Joseph Winterbotham Collection — *Frontispiece*

LETTER NO. 222 (detail). The Hague, August, 1882 — 8

The State Lottery. The Hague, October, 1882. Crayon, 15 × 22½". F 970, JH 222. Rijksmuseum Vincent van Gogh, Amsterdam — 14 top

Study of a Tree. The Hague, April, 1882. Crayon, pencil, watercolor, lightly washed, 19¼ × 27". F 933, JH 142. Kröller-Müller State Museum, Otterlo — 14 bottom

Peasant Woman in a White Cap. Nuenen, April, 1885. Oil on canvas, 17¼ × 14¼". F 85, H 100, JH 693. Kröller-Müller State Museum, Otterlo — 15

**Portrait of a Woman.* Antwerp, December, 1885. Oil on canvas, 23½ × 19¾". F 207, H 223, JH 979. Collection Alfred Wyler, New York — 17

Studies of Hands. Nuenen, 1885. Crayon, 7¾ × 13". F 1155, JH 744. Rijksmuseum Vincent van Gogh, Amsterdam — 18 top

The Ox Cart. Nuenen, July, 1884. Oil on canvas on panel, 22 × 32". F 38, H 44, JH 504. Kröller-Müller State Museum, Otterlo — 18 bottom

Peasant Woman. Nuenen, 1885. Crayon, 15¾ × 13". F 1182, JH 590. Rijksmuseum Vincent van Gogh, Amsterdam — 19

**The Loom.* Nuenen, June, 1884. Oil on panel, 16¼ × 22½". F 32, H 36, JH 480. Kröller-Müller State Museum, Otterlo — 20–21

Peasants Digging. Nuenen, 1885. Crayon with watercolor, 7¾ × 13". F 1299, JH 874. Kröller-Müller State Museum, Otterlo — 22–23

**The Potato Eaters.* Nuenen, April–May, 1885. Oil on canvas, 32¼ × 45". F 82, H pl. I., JH 764. Rijksmuseum Vincent van Gogh, Amsterdam — 24–25

Peasant Woman Digging. Nuenen, 1885. Crayon, 19½ × 15¾". F 1251, JH 841. Rijksmuseum Vincent van Gogh, Amsterdam — 26

Study of an Auction Near Nuenen. Nuenen, May, 1885. Crayon, 13¾ × 8¼". F 1112, JH 768. Kröller-Müller State Museum — 27

**Autumn Landscape with Four Trees.* Nuenen, November, 1885. Oil on canvas, 25¼ × 35". F 44, H 49, JH 962. Kröller-Müller State Museum, Otterlo — 28

**Montmartre.* Paris, 1886. Oil on canvas, 17¼ × 13". F 272, H 370, JH 1183. The Art Institute of Chicago. Helen Birch Bartlett Memorial Collection — 29

Montmartre, Le Moulin de la Galette. Paris, 1886. Oil on canvas, 15¼ × 18″. F 227, H 267, JH 1170. Kröller-Müller State Museum, Otterlo 30–31

*La Segatori in the Café du Tambourin. Paris, 1887. Oil on canvas, 21¾ × 18¼″. F 370, H 299, JH 1208. Rijksmuseum Vincent van Gogh, Amsterdam 32

Interior of a Restaurant. Paris, 1887. Oil on canvas, 18 × 22¼″. F 342, H 369, JH 1256. Kröller-Müller State Museum, Otterlo 33

Reclining Nude. Paris, 1887. Oil on canvas, 9½ × 16¼″. F 329, H 111, JH 1215. Collection Mrs. S. van Deventer, Oberägeri, Switzerland 34

*Female Torso. Paris, 1887. Oil on canvas, 28¾ × 21¼″. F 216, H 241, JH 1348. Private collection, Tokyo 35

Japonaiserie—The Actor (after Kesai Yeisen). Paris, beginning 1888. Oil on canvas, 41¼ × 24″. F 373, H 234, JH 1298. Rijksmuseum Vincent van Gogh, Amsterdam 37

*A Wheat Field. Paris, c. 1887. Oil on canvas, 21¼ × 25½″. F 310, H 360, JH 1274. Rijksmuseum Vincent van Gogh, Amsterdam 38–39

LETTER NO. 583B, to Signac. Arles, March, 1889 40

Shoes. Arles, August, 1888. Oil on canvas, 17¼ × 20¾″. F 461, H 488, JH 1569. Collection Kramarsky, New York 44

*Self-Portrait with Easel. Paris, 1888. Oil on canvas, 25½ × 20″. F 522, H 425, JH 1356. Rijksmuseum Vincent van Gogh, Amsterdam 47

*The Drawbridge. Arles, May, 1888. Oil on canvas, 19¾ × 25¼″. F 570, H 588, JH 1421. Wallraf-Richartz Museum, Cologne 58–59

Farmhouse in Provence. Arles, 1888. Oil on canvas, 18 × 24″. F 565, H 542, JH 1443. National Gallery of Art, Washington, D. C. 60 top

Farmhouse in Provence. Arles, 1888. Pen and India ink, 14¾ × 20½″. F 1478, JH 1444. Rijksmuseum, Amsterdam, on loan to the Stedelijk Museum, Amsterdam 60 bottom

Wheat Field with House. Arles, May, 1888. Pen and India ink, 10 × 13¾″. F 1415, JH 1408. Rijksmuseum Vincent van Gogh, Amsterdam 61 top

Wheat Field. Arles, 1888. Oil on canvas, 19¾ × 24″. F 564, H 541, JH 1475. P. and N. de Boer Foundation, Amsterdam 61 bottom

*"La Mousmé." Arles, July, 1888. Oil on canvas, 29¼ × 23½″. F 431, H 460, JH 1519. National Gallery of Art, Washington, D.C. Chester Dale Collection 63

The Postman Roulin. Arles, August, 1888. Pen, 12½ × 9½″. F 1458, JH 1536. Collection Dr. H. R. Hahnloser, Bern, Switzerland 64

*The Postman Roulin. Arles, August, 1888. Oil on canvas, 31¼ × 25″. F 432, H 461, JH 1522. Museum of Fine Arts, Boston 66

*The Zouave. Arles, August, 1888. Oil on canvas, 32 × 25½". F 424, H 450, JH 1488. Private collection, South America 67

Garden of the Hospital at Arles. Arles, May, 1889. Sepia, 18 × 23¼". F 1467, JH 1688. Rijksmuseum Vincent van Gogh, Amsterdam 68 top

Garden with Thistles. Arles, October, 1888. Pen, 9¾ × 12½". F 1466, JH 1552. Rijksmuseum Vincent van Gogh, Amsterdam 68 bottom

The Rock. Arles, July, 1888. Reed pen, 19¼ × 24". F 1447, JH 1503. Rijksmuseum Vincent van Gogh, Amsterdam 69

*Old Peasant (Patience Escalier). Arles, August, 1888. Oil on canvas, 27¾ × 22¾". F 444, H 479, JH 1563. Private collection 71

Émile Bernard. Portrait of the Painter Eugène Boch. 1891. Private collection, Tournai 72

Portrait of the Painter Eugène Boch. Arles, September, 1888. Oil on canvas, 23½ × 17½". F 462, H 490, JH 1574. Louvre, Paris 73

*Oleanders. Arles, August, 1888. Oil on canvas, 23½ × 28¾". F 593, H 594, JH 1566. The Metropolitan Museum of Art, New York 74–75

Bouquet. Arles, 1888. Oil on canvas, 25½ × 21¼". F 588, H 602, JH 1335. Collection Mr. and Mrs. W. Averell Harriman, New York 76

Sunflowers. Paris, summer 1887. Oil on canvas, 23½ × 39¼". F 452, H 280, JH 1330. Kröller-Müller State Museum, Otterlo 77

*Sunflowers. Arles, August, 1888. Oil on canvas, 36¾ × 28¾". F 454, H 467, JH 1562. Tate Gallery, London 79

Van Gogh's House at Arles. Arles, September, 1888. Oil on canvas, 30 × 37". F 464, H 489, JH 1589. Rijksmuseum Vincent van Gogh, Amsterdam 80

Van Gogh's House at Arles. Arles, May, 1888. Watercolor and reed pen, 9¾ × 12". F 1413, JH 1591. Rijksmuseum Vincent van Gogh, Amsterdam 81

*Sidewalk Café at Night. Arles, September, 1888. Oil on canvas, 32 × 25¾". F 467, H 493, JH 1580. Kröller-Müller State Museum, Otterlo 82

The Night Café. Arles, September, 1888. Oil on canvas, 27½ × 35". F 463, H 491, JH 1575. Yale University Art Gallery. Bequest of Stephen C. Clark 83

Interior of the Restaurant Carrel at Arles. Arles, September, 1888. Oil on canvas, 21¼ × 25½". F 549, H 554, JH 1572. Private collection, Providence, Rhode Island 85

*Public Garden at Arles. Arles, October, 1888. Oil on canvas, 28¾ × 36¼". F 479, H 504, JH 1601. Private collection 86–87

Still Life with Drawing Board and Onions. Arles, January, 1889. Oil on canvas, 19¾ × 25½". F 604, H 596, JH 1656. Kröller-Müller State Museum, Otterlo 88

Still Life with Lemons and Blue Gloves. Arles, January, 1889.
Oil on canvas, 19 × 24½". F 502, H 525, JH 1664.
Collection Mr. and Mrs. Paul Mellon 89

**La Berceuse.* Arles, December, 1888–March, 1889.
Oil on canvas, 36¼ × 28¾". F 504, H 528, JH 1655.
Kröller-Müller State Museum, Otterlo 91

"Les Alyscamps." Arles, November, 1888. Oil on canvas,
28¾ × 36¼". F 486, H 513, JH 1620. Kröller-Müller State
Museum, Otterlo 92–93

**The Bridge at Trinquetaille.* Arles, October, 1888. Oil on
canvas, 28¾ × 36½". F 481, H 506, JH 1604. Collection
Kramarsky, New York 94–95

The Sower. Saint-Rémy, 1889. Lead pencil, 9½ × 10¾".
F 1551, JH 1898. Rijksmuseum Vincent van Gogh,
Amsterdam 96

**The Sower.* Arles, October, 1888. Oil on canvas, 13 × 16¼".
F 451, H 480, JH 1629. Rijksmuseum Vincent van Gogh,
Amsterdam 98–99

One-Eyed Man. Arles, Saint-Rémy, 1888. Oil on canvas,
22 × 36¼". F 532, H 559, JH 1650. Rijksmuseum Vincent
van Gogh, Amsterdam 100

The Schoolboy. Saint-Rémy, January, 1890. Oil on canvas,
24¾ × 21¼". F 665, H 678, JH 1879. Museu de Arte, São
Paulo 101

**Portrait of Armand Roulin.* Arles, August–November, 1888.
Oil on canvas, 25½ × 21¼". F 492, H pl. XIII, JH 1642.
Folkwang Museum, Essen 102

**Madame Roulin and Her Baby.* Arles, November, 1888. Oil
on canvas, 25½ × 20". F 491, H 519, JH 1638. The
Metropolitan Museum of Art, New York. Robert Lehman
Collection 103

**Promenade at Arles.* Arles, November, 1888. Oil on canvas,
28¾ × 36¼". F 496, H 516, JH 1630. Hermitage,
Leningrad 106

**L'Arlésienne (Madame Ginoux).* Arles, November, 1888. Oil
on canvas, 35½ × 28¼". F 488, H 515, JH 1624. The
Metropolitan Museum of Art, New York. Bequest of Samuel
A. Lewisohn 107

The Novel Reader. Arles, November, 1888. Oil on canvas,
28¾ × 36¼". F 497, H 517, JH 1632. Collection Mr. and
Mrs. Louis Franck, Gstaad, Switzerland 108

Van Gogh's Bedroom (detail of letter No. 554). Arles, October,
1888. Pen. Rijksmuseum Vincent van Gogh, Amsterdam 109

**Van Gogh's Bedroom.* Arles, October, 1888. Oil on canvas,
28½ × 36¼". F 484, H 510, JH 1771. The Art Institute
of Chicago 110–111

**Van Gogh's Chair.* Arles, December, 1888–January, 1889.
Oil on canvas, 36½ × 29". F 498, H 521, JH 1635.
National Gallery, London, on loan to the Tate Gallery,
London 113

Portrait of the Head Guard at St. Paul's Asylum. Saint-Rémy,
September, 1889. Oil on canvas, 24 × 18". F 629, H 623,
JH 1774. Collection Mrs. G. Dübi-Müller, Solothurn,
Switzerland 114

Garden of St. Paul's Asylum. Saint-Rémy, October, 1889. Oil on canvas, 28¾ × 36¼". F 660, H 669, JH 1849. Folkwang Museum, Essen 115

**Self-Portrait with Pipe and Bandaged Ear*. Arles, January–February, 1889. Oil on canvas, 20 × 17¾". F 529, H pl. XII, JH 1658. Private collection 117

The Starry Night (Cypress with Moon). Saint-Rémy, June, 1889. Reed pen, pen, and ink, 18½ × 24½". Formerly Kunsthalle, Bremen (lost during World War II) 118–119

Flowering Stems. Saint-Rémy. 1890. Pen, 16 × 12". F 1612, JH 2059. Rijksmuseum Vincent van Gogh, Amsterdam 120

**Irises*. Saint-Rémy, May, 1889. Oil on canvas, 28 × 36¾". F 608, H 606, JH 1691. Joan Whitney Payson Gallery of Art, Westbrook College, Portland, Maine 120–121

The Starry Night. Saint-Rémy, June, 1889. Oil on canvas, 28¾ × 36¼". F 612, H 612, JH 1731. Museum of Modern Art, New York. Lillie P. Bliss Collection 122–123

**The Enclosed Field*. Saint-Rémy, March–April, 1890. Oil on canvas, 28½ × 36¼". F 720, H 662, JH 1728. Kröller-Müller State Museum, Otterlo 124–125

Landscape with Ploughed Fields. Saint-Rémy, November, 1889. Oil on canvas, 28 × 35¾". F 737, H 739, JH 1862. Formerly collection Mrs. Robert Oppenheimer, Princeton, New Jersey 125

**Storm-Beaten Pine Trees Against a Red Sky*. Saint-Rémy, November, 1889. Oil on canvas, 36¼ × 28¾". F 652, H 573, JH 1843. Kröller-Müller State Museum, Otterlo 128

**Portrait of the Artist*. Saint-Rémy, September, 1889. Oil on canvas, 22½ × 17¼". F 626, H 624, JH 1770. Private collection, New York 131

Olive Grove. Saint-Rémy, September–October, 1889. Oil on canvas, 28¼ × 36¼". F 585, H 708, JH 1758. Kröller-Müller State Museum, Otterlo 132–133

**Wheat Field with Cypresses*. Saint-Rémy, October, 1889. Oil on canvas, 28¾ × 36¾". F 615, H 611, JH 1755. National Gallery, London 134–135

Wild Vegetation. Saint-Rémy, 1889. Reed pen, 18½ × 24½". F 1542, JH 1742. Rijksmuseum Vincent van Gogh, Amsterdam 136

**Landscape with Olive Trees*. Saint-Rémy, October, 1889. Oil on canvas, 28½ × 36¼". F 712, H 635, JH 1740. Private collection, New York 138–139

Cart with Horse. From a sketchbook. 7 × 8¼". Rijksmuseum Vincent van Gogh, Amsterdam 142

**Road with Cypresses*. Saint-Rémy, May, 1890. Oil on canvas, 36¼ × 28¾". F 683, H 695, JH 1982. Kröller-Müller State Museum, Otterlo 143

Snowy Landscape. Saint-Rémy, c. 1890. Lead pencil, 9 × 12½". F 1591, JH 1907. Rijksmuseum Vincent van Gogh, Amsterdam 144

**The Good Samaritan* (after Delacroix). Saint-Rémy, May, 1890. Oil on canvas, 28 × 23¼". F 633, H 698, JH 1974. Kröller-Müller State Museum, Otterlo 146

*Pietà (after Delacroix). Saint-Rémy, September, 1889.
Oil on canvas, 28¾ × 23¾″. F 630, H 626, JH 1775.
Rijksmuseum Vincent van Gogh, Amsterdam 147

Landscape at Saint-Rémy. Saint-Rémy, c. 1890. Crayon,
12½ × 9½″. F 1593, JH 1906. Rijksmuseum Vincent
van Gogh, Amsterdam 148

Cypresses. Saint-Rémy, June, 1889. Reed pen and ink,
24½ × 18½″. F 1525, JH 1747. The Brooklyn Museum,
New York 149

*Prisoners' Round (after Gustave Doré). Saint-Rémy, February,
1890. Oil on canvas, 31½ × 25¼″. F 669, H 690, JH 1885.
Pushkin Museum, Moscow 151

Interior of a Farm. Saint-Rémy, c. 1890. Charcoal and pencil,
13½ × 19¾″. F 1588, JH 1954. Rijksmuseum Vincent van
Gogh, Amsterdam 152

*The Road Menders. Saint-Rémy, November, 1889.
Oil on canvas, 29¼ × 36¾″. F 657, H 667, JH 1860.
The Cleveland Museum of Art. Gift of Hanna Fund 154

On the Road. Saint-Rémy, c. 1890. Pencil, 9¾ × 10″. F 1596,
JH 1943. Rijksmuseum Vincent van Gogh, Amsterdam 156

Study of Female Figures. Saint-Rémy. Lead pencil, 9 × 2¼″.
F 1606, JH 1939. Rijksmuseum Vincent van Gogh,
Amsterdam 157 left

Studies of Peasant and Horse. Saint-Rémy. Lead pencil,
9 × 2¼″. F 1606, JH 1941. Rijksmuseum Vincent van
Gogh, Amsterdam 157 center

Studies of Female Figure and Landscape with Man. Saint-Rémy.
Lead pencil, 9½ × 3″. F 1606/7, JH 1938. Rijksmuseum
Vincent van Gogh, Amsterdam 157 right

*Cypresses with Two Figures. Saint-Rémy, June, 1889.
Oil on canvas, 36¼ × 28¾″. F 620, H 617, JH 1748.
Kröller-Müller State Museum, Otterlo 159

*Portrait of the Artist. Saint-Rémy, May, 1890. Oil on canvas,
25½ × 21¼″. F 627, H 748, JH 1772. Louvre, Paris 163

Portrait of Dr. Gachet. Auvers, June, 1890. Oil on canvas,
26¾ × 22½″. F 754, H 753, JH 2014. Louvre, Paris 165

*Portrait of Dr. Gachet. Auvers, June, 1890. Oil on canvas,
26 × 22½″. F 753, H 752, JH 2007. Collection Kramarsky,
New York 167

White Chestnuts. Auvers, May, 1890. Oil on canvas,
28¼ × 35¾″. F 820, H 747, JH 2010. Collection Emil G.
Bührle, Zurich 168

*Peasant Girl. Auvers, June, 1890. Oil on canvas,
36¼ × 28¾″. F 774, H 766, JH 2053. Collection Dr. H. R.
Hahnloser, Bern, Switzerland 171

Houses at Auvers. Auvers, June, 1890. Oil on canvas,
28¾ × 23½″. F 805, H 789, JH 1989. Museum of Fine
Arts, Boston 172

*Stairway at Auvers. Auvers, June, 1890. Oil on canvas,
19 × 27½″. F 795, H 783, JH 2111. City Art Museum,
St. Louis 174–175

Photograph Credits

The Poppy Field. Saint-Rémy, April, 1890. Oil on canvas,
28½ × 36″. F 581, H 696, JH 1751. Kunsthalle, Bremen 176

Three Trees. Auvers, June, 1890. Oil on canvas, 25¼ × 30¾″.
F 815, H 800, JH 2000. Kröller-Müller State Museum,
Otterlo 177

*The Church of Auvers. Auvers, June 4–8, 1890. Oil on
canvas, 37 × 29¼″. F 789, JH 2006. Louvre, Paris 179

Child with Orange. Auvers, June, 1890. Oil on canvas,
19¾ × 20″. F 785, H 777, JH 2057. Collection Mrs. L.
Jaggli-Hahnloser, Winterthur, Switzerland 182

*Mademoiselle Ravoux. Auvers, June, 1890. Oil on canvas,
26½ × 21¾″. F 768, H 767, JH 2035. Private collection,
Switzerland 183

Self-Portrait. From a sketchbook. Paris. 7¼ × 6″.
Rijksmuseum Vincent van Gogh, Amsterdam 184

Portrait of Theo van Gogh. Photograph 185 left

Portrait of Albert Aurier. Photograph 185 right

*Crows Over the Wheat Field. Auvers, July, 1890. Oil on
canvas, 20 × 39½″. F 779, H 809, JH 2117. Rijksmuseum
Vincent van Gogh, Amsterdam 186–187

Gravestones of Vincent and Theo van Gogh.
Photograph 188–189

With the exception of the following, all photographs reproduced in
this book were acquired from the museums and collectors to whom
the works belong:
A. C. L., Brussels, 57; Archives Photographiques, Paris, 73, 165;
Bernheim-Jeune, Paris, 60 top; Walter Dräyer, Zurich, 168;
George Flipse, Arnhem, 34; Peter A. Juley & Son, New York, 125;
J. de Kreuk, Arnhem, 8; Marlborough Fine Art Ltd., London, 89;
Printroom, University of Leiden (Collection E. Andriesse),
188–89; Michael Speich, Winterthur, 182; Stickelmann, Bremen,
118–19, 176; Witzel, Essen, 115; Nico Zomer, Amsterdam, 61
bottom.